Romance & Ritual

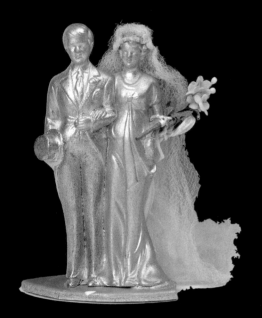

Celebrating

the Jewish

Wedding

Romance

&Ritual

Celebrating the Jewish Wedding

Edited by
Grace Cohen Grossman

Skirball Cultural Center
Los Angeles

in association with
University of Washington Press

SPONSORSHIP OF THE EXHIBITION WAS PROVIDED BY:
The Maurice Amado Foundation
Carylon Foundation
Leonard & Elaine Comess
The Nathan Cummings Foundation
Lee & Irving Kalsman Family Foundation
The Karma Foundation
Susanne & Paul Kester Family Foundation
Ornest Family Foundation
Renée Strauss for the Bride
Burton & Charlene Sperber

GENEROUS SUPPORT WAS GIVEN BY:
American Express
Peachy & Mark Levy Family Foundation
Helen Mars & Family

AND ADDITIONAL SUPPORT CAME FROM:
Madelyn Goodwin
MAC Cosmetics
Skirball Cultural Center Volunteer Council
Streit's Matzos

WE ARE GRATEFUL FOR THE FOLLOWING IN-KIND DONORS:
Autry Museum of Western Heritage
Diamond Foam & Fabric
Elegant Bride
Millennium Marketing
VONS, A Safeway Company

This catalogue was made possible by a gift from
the Susanne & Paul Kester Family Foundation

Distributed by University of Washington Press

Skirball Cultural Center
2701 N. Sepulveda Blvd.
Los Angeles, CA 90049
(310) 440-4500
www.skirball.org

The Skirball Cultural Center is an affiliate of Hebrew Union College.

Fig. 1 Wedding cake ornament, 1920 (cat. no. 134)
Fig. 2 Detail of Fiorenzuola *Ketubbah* (cat. no. 5)

Contents

6

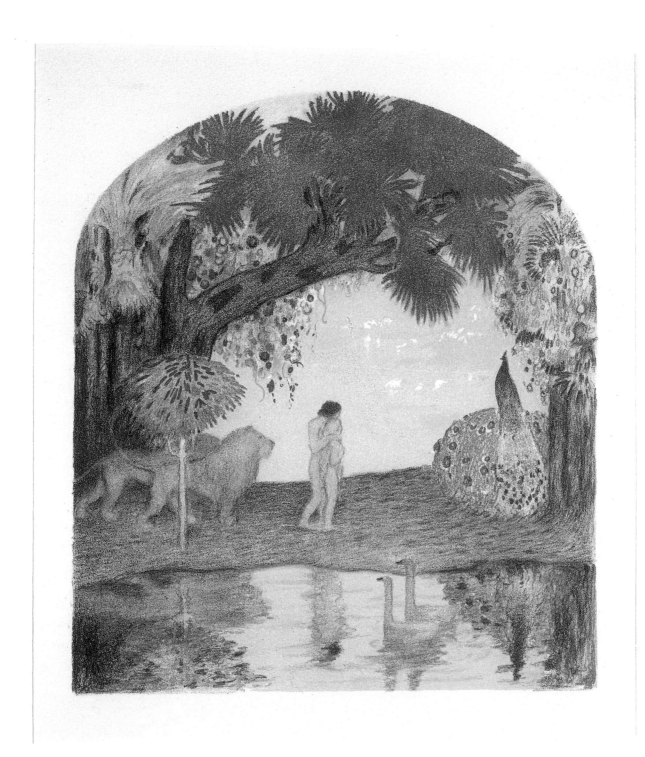

Fig. 3 *The Wandering of Adam and Eve,*
Abel Pann, circa 1924–6 (cat. no. 162)

"Bone of My Bone, Flesh of My Flesh"

Uri D. Herscher

LONELINESS IS A CONDITION human beings have always striven to escape. The awareness that loneliness constitutes a serious threat is echoed in the Creation saga of the Hebrew Bible: the Creator God, having brought Adam into being and installed him in the Garden of Eden amidst all its delights, recognizes–artist that He is–the Creation is somehow incomplete. As the Book of Genesis, chapter 2, has it: "The Lord God said, it's not good for Adam to be by himself; I'll make him a companion"–and the Creator God goes on to produce myriads of animals and birds and has Adam assign them names, but a sense of incompleteness persists: "He's not found Adam a companion." At length, a divine anesthetic is applied, a divine surgery performed, and Eve emerges; "bone of my bone, flesh of my flesh," Adam proclaims jubilantly!

No nuptial pomp and circumstance–that will come later, especially in post-biblical rabbinical elaborations–but the point has been made in the Genesis account: loneliness means that the Creation is incomplete; something must be done to complete it; a human being needs the proximity and intimacy of a fellow human being to feel the completeness whose character and priority even the Creator God–not being human?–does not initially comprehend.

When the rabbis come into the picture uncounted generations later, they do not need to be reminded of what it took the Creator God some time to divine. The *sheva berakhot*, the Seven Benedictions, they (or a great anonymous poet in their midst) devise for the nuptial ceremonies spell out the paramount importance to be ascribed to the occasion. For them, the banishing of loneliness, the conjoining of two human beings in marital intimacy, revives the lost Garden of Eden; as the Sixth Benediction puts it, the *re'im ahuvim*, the "friends and lovers" who are the newlyweds, will be gladdened as the biblical Adam was gladdened in Eden.

More, their coming together in matrimony unmistakably bespeaks a messianic mission. Human life, the Fourth Benediction declares, is divinely a *binyan adey ad*, an "eternal edifice"–calling to mind surely the unique, no longer existent *binyan* in Jerusalem, the Holy Temple. The *ḥurban*, the destruction of that Temple, and its accompanying *galut* (exile), are alluded to in the Fifth Benediction, which transcends the grievous memory of *ḥurban* and *galut* by seeing in marriage a promise of *qibbuts baneha* (restoration). Jerusalem, barren of her Temple, rejoices in the prospect of "her children restored to her in joy," a messianic culmination.

The climactic Seventh Benediction makes the messianic point even more strongly. In this Benediction the liturgical poet has set no bounds to the joy of the marital event–and assembles a mini-thesaurus of synonyms denoting joy: "rejoicing and happiness, delight, bliss, gladness and glee, love and harmony, peace and intimacy!" Nowhere else in the vast and expressive library of texts that make up Jewish liturgy is there the like of the Seventh Benediction, which proceeds then into a clear messianic vision: "Without delay...let there be heard in the cities of Judah and in the streets of Jerusalem the sounds of festivity and rejoicing, the voices of bridegroom and bride, the joyful shouting of bridegrooms from their wedding canopies and of young men exuberant in their wedding revels."

These texts and the emotions they capture, the hopes and expectations they cherish, invoke a luminosity that, while couched in Jewish vocabulary and infinitely precious on that score, adds up to a profound expression of human feeling and human need. Loneliness is an insupportable incompleteness; to enjoy the intimacy of a human companion is a redemption.

Acknowledgments

A PROJECT OF THIS SCOPE could only be realized through the cooperative efforts of many. We are deeply grateful to those who generously funded the exhibition for their understanding of our goals and excitement about what we hoped to achieve. A list of contributors at the time of publication is to be found at the front of the catalogue. Our profound thanks goes to those who have donated their family heirlooms to the Skirball, where they will be preserved for generations to come. In addition, we also want to thank the lenders who have made their personal treasures available for this exhibition. Producing the installation and related programs has been a true team effort on the part of the Skirball staff and they all deserve special thanks and recognition for their contributions. My longtime colleagues Nancy Berman, Director Emeritus and Curator at Large, Adele Lander Burke, Vice President, Museum and Education, and Barbara Gilbert, Fine Arts Curator, as ever, were stalwart supporters and always available sounding boards for the exhibition plans. Tal Gozani, Assistant Curator, worked on the countless details of the exhibition and catalogue and organized all of the loans from the Skirball docents and volunteers for the exhibition, video, and website. As always, Paul Heller spun his magic in creating the video. David Greenfield developed the web presentation. Esther Yoo, Registration Assistant, diligently compiled label entries, arranged loans, and assisted the textile conservators. Dan Smith, Assistant Registrar, facilitated the photo documentation of the collection. Gloria Frankel ably organized the loans from the Iranian community. Marcie Kaufman, Core Exhibition Manager, was ever ready to assist on an "as needed" basis. Summer intern Leah Angell helped develop the initial research. Museum volunteer Sam Schaffer computerized all of the data on the postcard collection. Dr. Ira Rezak surveyed the medal collection and provided useful information.

Darcie Fohrman, who has been my associate and friend for thirty years, designed a wonderful installation, creatively integrating the many different components of the exhibition. Her technique of conceptual planning enabled all of the Skirball staff to participate in the process of exhibit development. Jeffrey Yoshimine, Chief Preparator, deftly and efficiently crafted the exhibit from the plans, assisted by John Elder and the entire preparation staff.

Preparing the many different types of objects for exhibition is a tremendous task that has been accomplished by the skilled conservators who work with the museum. Many items, in particular the *ketubbot*, have been part of ongoing conservation projects. During the past decade, Nancy Turner, parchment conservator, has worked on many of the marriage contracts and scrolls in the collection. Lisa Forman, paper conservator, treated ceremonial items, documents and fine arts. Rosa Lowinger and the staff at the Sculpture Conservation Studio, worked on all types of three dimensional objects in many different media. Tanya Thompson has treated a number of the paintings. For this exhibition the textile conservators took a leading role. Sharon Shore, along with Cara Varnell, worked on nearly thirty items of wedding apparel and prepared all of the mannequins for display. Moreover, their contributions to this catalogue are important additions to the field of conservation literature. Tawny Sherrill, costume historian, advised on the descriptions of the bridal gowns. Ann Lauterbach, longtime volunteer needleworker for the museum, assisted the textile conservators and also created all of the clothing for the children's "dress-up" corner. Julie Breitstein, one of the museum's very first volunteers, created silk roses for the brides' bouquets.

Special thanks go to the contributors to the catalogue. Their scholarship will make this catalogue have an impact well beyond the scope of this exhibition. As always, Stanley F. Chyet, Chair of the Skirball Publications Committee, and my teacher and mentor, has been a sage advisor in editing this volume. Letitia Burns O'Connor and Dana Levy of Perpetua Press have

played a vital role in the creation of this catalogue, well beyond the scope of normal editorial and design work. Susan Einstein did an exceptional job of photographing the wedding gowns, in addition to scores of other objects in the exhibition. I especially want to express my deep gratitude to Susanne Kester for all of her devoted work for so many years as the person responsible for the Media Resources Department. Her diligence, masterful organization, and her positive attitude and good humor are a model for us all. We are grateful for the contribution from Susanne and her husband Paul that has made this publication possible.

As always, Skirball staff members went into high gear from the first planning meetings. Jocelyn Tetel, Vice President for Advancement, diligently sought the support needed for the exhibition and all related programs. Lori Starr, Vice President External Affairs, and her entire department have all worked hard to "get the word out" to the public. Robert Kirschner, Vice President for Programs, Jordan Peimer and Amina Sánchez, Associate and Assistant Director of Programs, developed a wonderful roster of special events that complement the exhibition. Gabrielle Tsabag and Ina Borenzweig, representing the Education Department, have developed fun and informative programs for school groups and families. Kathryn Radcliffe, Executive Assistant to Adele Burke, keeps it all running smoothly.

Finally, my thanks to Uri D. Herscher, President of the Cultural Center. This exhibition marks my eighteenth year working at the Skirball and with Uri. He is truly a visionary who enables those of us who work with him to fulfill our personal goals.

GCG

9

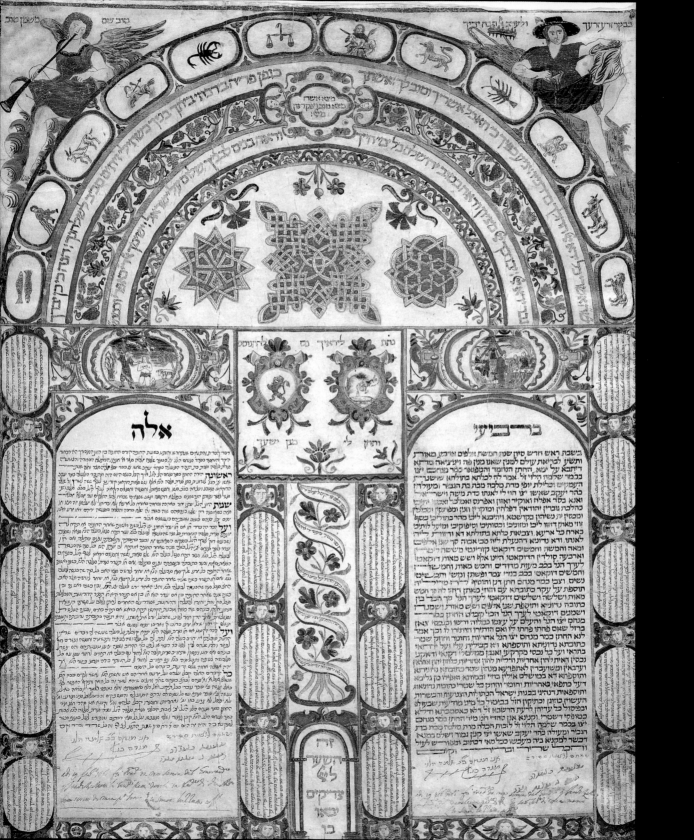

Finding the Perfect Match

Grace Cohen Grossman

"LOOK AT THIS!" How often members of the staff said those words as each of nearly twenty-five thousand objects was carefully packed for the museum's move in 1996 to its new home at the Skirball Cultural Center. The move from the downtown Los Angeles campus of Hebrew Union College provided the rare opportunity to explore anew the resources of the nearly century-old, yet growing and dynamic Skirball collection. As the fifth anniversary of the Skirball Cultural Center approached, with many of the collection's treasures newly installed in the long-term exhibition chronicling Jewish life and traditions in the Old World and the New, we thought to mark this milestone with a temporary exhibition, also drawn from the Skirball collection, that celebrates weddings in Jewish life and history.

Because the subject of weddings is so rich in potential, the research became a wonderful quest and the process of deciding what to include a tremendous challenge. As planning evolved, we determined two goals for the exhibition: to present marriage rituals and customs from different times and places through the diversity of treasured heirlooms in the Skirball collection; and to capture the romance of weddings and the joy of sharing a lifetime of experiences with one's soul mate.

Jewish weddings have been defined in the evolving literature of our culture as both a joyous event and a sacred act. The Hebrew term for weddings is *kiddushin*, from the verb *le-kadesh*, "to make holy." Several rituals and symbols that are integral to each wedding ceremony reflect this spirit. In their essay, "Law or Custom? The Historical Evolution of Jewish Wedding Ceremonies," Tal Gozani and Didier Y. Reiss describe the separate rituals of betrothal and marriage that have merged in the Jewish wedding. "A Guide to Wedding Rituals," compiled by Gozani, is a glossary of the customs and ceremonies one may encounter in contemporary weddings.

Jewish law stipulates few requirements for a wedding, but it does not prohibit the very human urge to embellish this important and personal event. The interaction of the Jewish community with its neighbors has shaped the way in which some of the aspects of the ceremony are conducted and the form and style of the objects used. This integration of traditions is perhaps most visible in the *ketubbah*, or marriage contract. Since antiquity, Jewish law has mandated that each bride receive a *ketubbah* from her husband. The stipulations of the contract have been her legal safeguard and guarantee, but the impulse in many communities has been to transform the formulaic *ketubbah* into a work

< **Fig. 4** Venice *Ketubbah*, 1649 (cat. no. 1)

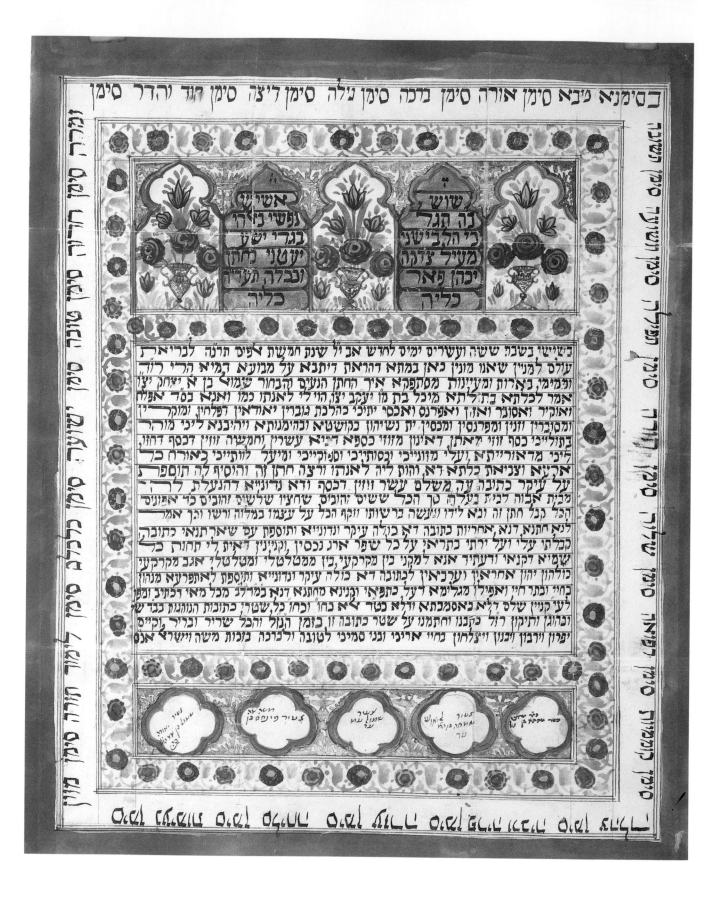

Fig. 5 Herat *Ketubbah*, 1895 (cat. no. 9)

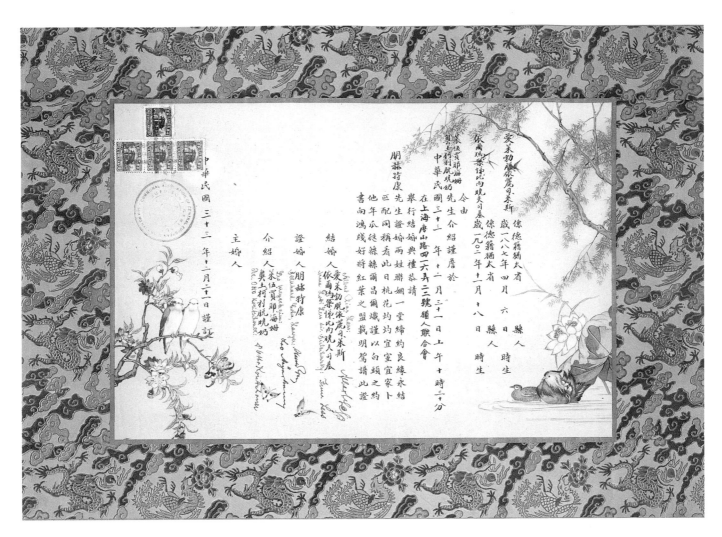

愛未勃脫依麗司朱斯

中華民國三十三年十二月二十日謹訂

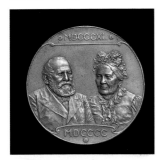

Fig. 6 Shanghai Marriage Document, 1940s (cat. no. 86)

Fig. 7 Sixtieth Anniversary Medal, 1900 (cat. no. 123)

of art. The Skirball Museum has one of the premier collections of *ketubbot* in the world, with more than four hundred examples dating from the seventeenth century to contemporary times and representing some twenty-five countries. A major study on the collection was published in 1990 in *Ketubbah: Jewish Marriage Contracts of the Hebrew Union College*, authored by Shalom Sabar, who has examined nuptial scenes on folk textiles as his contribution to this catalogue.

More than one hundred fifty marriage contracts from Italy, source of the greatest number of decorated *ketubbot*, were collected nearly a century ago in Germany by Berlin businessman Salli Kirschstein. These were among the six thousand items in the Kirschstein Collection, which was acquired for the museum in 1926. It is likely that Kirschstein had purchased many, if not most, of the marriage contracts in 1908 from another collector, Heinrich Frauberger, director of the Kunstgewerbemuseum (Arts and Crafts Museum) in Düsseldorf, Germany. How Frauberger, a Catholic, became interested in Jewish art will never really be known. How he managed to assemble such a remarkable collection is even more of a mystery. The likelihood is that he responded visually to the designs that draw on a wealth of imagery from baroque Italy. The earliest of the Italian *ketubbot* in the collection, produced in Venice in 1649 (Fig. 4), incorporates a portal motif likely inspired by the façade of the fifteenth-century church of Santa Maria dei Miracoli designed by Pietro Lombardi. On the *ketubbah*, the church's windows have been replaced by intricate knots, a popular motif of the period, highlighted with gold leaf. Other quoted motifs include, for example, a nude, reclining Venus akin to Titian's *Venus of Urbino* (1538) on a 1790 *ketubbah* from Pisa (Fig. 66).

Images on marriage contracts collected over the years reflect the communities in which they were made: on an 1895 *ketubbah* from Herat, Afghanistan (Fig. 5), the text is

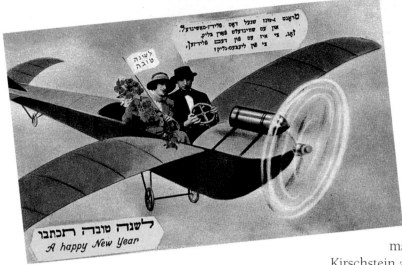

לשנה
טובה

טראָגט אַזוי שנעל דאַס פּליִיד-מאַשינדעל,
און עם שוינצעלט פאַרן בליִיק.
זאָג, צי איז עם פון דעם פּליִד-זען,
צי פון ליִעבעס-בליִיק.

לשנה טובה תכתבו
A happy New Year

Fig. 8 Romantic
New Year's Greeting:
Airplane Ride, circa 1915
(cat. no. 94)

14

framed by an arcade that echoes Islamic architectural design. A marriage certificate from Shanghai, written in Chinese characters and with a dragon motif repeated in the border, was used for the wedding of a German refugee couple in the 1940s (Fig. 6).

Kirschstein also amassed a phenomenal group of more than five hundred folk art textiles known as *Wimpeln*, Torah binders, created to commemorate the birth of a baby boy and made from the linen swaddling cloth used at the child's circumcision ceremony. The cloth was cut into strips and sewn together to make a long banner, then lovingly embroidered or painted with the boy's name, his date of birth, and the Hebrew blessing recited at the circumcision ceremony that is translated, "may he grow to study Torah, to get married, and to do good deeds." Each *Wimpel* is personalized with images that reference that blessing, and many include a wedding scene replete with a ḥuppah, the marriage canopy. Creating the *Wimpel* was a European tradition that began in southern Germany. By custom, the *Wimpel* was presented by the child when he came to the synagogue for the first time and was used on that occasion to wrap the Torah scroll, again on his bar mitzvah, and sometimes on the Sabbath before his wedding. The binders were kept in the synagogue as a type of birth record, and the intrepid Kirschstein, who may have been alert to population shifts, possibly acquired the textiles from synagogues that were closing or had few remaining members.

The work on the *Wimpeln* ranges from primitive to highly sophisticated depending on the skills of the maker. Some binders were apparently made by professional embroiderers, as is likely the case of a 1719 *Wimpel* for Benjamin Wolf (Fig. 20). Shalom Sabar presents an in-depth review of the custom of making *Wimpeln* in his essay, "'May He Grow Up to the Ḥuppah': Representations of the Wedding on Ashkenazi Torah Binders."

The Skirball collection also reflects Salli Kirschstein's wide-ranging interest in the fine arts. Among the artworks he collected are some very fine paintings of German Jews, including commissioned portraits of husbands and their wives intended to be hung in the family home. Barbara C. Gilbert discusses these commissions, including two from the Kirschstein Collection, in her essay "Beloved Companions: Portrait Pairs in the Skirball Collection." Many of the six portrait pairs in the exhibition were painted years into their marriage and their images seem to epitomize the wisdom of experience. We have taken the liberty of including them in the exhibition as symbols of realizing the ideal of marriage, "to find a perfect match."

Reexamining the collection from the perspective of nuptial artifacts led to some discoveries of seldom-seen items. A group of objects that has received little attention in recent years is commemorative medals. These were acquired in the early twentieth century from another European collector, Joseph Hamburger. Among the hundreds of medals are a number of nineteenth-century examples that commemorate weddings and anniversaries. The earliest known Jewish portrait medals, which date to the Renaissance, were apparently commissions, just as painted portraits would have been. Medals were cast to honor personalities in many fields of endeavor, including law, medicine, literature, and music, and to commemorate historical events and dedications of important new synagogues and community buildings. Personal medals recording weddings and

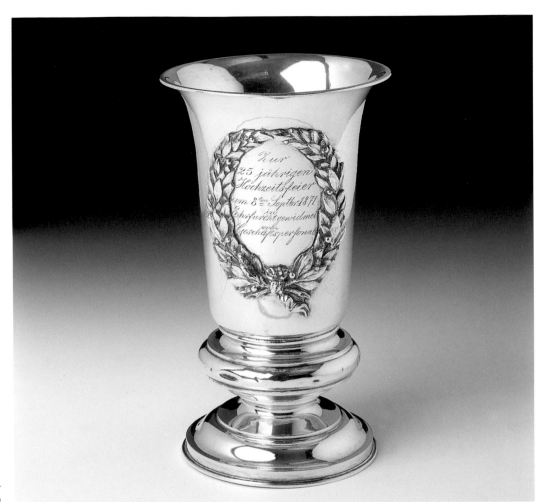

Fig. 9 Silver Wedding Anniversary Cup (cat. no. 141)

anniversaries developed later from this genre. The medal struck in Vienna in 1900 to commemorate the sixtieth wedding anniversary of Moses and Miriam Luria features tender portraits of the elderly couple by maker Karl Maria Schwerdtner (Fig. 7).

The museum holds almost three thousand vintage postcards, but these may originally have been considered an ephemeral collection as there is no documentation of how and when they were acquired. Since the move to the Cultural Center, the data on the postcards have now been computerized, thanks to a dedicated volunteer, and are now accessible for research and exhibition. Among the early twentieth-century cards (see pp. 122–3) are romantic greetings for the Jewish New Year with flowery messages in Yiddish and images of couples in rowboats and propeller planes (Fig. 8), on the telephone, and even in a balcony scene à la *Romeo and Juliet*.

American Jewish weddings have mirrored the changing taste of the general population, a theme Jenna Weissman Joselit discusses in her essay, "Pomp, Circumstance, and the American Jewish Wedding." The fascinating encounter of Jewish tradition and American wedding customs as they evolved during the past century is also revealed by wedding attire worn by nine brides, several grooms, and a number of children who were flower girls and ring bearers. These changing fashions (see pp. 92–110) allow us to experience the changing tastes in American Jewish marriages since 1890.

Photographs and mementos related to courtship and engagement, weddings, and anniversaries are presented because such personal memorabilia are an important form of documentation and preservation. Many of these items are on loan from Skirball docents and volunteers, including a selection of cards from the unparalleled collection of anniversary tributes made by artist and long-time museum docent Jerry Novorr for his wife Pearl every year since they were wed in 1939 (cat. no. 150). Videotaping of weddings,

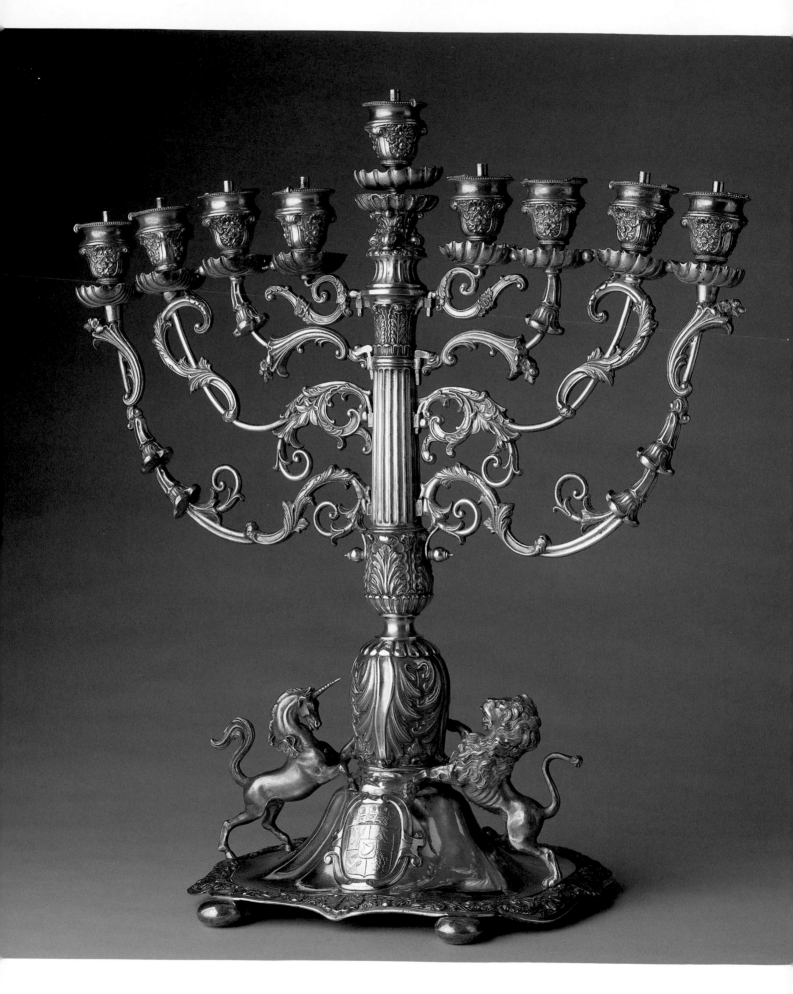

Fig. 11 *Tavla de Dulsé* (Tray for Sweets), 1920s (cat. no. 67)

< **Fig. 10** Rothschild Hanukkah Lamp (cat. no. 116)

Fig. 12 *Shalaḥ Manot* and
Matan Beseter Tzedakah
Plate, Moshe Zabari, 1989
(cat. no. 144)

popular in recent years, has also made it possible to compile a selection culled from over
twenty weddings to highlight different aspects of the ceremony and celebrations. This
material will be available on the website of the Skirball Cultural Center as well as in the
exhibition. A photographic essay by Bill Aron documenting a wedding at the Skirball
Cultural Center in 1999 is included among the contemporary wedding artifacts.

The ideals, realities, and challenges of the American Jewish experience are reflected
in the family heirlooms given to the museum's collection program Project Americana.
Established in 1985 to further the objectives of the future Cultural Center, then in its
planning stage, the premise of Project Americana is that everyone has a valuable story to
tell and that objects play an important role in the preservation of those cherished stories.
Some objects, like a twenty-fifth anniversary cup from Berlin (Fig. 9), are treasures that
link an American family to its ancestors. Many others reflect various aspects of American
Jewish life, especially the celebration of life-cycle events. Whenever an object is donated
to Project Americana, every effort is made to record background information. When a
wedding gown is acquired, for example, the personal history of the bride and groom is
recorded and other objects related to the wedding itself are collected: a photograph, an
invitation, a memento from the celebration. These artifacts help capture a moment to be
shared with later generations.

It is the museum's good fortune to be able to borrow wedding clothing from local
families to reflect communities including Morocco, Iraq, and Iran, that are not yet
represented in the Skirball collection. We are grateful to those families who lent
these items for the exhibition. A contemporary practice among young couples whose
families originally came from these communities and others in the Middle East is to wear
traditional costumes for some aspect of their wedding celebrations. In their essay entitled

"Traditional and Transitional Bridal Costumes in Middle Eastern Jewish Communities," Esther Juhasz and No'am Bar'am Ben Yossef discuss the many types of nuptial outfits that evolved in these lands and the changes that occurred with modernization. A long-term loan from folklorist Keren Tzionah Friedman makes it possible for the museum to display a bridal tableau from Djerba (Fig. 115) in the Cultural Center's core exhibition, *Visions and Values: Jewish Life from Antiquity to America.* Friedman describes the objects she collected while living on the Tunisian island and discusses Jewish wedding celebrations in Djerba in her essay, "A Nuptial Fortnight in Djerba."

A group of eighteenth- and nineteenth-century wedding rings from Italy are among other wedding and marriage-related objects also in the museum's core exhibition, including *ketubbot* from several different countries. The Rothschild Hanukkah lamp (Fig. 10), which may have been presented as a wedding gift from Baron Wilhelm Karl von Rothschild (1829–1901) to his bride Mathilde (1832–1924), is an example of a personal object that also reflects Jewish ritual. A *tavla de dulsé* (tray for sweets) (Fig. 11) was typically included in the bride's trousseau in Turkey and on the island of Rhodes because the sweets she served epitomized the warm welcome guests would receive in her home. Other dowry items from Turkey and Rhodes—including embroidered towels and beautiful clogs (Fig. 104) for the bride to take to the *mikveh*, ritual bath—are specifically related to weddings. A nineteenth-century silver-gilt filigree case for a *megillat Esther* (Esther scroll), was a traditional engagement gift to bridegrooms in Izmir, Turkey (cat. no. 68). A special container, the *Shalaḥ Manot* and *Matan Beseter Tzedakah* Plate (Fig. 12) crafted by master silversmith Moshe Zabari in honor of the fortieth wedding anniversary of Peachy and Mark Levy represents the dual aspect of giving gifts to friends and aid to the needy on Purim, which coincided with the Levys' wedding day.

To highlight contemporary Jewish weddings, the museum has invited artist Ed Massey to re-create, in a site-specific installation, the 1998 engagement and wedding of the artist and his bride, Dawn Harris. The engagement and Massey's highly imaginative proposal took place at the beach at a one-year-old child's birthday party he orchestrated for the occasion. The ring was hidden among little boxes of gift toys in a piñata, and the first section of the installation reenacts that scene. For the wedding ceremony itself, Massey created a spectacular gown for Dawn—a moveable wedding sculpture weighing nearly two hundred pounds—a confection of pastel plaster roses replete with a duck pond on the train. The wedding took place under a simple prayer-shawl *ḥuppah* in a beautiful garden setting, which has been recreated in the Skirball galleries. Dawn's gift to Ed was music she composed for the wedding, which is played in the gallery. Massey's artwork truly symbolizes the "Romance and Ritual" that the celebration of marriage represents in Jewish life.

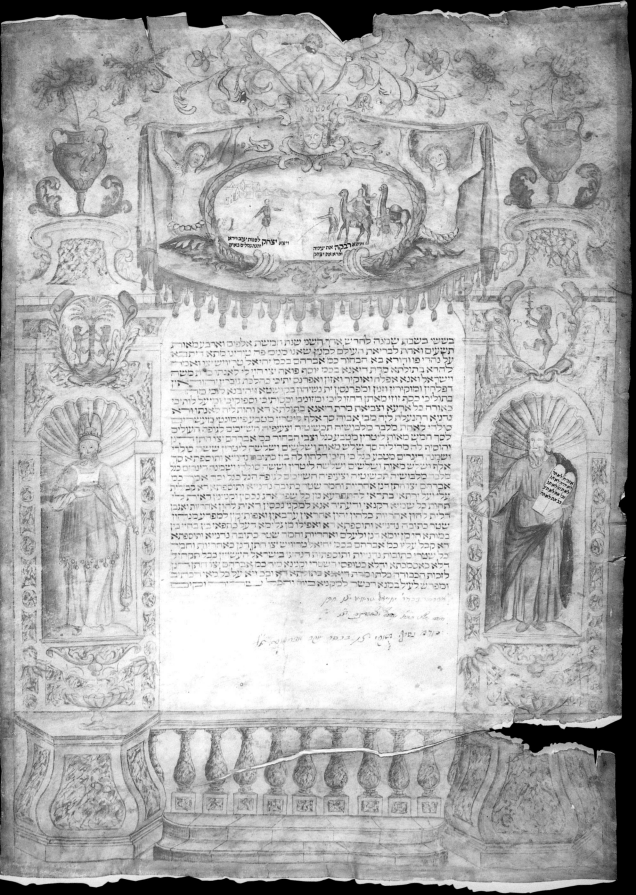

בששי בשבת ישמגה לחדש אדר השני שנת חמשת אלפים וארבע מאות
תשעים ואחת לבריאת העולם למנין שאנו מנין פה טריני מתא דיתבא
על נהרי פו והירא בא הבחור כמ' אברהם בכמ' יחזקאל טריויש יצו ואמר
להדא בתולתא כרת דיאנה בכמ' יוסף פואה יצו הין לי לאנתו כדת משה
וישראל ואנא אפלח ואוקיר ואיזון ואפרנס יתיכי כהלכת גוברין יהודאין דְ
דפלחין ומוקירין וזנין ומפרנסין ית נשיהון בקושטא ויהיבנא לכי מהר בתו
ליכי כסף זוזי מאתן דחזו ליכי ומזוני וכסותי וספוקיכי ומיעל לותיכי
כאורח כל ארעא וצביאת מרת דיאנה כהלתא דא והות ליה לאנתו וּדֵא
נדוניא דהנעלת ליה מבי אבוה סך אלה ליטרין בטבעא פימונט מישַׁריים
סולדי לאהה מלבר מלבושיה תכשיטיה ויציעתא היטיבכם לגופה העולים
לסך חמש מאות ליטרין מטבע ענל וצבי הבחור כמ' אברהם חתן דנן
יהוסיף לה מדיליה סך שליש מאתן שלשים ליטרין וחמשה סולדי סולדי
ושכינת הינרים מטבע כג' כי הכי דלחזו לה בין כתובה נדניא ותוספתא
מלבר מלבושיה תכשיטיה ויציעתה השייכים כלנף הנל כל וכד אמר כמ'
אברהם חתן דנן אחריות וחומר שטר כתובה נדניא דא תוספתא רא קבלית עלי ועל ירתי בתראי לאתפרעא מכל שפר ארג נכסין וקנינין דאית לי
תחות כל שמיא וראית אנא למקנא נכסין דאית להון אחריות ואגבן
דלית להון אחריות כלהון יהון אחראין וערבאין לאפרעא מנהון שטר פתתא וחמר
שטר כתובה נדניא ותוספתא רא ואפילו מגלימא דעל כתפאי בין בחיי בין
דא קבל עלוי כמ' אברהם בכמ' יחזקאל טריויש יצו שטר כתובה כתבובה ותוספתא וחמר
כל שטרי כתובות נדוניות ותוספתא כל נשיאה באחריות וחמר
דלא כאסמכתא ודלא כטופסי דשטרי וקנינא מיד בכמ' אברהם חתן הזל
לזכות וכבודה כלהו כמ' דא בכל מה דאמור לעיל וקיום
ומפר יש לעילא כדינא רכשר למקנא ביה וקים

ויצא יצחק לפנות ערב והנה גמלים באים

ותשא רבקה את עיניה ותרא את יצחק

Law or Custom?

The Historical Evolution of Jewish Wedding Ceremonies

Tal Gozani *and* Didier Y. Reiss

EWISH WEDDINGS are like beautiful quilts embroidered with biblical, talmudic, and contemporary themes. They intertwine laws, liturgies, and customs that have developed over several millennia and simultaneously honor and confront an ancient heritage in a fruitfully open-ended conversation. Celebrating Jewish history and tradition, on the one hand, and expressing idiosyncratic contemporary visions of family, on the other, Jewish wedding ceremonies reflect the diversity of Jewish identities throughout history that continues to this day.

Biblical View of Marriage

The Bible provides the ethical foundation for Jewish marriage, but offers few specific instructions for conducting wedding ceremonies. The Bible depicts marriage as the ideal human state, suggesting that "it is not good that man should be alone" (Genesis 29:22, 27), but it is not explicit about how such a union should be consummated.[1] The description of the wedding of Jacob and Leah suggests that celebrations could last as long as a week. Elsewhere in the Bible there is evidence not only of elaborate wedding processions, accompanied by music, for both bride and groom but also of special marriage attire and adornment. Except for a few homiletic injunctions and vague references to festivities surrounding the event, however, the Bible is notably silent about the wedding ritual itself.

Marriage as Transaction

The foundational text of rabbinic Judaism, the Mishnah (second century C.E.), is similarly terse in its descriptions of wedding ceremonies, but it began the process of fixing their essential elements, especially *erusin* (betrothal) and *nissu'in* (marriage proper). The Tannaim (rabbis) who wrote the Mishnah created a systematic legal and interpretive framework for all future discussions about Jewish marriage. The Tannaim codified basic legal protections for husbands and wives in and after marriage that were roughly akin to the protections enjoyed by buyers and sellers in generic economic transactions. In establishing legal criteria for Jewish marriages, the Mishnah refined the biblical language of *kinyan* (acquiring), declaring simply that "women [were] *acquired* in [one of] three ways…: by money, by legal deed, or by intercourse."[2]

Although the institution of Jewish marriage was accorded legal footing as early as the second century, the traditional Jewish wedding ceremony as we know it today did not emerge until the final redaction of the Babylonian Talmud in the sixth century. The Amoraim (rabbis of the talmudic period) retained and amplified the legalistic perspective

< **Fig. 13** Turin *Ketubbah*, 1731 (cat. no. 2)

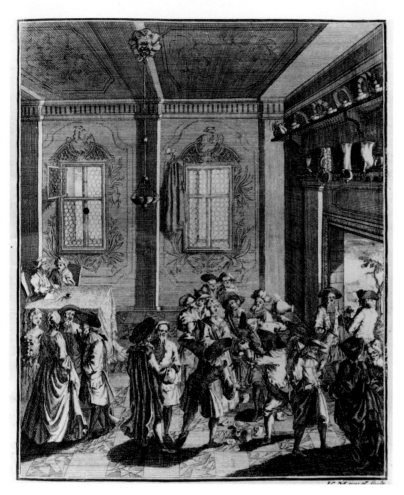

Fig. 14 *At the Betrothal,* from J. Ch. G. Bodenschatz, *Kirchliche Verfasung der heutigen Juden,* 1748. Courtesy Hebrew Union College, Frances-Henry Library, Los Angeles

of the mishnaic Tannaim. For instance, the Talmud reinforced the legality of wedding proceedings by mandating that both elements of the ceremony had to be properly witnessed. The Talmud completely transformed Jewish wedding celebrations by instituting a precise regime of rituals and liturgies and imbuing them with a solemn air of religious sanctity. Standardizing Jewish wedding ceremonies for the first time, the Talmud redefined Jewish marriage as both a social and a sacred act requiring the rabbis' utmost attention. The mishnaic framework of *kinyan* persists, reflecting the continued social importance of marriages as economic unions, but the Talmud also superimposed a new language of *hekdesh* (sanctification) to underscore the complex religious role of marriage.

The Amoraim created a comprehensive body of marriage legislation that dealt with everything from the initial engagement process (*erusin*) to the laws of family purity (*niddah*) and even divorce and death. Extrapolating broad meaning from a few isolated Bible verses, the Talmud developed an elaborate interpretative scheme to justify a new rabbinic mandate for standardizing and supervising Jewish wedding ceremonies. By making rabbinic sanction central to the legitimacy of Jewish marriage, the talmudic sages formalized what had hitherto been relatively impromptu affairs. Moreover, by introducing a new level of legal complexity, they guaranteed that henceforth rabbis, guardians of the Jewish law, would take an integral part in planning all future Jewish weddings.

The Institutionalization of Wedding Customs

Strictly speaking, the Talmud simply mandated that, in an act of symbolic acquisition, the groom bestow on the bride, before witnesses, an object worth more than a *perutha*, the smallest denomination of currency at the time, while simultaneously reciting a ritual formula of acquisition and consecration to ensure the transaction's religious significance. In fact, the laws so established went far beyond this, discussing in great detail dowries, sexual conduct, and, more generally, the rights and responsibilities of brides and grooms, wives and husbands. The Talmud extolled the virtues of certain celebratory customs, declaring in purposeful exaggeration that the merits of participating in marriage ceremonies superseded even the value of Torah study. The Talmud even declared the entertaining of bride and groom a *mitzvah*, and includes a serious description of precisely how one should dance before the bride. Referring to a full week of festivities accompanied by the recitation of special blessings at all meals, the Talmud seemed to accord the celebration of weddings the same status as the celebration of religious holidays. Although specific customs were perpetually created and re-created in response to changing concerns, later Jewish communities still found the legal and religious skeleton for celebrating Jewish weddings in the Talmud.

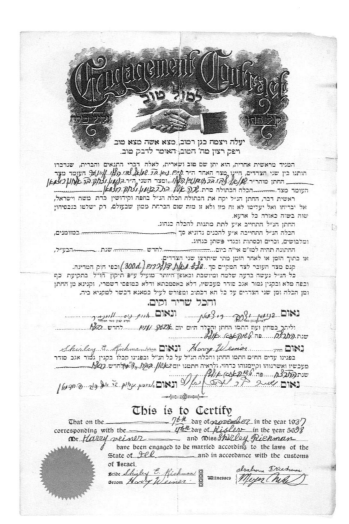

Structure and History of the Wedding Ceremony

The two central parts of the marriage ceremony have, from the Mishnah through today, consisted of *erusin* and *nissu'in*. For a full millennium these two events of the wedding were separated by as much as a year, but the talmudic scheme eliminated this temporal separation in the eleventh century.

Erusin, the formal engagement of bride and groom, was ordinarily performed at the bride's home; it finalized mutual agreements between two families to make the subsequent consummation of the marriage possible (Fig. 14). After financial terms had been agreed upon by the families, the groom, in a brief ceremony, bestowed a modest ring[3] to his bride while reciting the following formula: "Behold, you are consecrated unto me with this ring according to the law of Moses and Israel." Sealed with one blessing over wine and another for the act of betrothal, the future marriage was then anticipated with an appropriately lavish banquet.

The formal consecration of a future marriage reflects the precarious social conditions prevalent in ancient times. For social and economic reasons it was absolutely crucial to secure a match for one's children as early as possible; the formal betrothal allayed parental worry while the children were still young and at home. The formality of the *erusin* ceremony, which rendered bride and groom virtually married, precluded hastily breaking agreements or considering other matches, while still allowing the young bride and groom time to mature. Moreover, the time between *erusin* and *nissu'in* allowed the bride to acquire a trousseau, including her personal effects and jewelry, and the groom to establish his financial independence, set up a home, and make arrangements for a bountiful wedding banquet.

While *erusin* bound bride and groom to each other in important ways, the marriage

was not consummated until after the *nissu'in* ceremony. The root form, from the verb *nassa*, which means "to carry or lift," suggests that the *nissu'in* ceremony originated in the days when a bride was physically carried through the streets to her new home. Standing together under the *huppah*, a symbolic act of intimacy, the couple conveyed their intention of creating a new home and life together. *Huppah* referred to either the groom's house, to which the bride was led, or to the canopy, symbolic of the house, under which the ceremony took place.[4] The bride's entering of the groom's house and cohabiting with him effected *nissu'in*. Several blessings were recited, which finalized and sanctified the couple's abode and the marriage, transforming bride and groom into wife and husband, liable to all the privileges and responsibilities of this new status.

Erusin and *nissu'in* differed in both function and feeling. *Erusin* acknowledged a legal contract expressed in precise formulas and transactions of the *ketubbah* (marriage contract) and *kinyan*, while *nissu'in* embodied a less tangible process, sealed not with documents but with actions. Betrothal designated the bride and groom off-limits to all others, but only nuptials intertwined their lives as a family. Thus, while *erusin* forged the initial connection between bride and groom, *nissu'in* ultimately connected husband and wife to each other and to God.

The year-long separation between the *erusin* and *nissu'in* ceremonies was eliminated in the eleventh century for practical reasons. First, two separate ceremonies necessitated two separate banquets, which imposed a heavy financial burden. Second, the Middle Ages were perilous times for Jews, and an intervening year could bring displacement or death to one of the parties, a fate potentially ruinous for both families involved. Finally, because many grooms lived with the bride's family before the *nissu'in*, the ceremonies were combined to remove the obvious and understandable temptations of couples who had been promised to each other but were forbidden to touch.

Jews have continued to frame their weddings around the historical functions of *erusin* and *nissu'in*, but the challenge of integrating them in a single coherent wedding narrative persists. The complex historical relationship of *erusin* and *nissu'in* thus continues to shape the overall contours of modern Jewish wedding celebrations and helps explain the occasionally awkward juxtapositions of legal and more ethereal elements that mark all Jewish weddings.

Post-Talmudic Wedding Customs

Traditional Ashkenazic weddings incorporate two well-known *erusin* ceremonies: the *Tisch* (groom's table) and *bedeken* (bridal veiling). Before the wedding ceremony proper, male guests are invited to a *Tisch* to witness the signing of various legal documents, including the so-called *tena'im* (formal engagement contract)(Fig. 15) and the *ketubbah*. Once these documents are signed, to the accompaniment of song and drink, the groom is escorted into another room where female guests are attending to the bride. The *bedeken*, in which the groom veils the bride, concludes the preliminary phase; the couple leads the procession of guests to the *huppah* for the actual wedding ceremony. Under the *huppah*, the rabbi recites the benedictions for wine (*kiddush*) and betrothal (*birkat erusin*) and the bride and groom drink from the first of two cups of wine, another reminder that the wedding ceremony formerly had two distinct parts. The climax of the wedding is the groom's bestowal on his bride of the wedding ring.

The transition between the two ceremonies, *erusin* and *nissu'in*, is symbolized by the

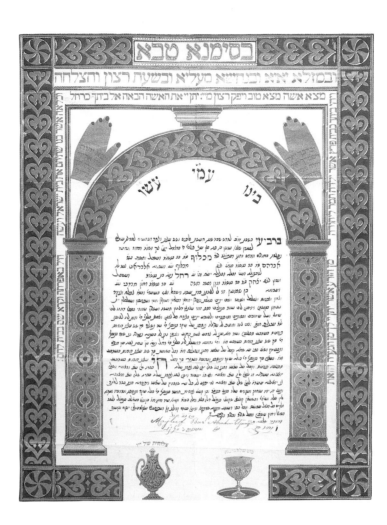

Fig. 16 Brazil *Ketubbah*, 1911
(cat. no. 10)

public reading of the *ketubbah* under the *ḥuppah*. Formally, *nissu'in* is initiated with the chanting of the seven marriage benedictions, the *sheva berakhot*, which precede the drinking of the second cup of wine. The end of the ceremony under the *ḥuppah* is marked by the dramatic shattering of a glass, a custom that is variously interpreted, including that it is intended to invoke the destruction of the Jerusalem Temple, a somber reminder of the Jewish diaspora even as a joyous event is celebrated.[5] Following this public ceremony, the couple traditionally was led to a secluded area, *yiḥud*, where the marriage could be consummated. *Yiḥud*, Hebrew for both "unification" and "privacy," offers the new couple a chance to spend some time together. Once the couple reappears after several minutes, the festivities—including eating, drinking, music, dancing, and general rejoicing—begin in earnest.

Diverse Expressions of the Wedding Ceremony

Ḥiddur mitzvah, literally the beautification of the commandments, refers to customs that are not integral to the legal or religious enactment of the wedding but which give it flavor. These creative opportunities for personal, familial, and communal expression reach back to talmudic times but always reflect contemporary tastes. Included in this category are such customs as the illumination of *ketubbot*, the decoration of *ḥuppot*, the entertainment of *ḥatan* (groom) and *kalah* (bride), and the donning of celebratory costumes.[6]

The illumination of the *ketubbah* emerged as an important custom in the Middle Ages. Unlike Torah scrolls or other ritual documents, relatively few requirements existed for the lettering or form of a *ketubbah*. These documents have been rendered in a broad variety of decorative designs over the course of generations but generally in the dominant artistic and cultural style of the country of origin. For example, in many Persian *ketubbot*, the text seems to float on magical Oriental carpets. In North Africa, the text is surrounded with intricate geometric shapes like those that adorned Moslem mosques.

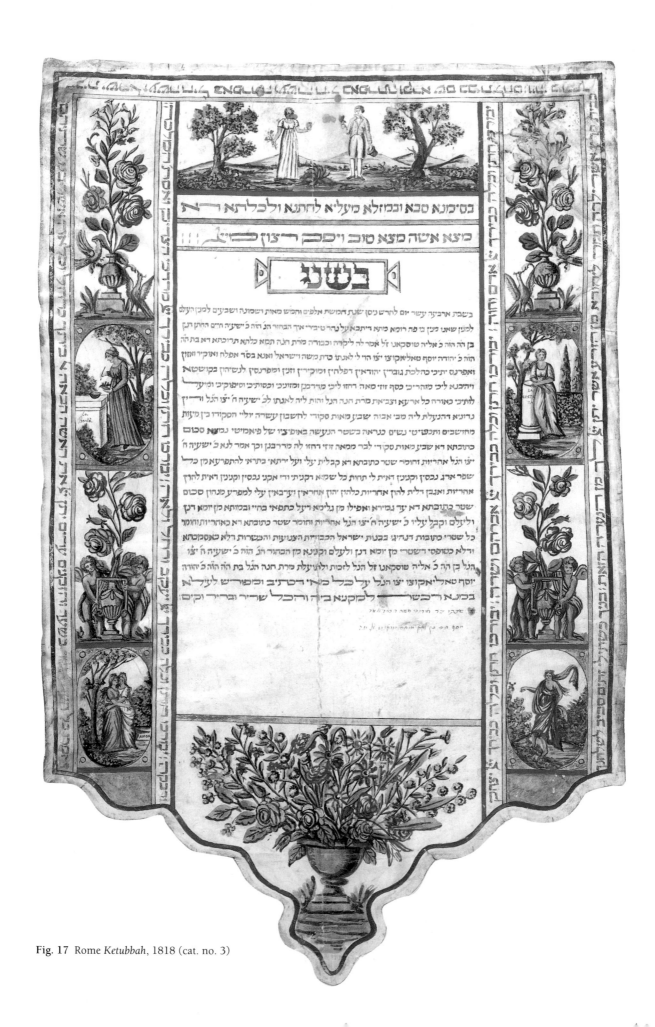

Fig. 17 Rome *Ketubbah*, 1818 (cat. no. 3)

Ketubbot created in Italy are particularly elaborate, with birds, flowers, Zodiac signs, biblical scenes, and families' coats of arms woven into and around the text (Fig. 17).[7]

Today, there is a rebirth of the illustrated *ketubbah*. Couples are using both old and new designs, and in non-Orthodox congregations, the text has been changed to reflect better the couple's personal commitments. For instance, the "equalized *ketubbah*," which emerged in the early 1970s, emphasizes the seriousness and mutuality of an agreement to marry. Often, such *ketubbot* are written in both English and Hebrew. Because Jewish law only recognizes the validity of the traditional *ketubbah* text, many couples are faced with the challenge of creating a *ketubbah* that is both egalitarian and follows the halakah. As long as the basic requirements spelled out in the Talmud are met, additions to the text are not strictly forbidden.

The idea of *huppah* has undergone profound transformations over the last two thousand years. Originally, the *huppah* referred to a special tent or room, by tradition built by the groom's father, to which the bride was brought in a festive procession for the marital union (*nissu'in*) at the end of the long period of betrothal (*erusin*). During talmudic times, the term *huppah* referred to the physical transfer of the bride from her father's to her husband's care. Later, as the act of *nissu'in* took on a more symbolic meaning, the *huppah*, too, became a symbolic sacred space, which the groom created by covering his bride with a garment. In North Africa, the groom spread his *tallit*, or prayer shawl, over the bride's head as a symbol of his sheltering her. In the European Middle Ages, following the French tradition, the bride and groom were both covered with such a *tallit*. During the late Middle Ages, the custom of using a portable canopy held aloft by four poles emerged.[8] Elsewhere in Europe, a richly embroidered Torah ark curtain, or *parochet*, was used for the same purpose. Whatever the precise shape or form of the canopy, however, *huppah* is now identified mostly with this physical canopy rather than with its function as symbolic seal of *nissu'in*.

Though the canopy serves a quasi-legal function, there are no specific halakhic requirements about its dimensions, shape, or decoration. Its appearance is thus entirely a matter of taste and offers another opportunity for personal expression and *hiddur mitzvah*. *Huppot* come in nearly every shape and form such as patchwork quilts, silk screens, embroidery, appliquéd scenes of Jerusalem, flowers, or symbols of the couple (Fig. 18). Some couples have pre-wedding parties during which their guests inscribe blessings and help decorate the *huppah* and the poles that support it. Some Jewish parents plant trees at the birth of their child for the future bride or groom to use for their *huppah*, recalling an ancient custom of making *huppah* posts from cedar or pine trees.

Over time the *huppah* became identified not only with shelter but was an auspicious symbol of the prosperity and fertility of the new couple. Related traditions include the custom in Libya, in which the groom would drop an earthenware pitcher of water from the roof and the bride would enter the house by walking through the water and carefully through the broken pottery. To promote good luck, some Sephardim in Israel used to break a specially baked cake above the heads of the bride and groom, while in Baghdad a loaf of bread was similarly cut above the head of the groom. All these customs were designed to bring bride and groom good fortune and fecundity.

Both the Bible and the Talmud underscore the importance of rejoicing at the wedding and of entertaining bride and groom.[9] Among Holocaust survivors, there is a

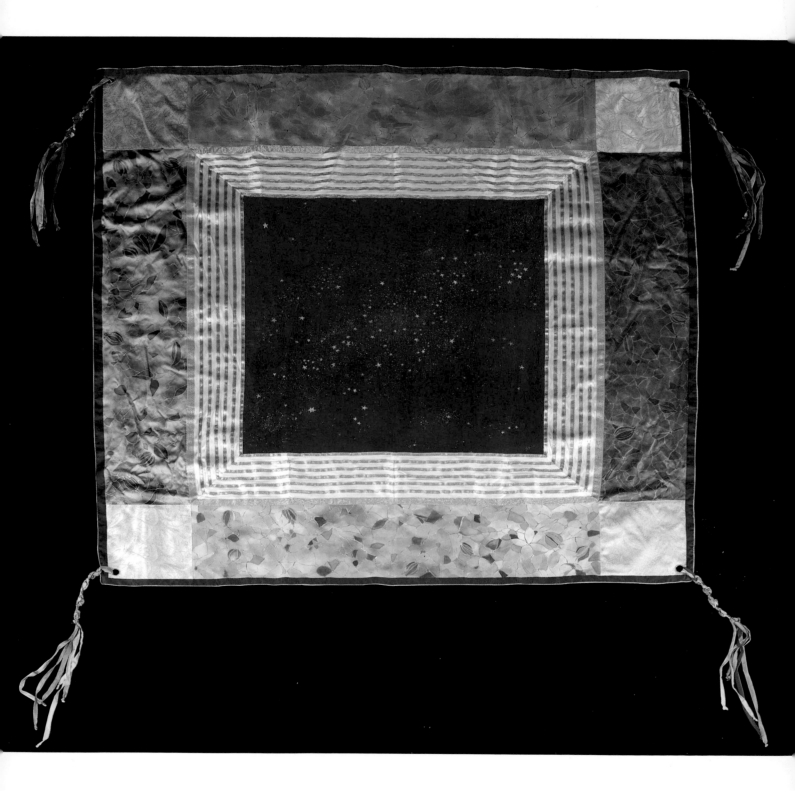

Fig. 18 *Ḥuppah*, Corinne Soikin Strauss, 1995 (cat. no. 164)

saying, "To dance at a Jewish wedding is to dance on Hitler's grave."[10] This celebratory custom has prevailed and is even considered a religious obligation. Every element of *simcha* (celebration) from the wedding meal to the music to the dancing is filled with joyful purpose. In the Middle East, special poems were sung during the wedding meal. A different sort of *ḥiddur mitzvah* took place in Yemen, where rose water was sprinkled on visitors as a welcoming gesture. In Italy, poems and songs were composed and sometimes printed by friends. In Eastern Europe, a jester entertained the bride and groom with juggling and dancing acts. At Hasidic weddings, the rabbi and the bride engaged in a special dance, *mitzvah tanz*, before the guests. The rabbi dances with the bride, each holding a corner of a handkerchief. His eyes closed, his thoughts elevated to the relationship between God and Israel, which is compared to the relationship between bride and groom, the rabbi recalls the words of the prophet: "As the bridegroom rejoices over the bride, so shall thy God rejoice over thee." (Isaiah 62:5)

Today's elaborate wedding ceremonies reflect a complex interweaving of Jewish past and present. New customs overlay the intricate tapestry of Jewish history, tradition, and law with more contemporary threads. Over the ages, the line between law and custom has been so blurred that it has become nearly impossible to disentangle matrimonial requirements from customs. Perhaps in no other event has custom and folkway intermingled with legal procedure to such an extent as in the Jewish wedding. Thus, while all Jewish weddings continue to share particular halakhic features, each bridal couple also approaches Jewish tradition in their own unique way. Over time, many wedding customs have been discarded and forgotten; others have persisted with even greater symbolic and emotional power than the original prescriptive elements. New rituals continue to be added to the repertory of wedding customs to this very day.

1. Genesis 2:18. The Bible speaks in terms of the husband *acquiring* or *taking* a wife but does not explicate those terms. See Genesis 2:24 and Deuteronomy 24:1. Wives were not, strictly speaking, their husband's property; the Bible specifies that husbands owed certain obligations—food, clothing, and conjugal rights—to their wives (Exodus 21:10) For a more complete discussion of the role of women in Jewish law see Judith R. Baskin, ed., *Jewish Women in Historical Perspective*, Detroit, MI, Wayne State University Press, 1991, and Rachel Biale, *Women and Jewish Law: The Essential Texts, Their History, and Their Relevance for Today*, New York, Schocken Books, 1995.

2. BT Kiddushin 1:1. The Mishnah employs the same vocabulary of acquisition in describing the two ways in which the woman may regain her independence, namely, through divorce or her husband's death.

3. Since the seventh century a ring has been the traditional and preferred object of exchange. See Mendell Lewittes, *Jewish Marriage: Rabbinic Law, Legend, and Custom*, Leonia, NJ, Jason Aronson Inc., 1994, pp. 71-73.

4. In talmudic times, it was customary for the father of the groom to construct the ceremonial *ḥuppah*.

5. For other interpretations of the meaning of the breaking of the glass see Joselit, this volume, and Sabar, also in this volume.

6. The making of kiddush cups provides another opportunity for *ḥiddur mitzvah* and personal symbolism. Judaica artists have recently revived the old European custom of creating a special wedding cup, a matched pair of goblets, or a double cup to represent the two distinct parts of the wedding ceremony.

7. For a comprehensive treatment of *ketubbot*, see Shalom Sabar, *Ketubbah*, Philadelphia, Jewish Publication Society of America, 1990.

8. For a more complete discussion about the emergence of portable *ḥuppot* see Sabar, this volume. See also Abraham P. Bloch, *The Biblical and Historical Background of Jewish Customs and Ceremonies*, New York, KTAV Publishing House, 1980, for a more general discussion of the origin of various religious customs including wedding rituals.

9. "He who makes the bride and groom rejoice is regarded as if he had built one of the ruins of Jerusalem." BT Berachot 6b.

10. Anita Diamant, *The New Jewish Wedding*, New York, Simon and Schuster, 1985, p. 29.

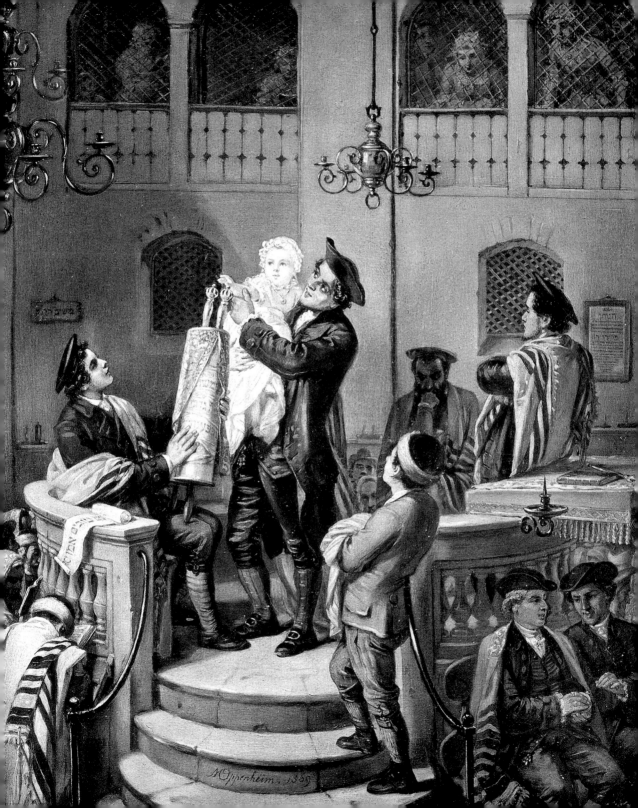

"May He Grow Up to the Ḥuppah"

REPRESENTATIONS OF WEDDINGS ON ASHKENAZI TORAH BINDERS

Shalom Sabar

The *Wimpel* and the Jewish Life Cycle

HE ASHKENAZI TORAH BINDER, commonly known as *Wimpel* or *mappah*, is an unusual object in the field of Jewish ceremonial art. It joins together the world of the synagogue with the traditions of the personal life cycle, enhancing the ideals and concepts of both. Moreover, while most Judaica objects are usually created for one particular life-cycle ceremony, the *Wimpel* is significantly different. It is created from the swaddling cloth used in the circumcision ceremony, but its usage later on, as well as the lengthy inscription and rich decorations it bears, reflect many interesting customs and concepts of Jewish life-cycle rituals in general. No other object in the Jewish tradition represents so succinctly and picturesquely the life of the traditional Jew in German-speaking lands of Central Europe.

The *Wimpel* sums up, textually and visually, the traditional life cycle. Since the late Middle Ages, German-speaking Ashkenazi communities created long linen Torah binders from the swaddling cloths upon which a male baby was circumcised. The cloth used during the sacred circumcision ceremony thereby acquired special significance and was no longer used to swaddle the baby. Instead, following the ceremony it was given to the mother or another female family member, who cleaned it, cut it into four pieces, and stitched them together lengthwise. The long strip was subsequently embroidered (and, from about 1750, often painted) with a lengthy dedicatory inscription, accompanied by appropriate colorful decorations. From Germany the custom spread to other communities, including Bohemia, Denmark, Switzerland, Alsace, the United States, and recently to Israel.[1]

When the boy went to the synagogue for the first time (the age of the child varied from one community to another), usually on Sabbath morning, the attractive *Wimpel* was presented to the synagogue and used as a binder in the *gelilah* ceremony (tying up the Torah scroll). The child would be carried to the women's gallery by his mother, and toward the end of the Torah reading, he would be handed to the father. The noted Frankfurt artist, Moritz Oppenheim (1800–1882), beautifully depicted in 1869 the impressive ceremony that takes place subsequently as the assembled congregation accepts the child's gift and puts it to use.[2] His grisaille painting (Fig. 19) shows the moment when the father holds the boy on the *bimah* (raised platform in the synagogue), letting the child touch the *rimmonim* (decorative finials) over the Torah scroll, which is rolled and tied up with an inscribed *Wimpel* (in Oppenheim's painting, the *Wimpel* actually bears the artist's full Hebrew name).

< **Fig. 19** *Das Schultragen*, Moritz Oppenheim, 1882 (cat. no. 14)

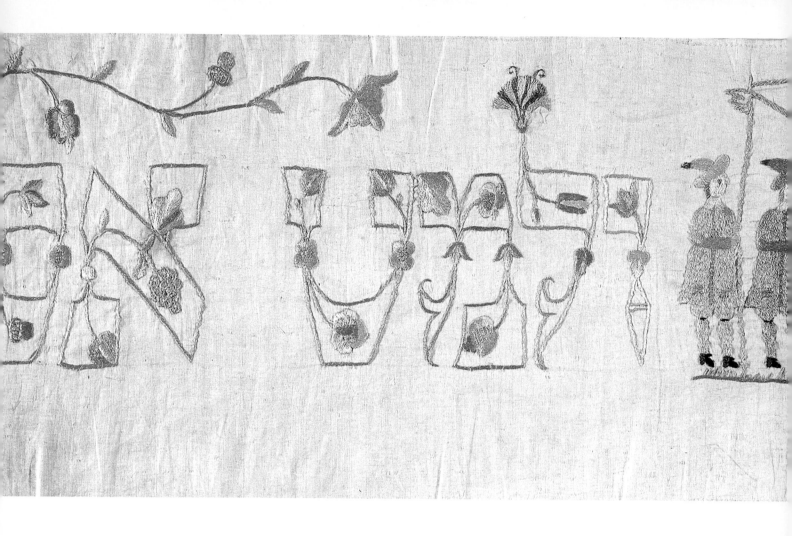

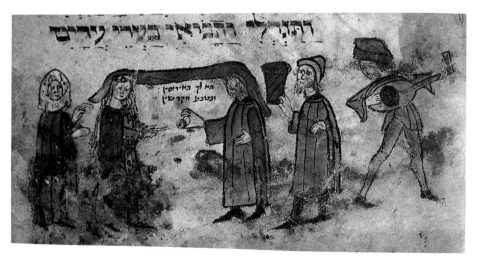

Fig. 21 *The Marriage of Moses and Zipporah*, "The Second Nuremberg Haggadah," Germany, 15ᵗʰ century. Photograph courtesy Schocken Library, Jerusalem

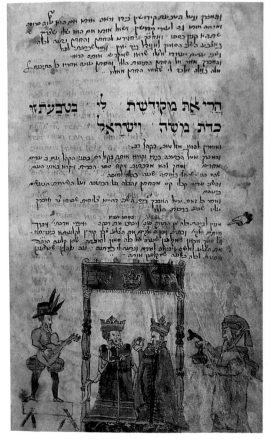

Fig. 22 Prayer Book, Eliezer Ben Mordecai, Germany, 1589. Mss. 8° Hs.7058, fol. 34 v, Courtesy Germanisches Nationalmuseum, Nuremberg

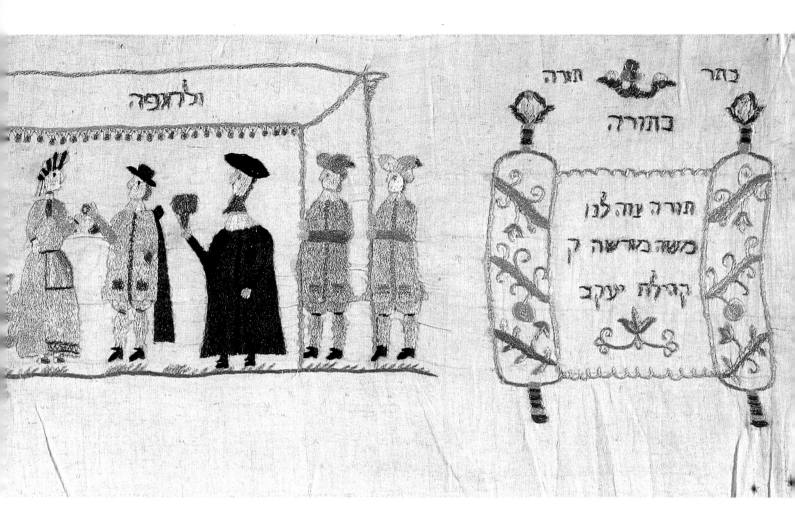

ולחופה

בחר

תורה

בתורה

תורה צוה לנו

משה מורשה ק

קהלת יעקב

Fig. 20 *Wimpel* (detail), 1719
(cat. no. 16)

The inscriptions on *Wimpeln* and the customs associated with them revealed the ideal course of a traditional Jewish life. A standard formula with minor variations developed over the course of time. Following the name of the child, the name of his father, and the full Hebrew date of his birth, there is usually a blessing derived from the circumcision liturgy: "May he grow [or: May the Lord cause him to grow] to [the study of] Torah, to get married [*ḥuppah*], and to perform good deeds. Amen, Selah."[3] The course of life that is delineated in the inscriptions and imagery corresponds to the four principal "rites of passage," or essential events, in human life: birth, coming of age (or initiation), wedding, and death. The rites that mark the passage involve many ceremonies and rituals that transform the individual from one stage in his or her life into a totally different being.[4] In Judaism these four stages obviously parallel circumcision (*berit milah*), bar mitzvah, wedding (*kiddushin*), and burial and mourning ceremonies. The inscriptions on *Wimpeln* clearly refer to the first three events and perhaps also allude to the fourth—good deeds and charity are often associated in Jewish tradition with burial.[5]

The personal history of a *Wimpel* does not end with its dedication to the synagogue. Years after its initial use, it occupies a central symbolic place again, this time in the bar mitzvah ceremony. When the boy reaches the age of thirteen, he publicly reads his Torah portion from the scroll bound with the very same textile used during his circumcision. After the reading from the Torah, he performs the *gelilah* with his personal binder. In this way the first covenant, the *berit milah*, is conceptually and symbolically carried on to the second covenant of the boy with Judaism and his people–as expressed in the new role he assumes with the bar mitzvah ceremony.[6]

In some German communities the *Wimpel* was later used in the wedding ceremony.

Fig. 23 *Wimpel* (detail), 1726 (cat. no. 17)

When the bridegroom was called to the Torah on the Sabbath preceding his wedding (*shabbat ḥatan*), the binder made after his circumcision years earlier would be used once again.[7] On rare occasions a *Wimpel* could have been produced exclusively for a wedding (or wedding anniversary).[8] The *Wimpel* is a unique object that best symbolizes the circle of life, the close affinity between the members of the community, and the covenant with the Torah.

The Ḥuppah Scene on Wimpeln

Although the wedding is not the central life-cycle event associated with the *Wimpel*, the depiction of nuptial scenes are the most varied, vivid, and interesting images of Jewish customs and ceremonies. Every *Wimpel* with a representation of a wedding should be viewed as an authentic document of the joyous ceremony. But even if it were not for the wedding, the figures in this scene, in particular those of the bridal couple, are always shown dressed at their best–thus contributing immensely to the history of Jewish costume. The rich visual material on marriage and nuptial customs specific to the communities that produced *Wimpeln* has been almost totally neglected in literature.[9]

All *Wimpeln* present the bride and bridegroom standing underneath the familiar portable *ḥuppah* with its four poles, but the general shape of the *ḥuppah* varies somewhat among *Wimpeln*. The *ḥuppah* on four poles, which is the most common form today, was a relatively new phenomenon in Ashkenaz when the earliest extant *Wimpeln* were produced.[10] In some depictions, only two poles are shown, but this reflects the technical difficulties and talents of the folk artists who decorated these cloths. Medieval miniatures in German Hebrew manuscripts reveal that in the fourteenth and fifteenth centuries the *ḥuppah* was often simply a *tallit*, prayer shawl or another piece of cloth, known in Hebrew as *sudar* (scarf), spread directly over the heads of the couple (Fig. 21).[11] Scholars have offered various reasons for the change to a portable canopy, including the possible influence of the Christian ritual of leading important church functionaries and reliquaries under a portable canopy or baldachin, which was also known by the German term, *Traghimmel*.[12] It is clear from the testimony of the ReMAh (Rabbi Moses Isserles, 1525/30–1572), who is apparently the first authority to report on the change, that the portable *ḥuppah* was a novelty in his time.[13]

While no sixteenth-century *Wimpeln* that show the new Ashkenazi *ḥuppah* have survived, an image of one is found in a prayer book manuscript from Germany dated 1589 (Fig. 22).[14] This scene resembles in many details the wedding images on later

Fig. 24 *Wimpel* (detail), 1834
(cat. no. 25)

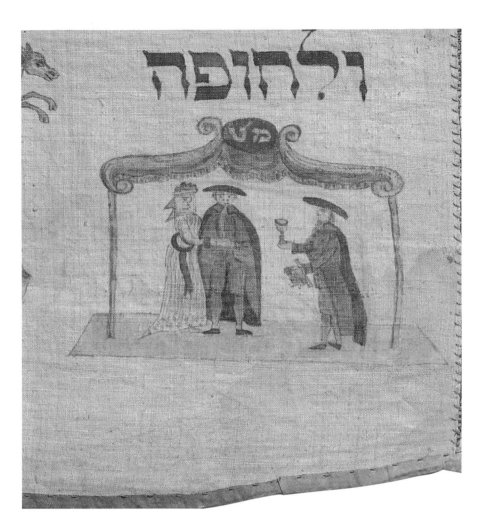

Fig. 25 *Wimpel* (detail), 1854 (cat. no. 27)

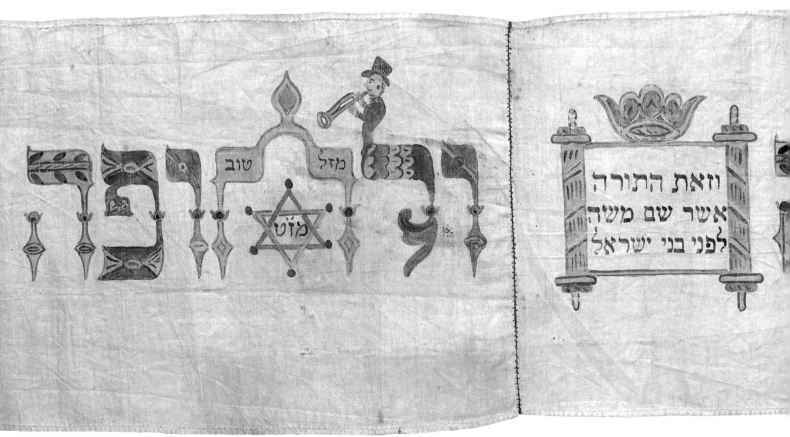

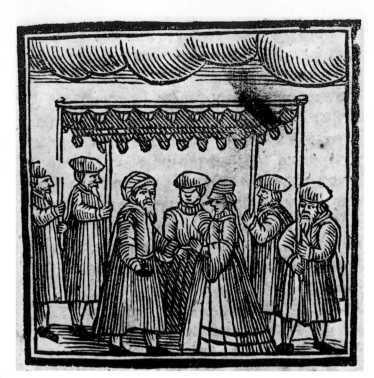

Fig. 26 *Sefer Minhagim* (Book of Customs), Amsterdam, Courtesy Hebrew Union College, Klau Library, Cincinnati

Wimpeln. Standing under the *ḥuppah*, the bridegroom holds high the wedding ring that he is about to place on the extended finger of the bride. The *ḥuppah* is flanked by a musician (left) and an officiant holding a flask of wine (right). A similar scene is found on the *Wimpel* dedicated by Benjamin Wolf, son of Rabbi Solomon, who was born in 1719 (Fig. 20). Other Torah-binding cloths emphasize the presentation of the ring[15] (Fig. 23), that of the officiant rabbi holding the cup of wine (Fig. 24), or the wedding musicians[16] (Fig. 25).

The miniature in the prayer book differs from standard representations of the weddings on *Wimpeln* in two minor, but revealing, details. In the miniature, the bridal couple wear crowns. This custom, which may have its roots in early talmudic practice, was widespread among Ashkenaz of the Middle Ages.[17] Crowns mainly adorned brides, but in this miniature the bridegroom also wears one, suggesting that some males donned crowns as well. On *Wimpeln* (and other representations of the Ashkenazi wedding from the seventeenth and eighteenth centuries) only brides–and not necessarily all of them–are shown wearing crowns, while the grooms' heads are covered with typical wide-brimmed hats (Figs. 23, 24). Evidently the bride wearing a crown, which is seen at some Jewish weddings to this day, remained popular throughout this period.[18]

The second difference between the prayer book miniature and representations on *Wimpeln* is the shape of the vessel that contains the wine for the blessing. In the *Wimpeln* it is commonly a large footed cup, similar in form to contemporary Judaic silver *kiddush* cups used on the eve of Sabbath. The miniature instead shows a flask or bottle with a narrow neck. The symbolism of this curious talmudic custom, which was well known in medieval Ashkenaz, is reported by the leading German authority, Rabbi Jacob ben Moses of Moellin (known as Maharil; ca. 1360–1427). In a book compiled by one of Maharil's faithful students, a bottle with a narrow neck is used as a symbol of the bride's virginity.[19] In later periods this custom became less common,[20] and other forms of wine cups—notably the double wedding cup made of two matching beakers, which form a barrel shape—became common in German lands.[21]

The wedding ring—a relative latecomer in Jewish tradition—is another curious aspect common to both this miniature and *Wimpeln*.[22] The prevalent German custom since the early Middle Ages has been to place the ring on the bride's "second finger, which is next to the thumb" (that is, the index or forefinger).[23] This is shown distinctly in the miniature and in many of the binders. In the miniature, the shape of the ring is clearly a flat, round circlet, which is generally consistent with the representation of this object in the binders (see our example of 1719, Fig. 20).[24] These flat rings, quite different from the many elaborate domed rings found in Jewish museums, are said to be "southern German or northern Italian."[25] The authenticity of these rings and their exact usage are still disputed by scholars.[26]

Despite its importance, the isolated miniature in the prayer book could not, naturally, have served as the pictorial source for the many individual decorators of binders. A more likely source is the well-known wedding image in the Ashkenazi

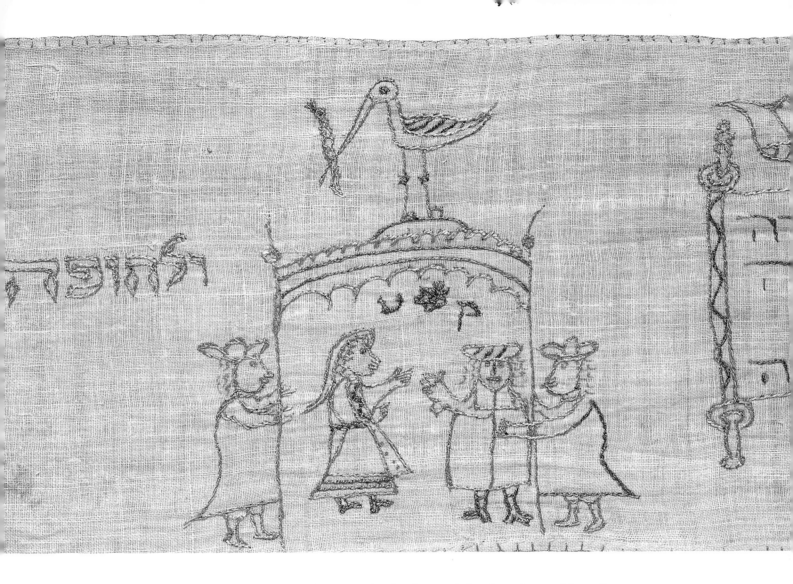

Fig. 27 *Wimpel* (detail), 1778 (cat. no. 22)

Minhagim (Book of Customs). The first such book with a wedding illustration was compiled by Simon Levi Guenzburg and published in Venice in 1593.[27] Later editions, printed chiefly in Amsterdam and Frankfurt, also include versions of this image (Fig. 26), which closely resemble the *ḥuppah* scene in many *Wimpeln*.[28] The popular image, available in many inexpensive editions, apparently served the makers of the binders as a basic and immediate source of inspiration, which could be readily modified or interpreted in individual styles.

Folk Customs and Wedding Scenes

Despite the folkloristic and repetitive nature of the decorations on *Wimpeln*, they frequently show the originality of their creators and reflect the wide variation of marital customs. The creative use of letters to evoke a variety of relevant themes is true for every section in the lengthy inscription on *Wimpeln*, but this device is especially prominent in wedding scenes. For example, in the word *u-le-ḥuppah*, the Hebrew letter *het*, which resembles two pillars topped by a roof, lends itself to the shape of an open canopy, suggesting the *ḥuppah* itself. In the *Wimpel* of Solomon (Zalman) Herrmann, dated 1854, the colorful letter *het* is expanded and has a decorative domed roof (Fig. 25). The upper section of the letter is inscribed with the words *mazal tov*, and the symbolic Shield of David, bearing an abbreviation of the same inscription, appears within the "canopy."[29] In a few other related *Wimpeln* the expanded *het* cleverly encloses the bridal couple.[30] Imaginative embellishment of the preceding letter, *lamed*, transforms its ascender, which is often employed for decorative features, into a musician playing a trumpet. Thus, the maker created a playful wedding scene, comprised of the wedding musician and the *ḥuppah* next to him, just by taking advantage of the shape of the Hebrew letters.

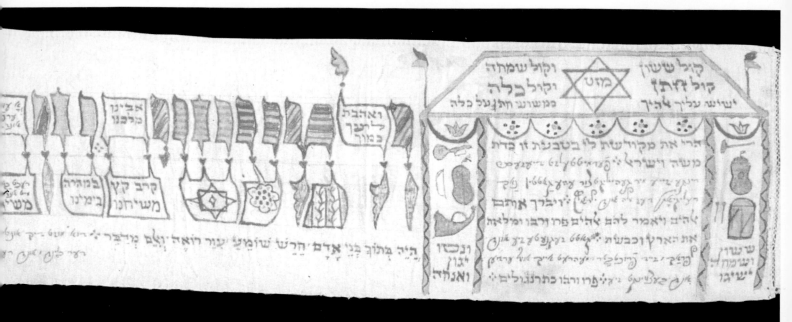

38

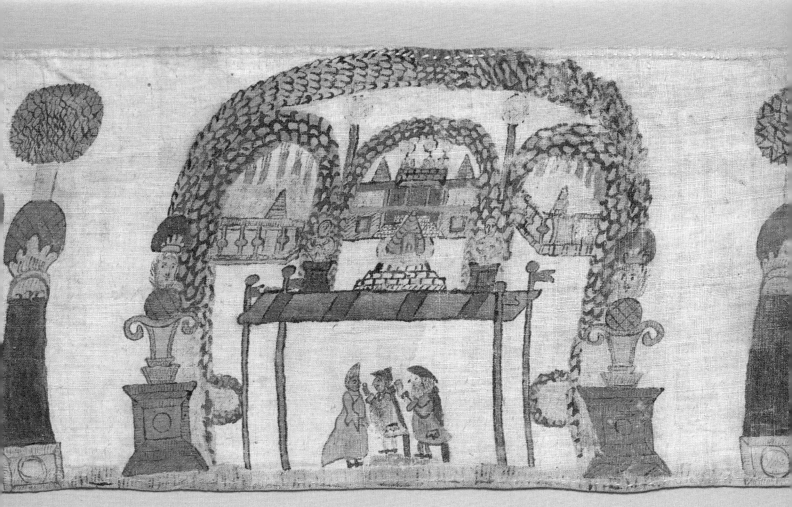

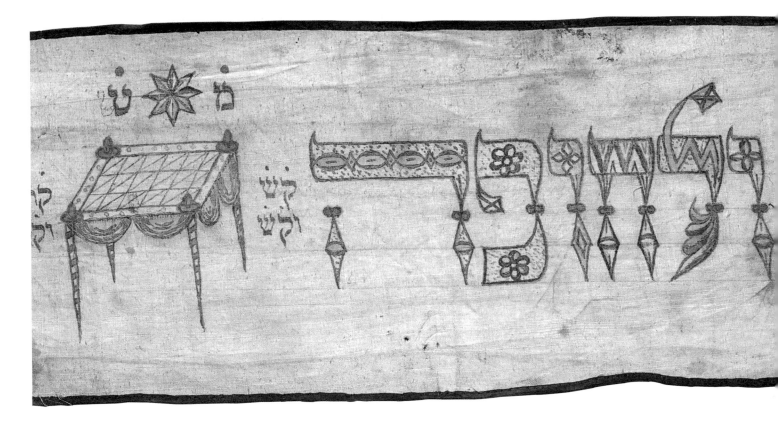

Fig. 30 *Wimpel* (detail), 1837
(cat. no. 26)

Curious wedding customs, some known from other sources as well, are attractively and picturesquely enhanced on binders. Some customs that do not emanate from Jewish tradition or sources are represented, but these reflect popular beliefs of the general population of the time. The binder of Menahem, son of Abraham Katz, who was born in 1778[31] (Fig. 27), in the fine collection of *Wimpeln* at the Skirball, includes an image of a stork carrying in its beak an elongated bundle above the embroidered *ḥuppah*. This familiar concept from European folklore, the stork bringing babies,[32] is known mainly from Christian society, but its depiction on a sanctified Torah binder is not surprising. The primary goal of marriage in Judaism is reproduction, and this concept was shown or implied in many ways—not only among German Jews but in other communities as well.[33] Other fertility symbols specifically rooted in Jewish tradition are employed in binders as well: for example, a pair of fish are shown in a *Wimpel* produced in the United States in 1927.[34] The association of the fish with fertility, known in several cultures, derives in an early form from the book of Genesis. Jacob's blessing to the sons of Joseph, Ephraim, and Manasseh (Genesis 48:16) includes the wish that they will "be fruitful and multiply," which is in Hebrew *ve-yidggu la-rov*, literally, "[multiply] like fish." For this reason pairs of fish appear in Jewish amulets for fertility, *ketubbot*, and other objects related to weddings.[35]

The blessing of fertility is not only illustrated with symbols, but in some *Wimpeln* also fully spelled out in the *ḥuppah* section. In a Bavarian binder dated 1855, which includes many inscriptions in both Hebrew and Judeo-German (Fig. 28),[36] a portable *ḥuppah* is filled with lengthy bilingual inscriptions flanked by musical instruments that symbolize the joy of the wedding. Following the *kiddushin* formula appears what is considered to be the first commandment in the Bible: "And God blessed them [Adam and

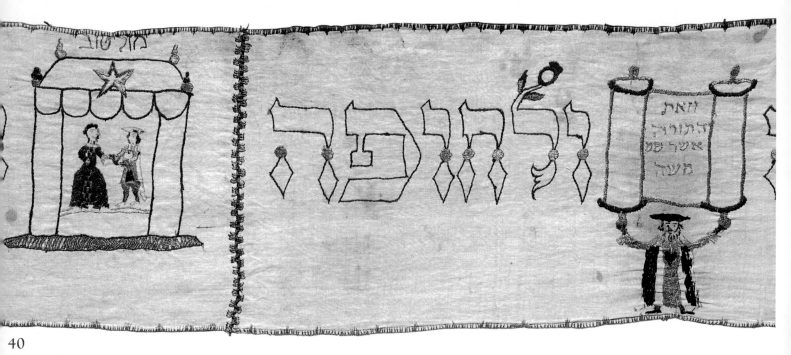

ולהכפר

מזל טוב

 וזאת התורה אשר שם משה

40

Fig. 31 *Wimpel* (detail), 1793 (cat. no. 23)

and Eve] and God said to them: Be fruitful and multiply, and replenish the earth and subdue it" (Genesis 1:28). The inscription is continued with the words: "be fruitful and multiply like roosters." This somewhat unusual blessing is derived from the Talmud: "It is the custom that when a bride and bridegroom were escorted, a cock and a hen were carried before them, as if to say 'Be fruitful and multiply like fowls,'" (BT, *Gittin*, 57a). For the same reason a rooster and a hen are sometimes illustrated in Yemenite *ketubbot*,[37] while in Germany it was customary to serve a chicken and an egg to the bridal couple immediately after the wedding blessings were recited.[38]

The wish for expanding the family assumes unexpected form at times. In the *Wimpel* of Yekutiel, son of Kaufmann, who was born in 1777, a large domed structure appears above the *ḥuppah,* enclosing an arcade of three arches with architectural elements (Fig. 29). At the center of this elaborate scene is a colorful house that emerges from the *ḥuppah,* most likely an allusion to the concept of "building [or establishing] a house in Israel," an idea first expressed in the story of the marriage of Ruth and Boaz at the city gate: "And all the people at the gate and the elders said: We are witnesses. May the Lord make the woman who is coming into your house like Rachel and Leah, both of whom built the house of Israel!" (Ruth 4:11). This verse is included on many *ketubbot*, especially of Sephardi and Italian communities, and is often rendered in an architectural setting, which obviously suggests the same meaning.[39]

Perhaps the most curious object represented in the *ḥuppah* scene in *Wimpeln* is a star design. The star assumes different shapes from a small, multi-pointed colorful design[40] (Figs. 23 and 30), to a five-pointed star[41] (Fig. 31), but most often, it is the enlarged familiar shape of the six-pointed Magen David[42] (Figs. 25 and 32). Above or inside the star the abbreviated Hebrew blessing *mazal tov* commonly appears surrounding the

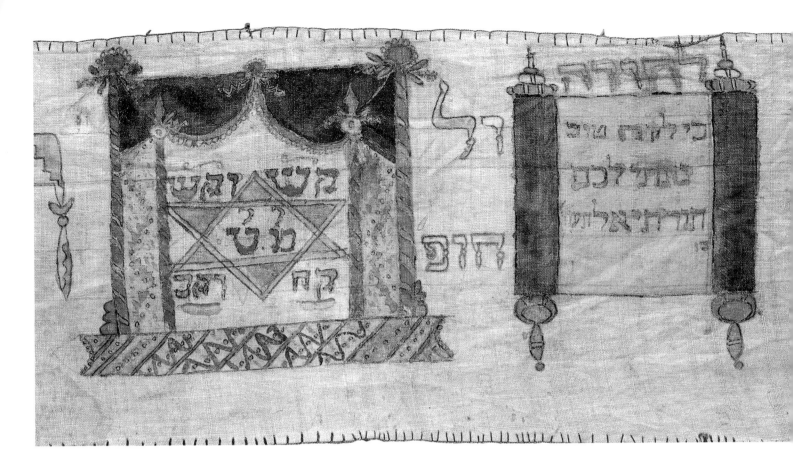

Fig. 32 *Wimpel* (detail), 1830 (cat. no. 24)

design in a ten-letter inscription, which is divided into four groups of two and three letters. These letters stand for the beloved wedding verse: "The voice of mirth and the voice of gladness, the voice of the bridegroom and the voice of the bride" (Jeremiah 7:34).

It may seem that this design, especially in the shape of the Magen David with the blessings around it, is nothing but the familiar Jewish symbol, which is here connected to the wedding, but closer scrutiny reveals that something else is intended. First, the Magen David is only one of several star designs used, and at that time this symbol did not bear the meaning it acquired with the emergence of the Zionist movement.[43] The extremely popular association of the six-pointed star with amulets, magic, and practical Kabbalah is closer to the meaning of the design in the binders.[44] Scholars have shown that this design represents a three-dimensional object—the stone upon which the bridegroom used to break the glass at the wedding.[45] Such wedding stones, known variously as *ḥuppahstein*, *Ehestein*, and *Traustein*, also called *sigilum Salomonis* (Seal of Solomon) or *scutum Davidis* (Shield of David), were customarily placed on the outside northern wall of German synagogues,[46] "From the north shall disaster break loose" (Jeremiah 1:14). Eighteenth-century images and descriptions of the ceremony found in books by German Hebraists confirm the earlier Jewish sources, in particular *Minhagei Maharil*:[47] following the betrothal benedictions, the bridegroom turned to the northern wall and shattered the glass against the *ḥuppahstein* (Fig. 33)

Wimpeln show that the wedding stone was carved as a five-or six-pointed star, like images of wedding stones found on binders. The shape of the star is often surrounded by the inscribed blessing *mazal tov*, which literally means "[May you have] a good star or constellation." The protection expression in this wish was thought to be needed especially at the crucial time of weddings, which popular belief held is exposed, like other

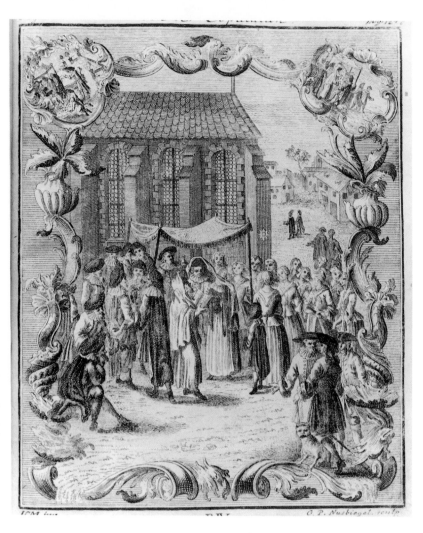

Fig. 33 *Wedding Ceremony*
from J. Ch. G.
Bodenschatz, *Kirchliche
Verfasung der heutigen
Juden,* 1748. Courtesy
Hebrew Union College,
Frances-Henry Library,
Los Angeles

transitional rituals, to evil and hostile forces.[48] Breaking a glass at the end of the wedding ceremony apparently served the same purpose, symbolically protecting the bridal couple at this "crisis" in their life cycle. The glass to be shattered was filled with wine in the hope of attracting the demons to their beloved drink so that they would be injured by the shards of broken glass.[49]

Ashkenazi weddings have customarily been performed outside the synagogue, under the open sky, which meant the star shape had an additional meaning. In imitating the shape of stars in the heavens, the *ḥuppahstein* implied God's promise of fertility to Abraham: "I will bestow My blessing upon you and make your descendants as numerous as the stars of heaven" (Genesis 22:17). This idea is enhanced on some extant *ḥuppahsteine* with other fertility symbols, such as the full-to-bursting horns of plenty that decorated the stone found in the early eighteenth century from the Rhineland synagogue at Bingen.[50] The importance of this symbol is emphasized on many *Wimpeln* because the inscribed pointed star is the only element that appears inside the illustrated *ḥuppah* (e.g., Figs. 25 and 32).

The wedding scene in some binders alludes to customs that are not necessarily common to all or most Jewish communities, but are specific to a location or region. For instance, the wedding scene in an Alsatian binder (*mappah*) of 1881, preserved in a private collection in Strasbourg,[51] shows the bridal couple sitting on chairs instead of standing under the *ḥuppah*, as in almost every other binder with this scene. The seated couple are facing another figure, the rabbi who is standing in front of a high pulpit. Members of the Strasbourg community explained that the bride and groom customarily fast on their wedding day and are very tired by the time the rabbi delivers the lengthy sermon, and so the couple is permitted to sit under the *ḥuppah*.

The *Wimpel* is an object that represents through its pious inscriptions and charming folk art the ideal life cycle of the traditional Jew. The makers of *Wimpeln* invested their foremost efforts and artistic talents, however naïve they may have been, in creating colorful and captivating wedding scenes. Moreover, these scenes provide a wealth of visual material—not always available in other sources—on the wedding customs, ideals of marriage, and folkloristic influences on the daily life and festivities of those Ashkenazi communities that followed the practice of decorating the Torah binder. Further research, to identify binders with specific communities, will undoubtedly reveal more curious local customs of celebrating Jewish weddings reflected in these charming objects.

This essay is fondly dedicated to Susanne and Paul Kester. Their devotion to Jewish life and Judaica as well as their assistance in my early research will never be forgotten.

I am grateful to Prof. Joseph Gutmann for a critical reading of this essay.

1. Note that the custom was not known among the communities of Eastern Europe. On the art of the *Wimpel*, see the pioneering study: P.J. Abbink van der Zwan, "Ornamentation on Eighteenth-Century Torah Binders," *The Israel Museum News*, 14, 1978, pp. 64–73. A selection of new studies is included in the recent exhibition catalog: A. Weber et al., eds., *Mappot …blessed be who comes: The Band of Jewish Tradition*, Osnabrück, Germany: Secolo Verlag, 1997 (and there is earlier literature; additional sources are cited in the notes below). For the most detailed recent study of the customs associated with the *Wimpel*, see B. S. Hamburger, *Shorshei Minhag Ashkenaz*, and Bene Berak: Mekhon Moreshet Ashkenaz, 2000, Vol. 2, pp. 322–604 (in Hebrew). A comprehensive study of the *Wimpeln* produced in one community is N. Feuchtwanger, "Torah Binders from Denmark," unpublished Ph.D. dissertation, the Hebrew University of Jerusalem, 1999 (in Hebrew with English abstract).

2. Cf. J. Gutmann, "*Die Mappe Schuletragen*–An Unusual Judeo-German Custom," *Visible Religion*, 2, 1983, pp. 167–173 (reprinted in *Mappot… blessed be who comes*, pp. 65–69). On this work and the other images in the series "Scenes from Traditional Jewish Family Life" by Oppenheim, see R. Dröse et al. *Der Zyklus "Bilder aus dem altjüdischen Familienleben" und sein Maler Moritz Daniel Oppenheim*, Hanau, Germany: CoCo-Verlag, 1996, esp. pp. 58–59.

3. Translation of the Hebrew inscription is based on J. Gutmann, *The Jewish Life Cycle* ("Iconography of Religions," XXIII, 4), Leiden, Netherlands: E. J. Brill, 1987, p. 7.

4. The classic theoretical study on this topic is still A. van Gennep, *The Rites of Passage*, Chicago, University of Chicago Press, 1960; and cf. V.W. Turner, *The Ritual Process: Structure and Anti-Structure*, Chicago, Aldine Pub. Co., 1969.

5. See J. R. Marcus, *Communal Sick-Care in the German Ghetto*, Cincinnati, Hebrew Union College Press, 1947, esp. pp. 116ff.; and cf. the entries "Charity" and "*Hevra Kaddisha*" *Encyclopaedia Judaica*, Jerusalem, Keter Publishing House, 1971 [henceforth *EJ*], Vols. 5 col. 347 and 8:442-446, respectively.

6. Cf. Barbara Kirshenblatt-Gimblett, "The Cut that Binds: The Western Ashkenazic Torah Binder as Nexus between Circumcision and Torah," in *Celebration: Studies in Festivity and Ritual*, ed. V. Turner, Washington D.C., Smithsonian Institution Press, 1982, pp. 136–46.

7. Cf. Grace Cohen Grossman, *Jewish Art*, Southport, CT, Hugh Lauter Levin Associates, 1995, p. 125. Apparently there is no evidence for the custom mentioned by Bernard Susser: "It was customary to stretch the *mappah* between the poles carrying the marriage canopy" (see his article "The Covenant of Circumcision," in *Mappot… blessed be who comes*, p. 45). Cf. Hamburger, *Shorshei Minhag Ashkenaz* (note 1, above), p. 528.

8. One noteworthy example was the Torah binder made in London in 1882 to honor the twenty-fifth wedding anniversary of Rabbi Nathan Marcus Adler (1803–1890), Great Britain's chief rabbi. Note that Rabbi Adler was of German origin (born in Hanover). His unusual *Wimpel* is preserved at the Magnes Museum, Berkeley. See R. Eis, *Torah Binders of the Judah L. Magnes Museum*, Berkeley, Judah L. Magnes Museum, 1979, no. BC 113, p. 65. Curiously a reverse of the traditional roles is made here–as the binder was dedicated to the London synagogue by Rabbi Adler's grandson, Naphtali (Hermann) ha-Cohen (on him and his renowned grandfather–see *EJ*, 2:278-79 and 285-86). Note that the *ketubbah* issued for Rabbi Nathan Adler and his wife Tzipor in Halberstadt, Germany, 1857, is preserved at the Library of the Jewish Theological Seminary of America (Ket. no. 85, unpublished).

9. Unfortunately, no scholarly attempt has been made yet to categorize the hundreds of extant illustrated *Wimpeln* according to their place of origin (based on variants in the inscriptions, decorative features and motifs, etc.). Such a study will enable scholars to localize the customs and other important features reflected in the *Wimpeln*. Exceptional in this respect are the binders of the Jews of Denmark, which were collected and preserved in one location already before World War II (see on them the dissertation of Feuchtwanger [note 1, above]; the wedding scene is discussed on pp. 159–164). And see S. Sabar, "Wedding Scenes on German Torah Binders," *Rimonim* (Jerusalem, Society for Jewish Art), 6-7, 1999, pp. 47–9 (in Hebrew). The present study is a much-expanded version of the Hebrew article.

10. See S. B. Freehof, "The *Chuppah*," in *In the Time of Harvest: Essays in Honor of Abba Hillel Silver*, ed. D. J. Silver, New York and London, Macmillan Company, 1963, pp. 186–93.

11. The miniature is from the so-called "The Second Nuremberg Haggadah," Germany, fifteenth century. (Jerusalem, Schocken Library, Ms. 24087, Fol. 12v; cf. T. and M. Metzger, *Jewish Life in the Middle Ages*, New York, Alpine Fine Arts Collection, 1982, p. 230 fig. 344). The subject of the miniature is actually the marriage of Moses and Zipporah.

12. See J. Gutmann, "Jewish Medieval Marriage Customs in Art: Creativity and Adaptation," in *The Jewish Family: Metaphor and Memory*, ed. D. Kraemer, New York and Oxford, Oxford University Press, 1989, p. 48.

13. See his remarks in *Shulhan Arukh, Tur Even ha-Ezer* 55:1. And cf. Freehof, pp. 187–88; Gutmann, p. 48.

14. Nuremberg, Germanisches Nationalmuseum, Ms. 80 Hs. 7058, fol. 34v. The manuscript was copied by Eliezer, son of the martyred Mordechai. On the manuscript and its interesting illustrations, see the brief notes of N. Roth, "'Al ha-Holle-Kreisch" and "Zutot mi-Ketav Yad Nuremberg," *Yeda-'Am: Journal of the Israel Folklore Society*, 25, 1961, pp. 66–69 (in Hebrew).

15. Wimpel of Abraham, son of Mordecai, born on 19 Heshvan 5487 (November 13, 1726).

16. Wimpel of Solomon (Zalman Herrmann), son of R. Moses, born 13 Tammuz 5614 (July 9, 1854).

17. See N. Feuchtwanger, "The Coronation of the Virgin and of the Bride," *Jewish Art*, 12/13, 1986/87, pp. 213–24.

18. Cf. ibid. pp. 222 ff.

19. See S. J. Spitzer, ed. *The Book of Maharil: Customs by Rabbi Yaakov Mulin*, Jerusalem, Mif'al Torat Hakhme Ashkenaz, Mekhon Yerushalayim, 1989, pp. 466–67 (in Hebrew). Cf. Roth, "Zutot," p. 68. And see R. Gladstein-Kestenberg, "Breaking a Glass at Weddings," *Studies in the History of the People and Land of Israel,* Haifa, University of Haifa Press, 4, 1978, pp. 205–8 (in Hebrew), who suggests that the Maharil apparently associated this custom with the breaking of the glass in the wedding (see below). Breaking a glass with a narrow neck would symbolize, according to this hypothesis, the "breaking" of the bride's virginity.

20. Note, however, that in the wedding picture of Moritz Oppenheim, created as late as 1860, two flasks with narrow opening are depicted. See Dröse, *Der Zyklus* (note 2, above), pp. 66–67.

21. Cf. J. Gutmann, "Wedding Customs and Ceremonies in Art," in *The Jewish Marriage Anthology*, eds. P. and H. Goodman, Philadelphia, Jewish Publication Society of America, 1977, p. 180 and fig. 17.

22. The ring is not mentioned in biblical or talmudic sources, and was introduced to the Jewish marriage ceremony only in medieval Europe. Cf. ibid. p. 52.

23. These are the words of the eminent early Ashkenazi authority Rabbi Eleazar ben Judah of Worms (ca. 1165–ca. 1238); see his halakhic book: *Sefer ha-Rokeah ha-Gadol*, Jerusalem, S. Weinfeld,1960, p. 238, no. 351 (in Hebrew).

24. And cf. also the *Wimpel* of 1927 in Fig. 12. Note that in this late binder the two intertwined rings, which obviously represent the symbol of the union between the bridegroom and bride, actually reflect the prevalent Christian custom. Strictly speaking, according to Jewish tradition, only one ring–that which the groom places on the bride's finger–is required to make the marriage legal.

25. For example, see M. E. Keen *Jewish Ritual Art in the Victoria & Albert Museum*, London, HMSO, 1991, p. 77 (examples are reproduced on pp. 79–86).

26. See, for example, G. Seidman, "Marriage Rings Jewish Style," *Connoisseur*, 206, 1981, pp. 48–51; idem, "Jewish Marriage Rings," *The International Silver & Jewellery Fair Seminar*, London, 1989, pp. 29–34.

27. See on this book: M. Epstein, "Simon Levi Ginzburg's Illustrated Custumal (Minhagim-Book) of Venice, 1593, and its Travels," *Proceedings of the Fifth World Congress of Jewish Studies*, Jerusalem, World Union of Jewish Studies, 1973, Vol. IV, pp. 197–218. On the illustrated editions of *Minhagim* books in general, see S. Sabar, "Minhagim Books," in *The Dictionary of Art*, London and New York, Grove/ Macmillan Publishers, 1996, Vol. 21, p. 636 (and cf. I. Ta-Shma et al. "Minhagim Books," *EJ*, 12:26-31).

28. The nearest parallel in the Skirball collection is in the *Wimpel* of 1719 (Fig. 5 [56.474]).

29. For the meaning of this symbol, see below.

30. For example, a *Wimpel* dated 1845 (The Israel Museum, Jerusalem, no. 150/87)—see *From the Secular to the Sacred: Everyday Objects in Jewish Ritual Use*, Jerusalem, Israel Museum, 1985, item no. 8 pp. 15–17; and cf. Sabar, "Wedding Scenes" (note 9, above), p. 48 fig. 4. The Israel Museum *Wimpel* is closely related to our example (Fig. 25), dated 1854. Another example which belongs to this group is a *Wimpel* dated 1840 in the collection of Temple Emanu-El, New York (see: C. Grossman, *A Temple Treasury: The Judaica Collection of Congregation Emanu-El of the City of New York*, New York, Hudson Hills Press, 1989, no. 42, p. 69). Judging from the example of the *huppah* as well as other scenes (see especially the illustration of the Torah), it is not improbable that all of these binders are the product of the same maker, or at least emanate from the same locality in Germany. One of these binders, that of Isaac (known as Isadore), son of Eliezer (HUCSM 56.614), was donated to the Skirball Museum by Irwin Randolph (b. 1917), Isadore Grohs's grandson. According to the latter, his grandfather was born in Frankfurt a m Main–which enables us to deduce the entire group was apparently created in this town.

31. *Wimpel* of Menahem, son of Abraham Katz, born on 1 Adar 5538 (February 28, 1778).

32. The association of the stork with the family and children dates back to Greek and Roman times. The common belief in Europe has been that the stork picks up babies from marshes, caves and other places where the souls of the unborn infants reside and bring them to their new homes. See, for example, the entry "Stork" in *Funk & Wagnall's Standard Dictionary of Folklore, Myth and Legend*, New York, Funk & Wagnall's, 1972, p.1083.

33. For example, in a Venetian *ketubbah* of 1649, which is preserved at the Skirball Museum, fertility is shown by the Christian allegory of *Guadagna* ("Gain" or "Profit")–a farmer with a bag of seeds. See: S. Sabar *Ketubbah: Jewish Marriage Contracts of the Hebrew Union College Skirball Museum and Klau Library*, Philadelphia and New York, Jewish Publication Society of America, 1990, pp. 186–189.

34. Preserved at the Jewish Museum, New York.

35. See for example the *Ketubbot* from Vienna, 1831 and Manila, 1918, reproduced in *ibid.* pp. 239 and 324, respectively. For other sources on the fish as fertility and marital symbol in Judaism, see S. Sabar, "Childbirth and Magic: Jewish Folklore and Material Culture," in *A Cultural History of the Jews*, ed. D. Biale, New York, Schocken Books, in press.

36. The binder is preserved in Congregation Emanu-El, New York. See Grossman, *A Temple Treasury* (note 30, above), no. 41, pp. 67–9, 70–71. The scene is reproduced in Sabar, "Wedding Scenes" (note 9, above), p. 49, fig. 8.

37. See S. Sabar," A Jewish Wedding in 18th Century San'a: The Story of the *Ketubbot* of the Al-Eraqi and Al-Sheikh Families–Between Tradition and Innovation," *Rimonim* (Jerusalem: Society for Jewish Art), 6–7, 1999, p. 27 (in Hebrew).

38. This German custom is reported already in *The Book of Maharil* (see note 9, above), p. 468. In the seventeenth century the noted beadle of the Worms community Yuspa Shammash (1604–1678) reiterates the continuation of this practice. See his book of customs *Minhagim de'K. K. Worms*, Jerusalem, Mif'al Torat Hakme Ashkenaz, Mekhon Yerushalayim, 1992, p. 41 (in Hebrew). And cf. Hamburger, *Shorshei Minhag Ashkenaz* (note 1, above), p. 477.

39. On this issue see the chapter "Praise Her in the Gates" in S. Sabar, *Mazal Tov: Illuminated Jewish Marriage Contracts from the Israel Museum Collection*, Jerusalem, Israel Museum, 1993, pp. 17–41

40. *Wimpel* of Herschel, known as Heinrich Gustav, son of Jacob Hirtz from Weilburg, born on 4 Tishri 5598 (October 3, 1837).

41. *Wimpel* of Lemle (Ascher), son of the esteemed rabbi Moses, born on 9 Sivan 5553 (May 20, 1793).

42. *Wimpel* of David, son of Abraham from Marfelden, born on 21 Elul 5590 (September 9, 1830).

43. For the history of the six-pointed star in Jewish sources, see G. Scholem, "Magen David," *EJ*, 11:687-697. And cf. G. S. Oegema, *The History of the Shield of David: The Birth of a Symbol*, Frankfurt am Main, Germany: Peter Lang GmbH, 1996.

44. See, for example, a Hebrew childbirth amulet from the late eighteenth-century Germany, the central design of which is a large Magen David inscribed with Kabbalistic formulas–reproduced and discussed in Sabar, "Childbirth and Magic" (note 35 above). On the association of this symbol with amulets see Scholem, Oegema, pp. 41–64, and cf. T. Schrire, *Hebrew Amulets: Their Decipherment and Interpretation*, London, Routledge & Kegan Paul, 1966, pp. 59–68.

45. See, for example, N. Feuchtwanger, "Interrelations between the Jewish and Christian Wedding in Medieval Ashkenaz," *Proceedings of the Ninth World Congress of Jewish Studies*, Division D, Jerusalem, 1986, Vol. 2, pp. 31–36. A. Weber, "From Leo to Virgo: The Binders of the Synagogue at Ichenhausen," in *Mappot…blessed be who comes* (note 1 above), p. 93.

46. Cf. Gutmann, "Medieval Marriage Customs" (note 12 above), p. 50. For a complete list and reproductions of the extant *huppahsteine* from German synagogues, see D. Davidovitch, "Breaking a Glass on the Wedding Stone–Jewish Matrimonial Customs Which Have Disappeared in Recent Generations," *Eretz Israel Museum Yearbook,* Tel Aviv, Eretz Israel Museum, 4, 1986/87, pp. 253–268 (esp. 260–265; in Hebrew).

47. See note 17, above.

48. For the marriage as a transitional ceremony see the works of van Gennep and Turner cited in note 4, above. Note that according to the *Shulhan Arukh, Tur Yoreh De'ah*, 179:2, marriages should be conducted on the first fifteen days of the month when the moon is still increasing–as this is considered an auspicious astral sign. Indeed, the *Ketubbot* of the past confirm that marriages were customarily celebrated on the said days (cf. Sabar, *Ketubbah* [note 33, above], p. 11). For the same reason, the marriage contracts, especially in Italy and the Sephardi world were decorated with the twelve signs of the zodiac. See examples in *ibid.*, pp. 62–6, 74–5, 141–142, 164–165, 170–171, 182, 186–187, etc.

49. See J. Z. Lauterbach, "The Ceremony of Breaking a Glass at Weddings," *Studies in Jewish Law, Custom and Folklore*, New York, Ktav Publishing House, 1970, pp. 1–29a. Note that other scholars, especially of Orthodox background, attempt to demonstrate the historical basis of the more traditional interpretations of this custom. See, for example, S. Hertz, "*Shevirat ha-Kos ba-huppah*," *Sinai*, 103, 1988/89, pp. 248–60 (in Hebrew). The fact is that breaking many glasses at weddings is common to this day in South German villages (i.e., non-Jewish). And cf. Gutmann, "Medieval Marriage Customs," p. 52. Associating the north with the source of evil is reiterated in the central book of the Kabbalah, *The Zohar*: "The [Hebrew] letter *Beit* of *Bereshit* [Genesis 1:1] is written large [i.e., larger than the letters that follow] as it is shaped like a house for the entire world…it has three sides with only one, the northern, left open and unbuilt, since it is the side of evil…for there resides the evil of the entire world" (*Midrash ha-Ne'elam*, *Song of Songs*, 17–see *Sefer Zohar Hadash im Peirush ha-Sulam*, Jerusalem, 1955, Vol. 21, p. 5). And cf. Lauterbach, p. 19 n. 31, who cites additional midrashic sources on this issue.

50. Preserved at the Israel Museum, Jerusalem. On this attractively carved stone see Davidovitch, "Breaking a Glass" (note 49, above), pp. 264–65 and fig. 19; cf. Goodman, *Jewish Marriage Anthology* (note 21, above), fig. 20 (following p. 108). On the symbolism of the *huppahsteine* see also F. Wiesemann, "Masel Tow für Braüt und Braütigam. Der Davidstern auf Hochzeitsteinen," in *Der Davidstern. Zeichen der Schmach–Symbol der Hoffnüng*, eds. W. Stegemann and S.J. Eichmann, Dorsten, 1991, pp. 87–91.

51. Reproduced in color in J. Ungerleider-Mayerson, *Jewish Folk Art from Biblical Days to Modern Times*, New York, Summit Books, 1986, p. 110; Sabar, "Wedding Scenes" (note 9, above), p. 49 fig. 7. On the Alsatian *Mappot* see R. Weyl and F. Raphaël, *L'imagerie juive d'Alsace*, Strasbourg, France, Éditions des Dernièrs Nouvelles, n.d. [1979?], pp. 19–35; F. Raphaël, "*Am Schawess brèngt mein Jénigle die Mappe in d'Schüle*: On Saturday my Grandson Will Bring the *Mappah* to the Synagogue," in *Mappot… blessed be who comes* (note 1), pp. 72–9.

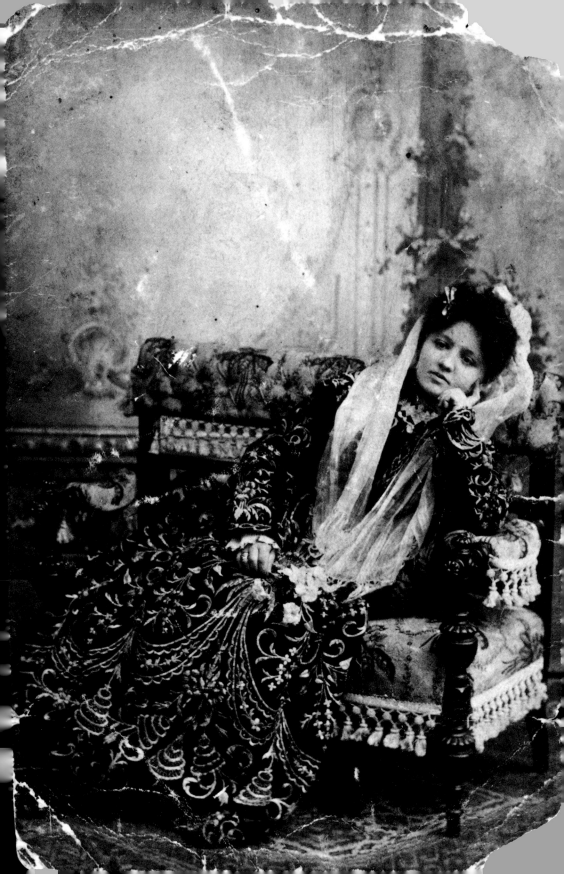

Traditional and Transitional Bridal Costumes in Middle Eastern Jewish Communities

Esther Juhasz *and* No'am Ba'ram Ben Yossef

BRIDAL OUTFITS from Jewish communities in the Muslim world prior to modernization display great variety in materials, cut, color, and ornament. Because there is no *halakah* (legal requirement) that determines wedding attire, this diversity reflects the influences of various styles of costume among the non-Jewish cultures in which Jewish communities were located. Although outfits that reflect the local culture predominate, several gowns made for Jewish brides stand out as distinctive of the Jewish community: the famous "great dress" from Morocco is an example. This brief look at the variety of bridal costumes in the process of transition, and what they stand for in the Jewish communities of the Islamic world, demonstrates how meaningful they were for the brides themselves, and how they embodied, as ensembles or in their details, a wide array of social, ethnic, and religious norms.

The diversity of dress also attests to differentiation among Jewish communities, as different traditions were practiced even among communities living in proximity to one another. The different character of urban and rural communities is evident in Yemen, for example. In other cases, it attests to the preservation of traditions of immigrant groups in new locales. For instance, the descendants of Jews expelled from Spain brought Sephardic traditions to the Ottoman Empire and North Africa; the Baghdadi Jews who emigrated to India brought their Iraqi attire with them and maintained it there.

Bridal outfits are complex, often incorporating special headgear, jewelry, facial decoration, and several garments. The bride is displayed in the most sumptuous finery, sometimes her own and sometimes loaned to her for the occasion, which reveals the significance this rite holds for the community. These costumes bestow a bride with a majestic splendor that persists throughout the wedding ceremonies, making her the center of attention not only for one day but a week or two. But these lavish outfits sometimes so restrict her movements that she is rendered a passive decorated object. The bride is led, guarded, and directed by a coterie of women around her and is expected to be restrained and obedient.

The dressing of the bride was a long, tedious process that followed strict rules under the direction of a skillful woman familiar with the tradition. The bride, in many cases a very young girl having no say in the matter, had to sit for hours and undergo such painful cosmetic treatments as hair plucking, until the costume was complete. Quite often her outfit was so heavy and cumbersome that she could hardly move.

< **Fig. 34** Bride in a *bindal* dress, a ceremonial costume worn after the wedding, Ruschuk, Turkey, early 20th century.
Courtesy of the Siman-Tov family, Jerusalem, and The Israel Museum, Jerusalem, Jewish Ethnography Archive

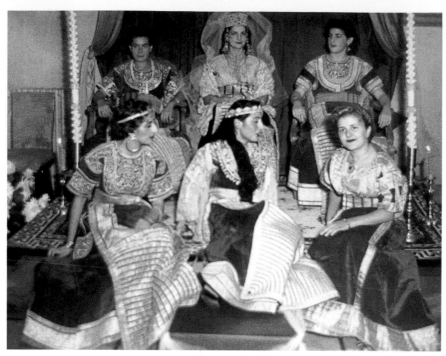

Fig. 35 Bride and brides-maids at henna ceremony in Casablanca, 1957
Courtesy of Benazraf family, Paris, and The Israel Museum, Jerusalem, Jewish Ethnography Archive

Complex outfits and a large quantity of jewelry were meant to highlight the wealth and standing of the bride's family. Jewels were, in some cases, part of the dowry or trousseau given to the bride by her family. In Djerba, Tunisia, for example, jewels worn on the bride's person from the wedding onward were a private fund to be cashed by her in case of need.[1]

No less than the display of wealth, bridal outfits were also imbued with symbolic and protective elements intended to ward off evil forces at a very vulnerable time for the bride and to bring luck and fertility to her marriage. Symbolic meaning and protective properties were ascribed to certain colors and ornaments in jewelry or embroidered on the bridal dresses. These amuletic motifs are usually common to both Jews and non-Jews in a shared area. For instance, the abundant use of pearls in headgear and necklaces and the use of coral were believed to avert evil. *Ḥamsa*, the open hand motif prevalent in North African jewelry and embroidery, is believed to ward off the evil eye; it is also found on the cap of the bride from Djerba (Fig. 116). Motifs of fish or wheat grains are symbolic of fertility; the tree of life is a blessing for long life. Only rarely are specific Jewish symbols or Hebrew inscriptions found on wedding costumes, but the Magen David (six-pointed star) or such inscriptions as *mazal tov* or *ben porat Yosef ben porat alei ayin*, "Joseph is a fruitful bough, even a fruitful bough by a well" (Genesis 49:22), appear on sequined or tinsel-embroidered tulle scarves from Iran to Georgia.

Life-cycle events—birth, marriage, death, and the connections among them—are recurring themes in marriage ceremonies and related symbolic artifacts. Evoking the day of death in a wedding ceremony is deemed a measure of humility and a protective device. In some cultures, a shroud was worn under the wedding dress; the embroidered shrouds from Tetouan in Morocco are an example of this custom.[2] Jewish brides in Kurdistan[3] wore their wedding night chemise as shrouds when they died. In rural Jewish communities of the central plateau of Yemen, two dresses identical in form and embroidery were made, one black, one white. In certain locales the white one is worn only for weddings, white being prohibited to Jews on a regular basis and permitted only on such festive occasions as weddings. In other villages both dresses were worn but the black was on top. This dress was also worn on Yom Kippur and as the woman's shroud.[4]

The actual wedding gown worn at the *kiddushin* ceremony was part of a set of outfits featured in various ceremonies, such as the henna night during the week prior to the wedding and the recitation of *sheva berakhot*, the Seven Blessings, a week afterwards. In some places, including Isfahan, Iran, and Bukhara in Central Asia (now Uzbekistan), the bride changed dresses every day and even several times a day to display the wealth of her trousseau. Because men and women celebrated many of the festivities separately, the bride in her finery was seen mainly by women. Fear of magic spells sometimes restricted the number of attendants at the *kiddushin* ceremony itself.

In many contemporary cultures, the bridal outfit is worn for one event, the wedding itself, but a century ago, it was the most beautiful dress in a bride's dowry, differing from other dresses in its rich fabric and wealth of decoration. Such outfits were worn first on the wedding day, which was symbolically evoked when the special dress was worn later to other family and community festivities.[5]

Wedding gowns were sometimes dedicated to synagogues and transformed into Torah mantles, ark curtains, or covers for the reader's desk. The owner of a dress might make such a donation in memory of her husband or other members of their family, or conversely a dress might be donated after her death in memory of the woman who had worn it.

In many traditional cultures, bridal dresses were very colorful and by no means featuring the color white exclusively. One finds dresses of all colors—red, green, and even black—some of the colors bearing symbolic and protective significance. The white wedding dress was introduced as part of the modernization process in many communities, which each enclave underwent at its own pace and mode. Even within various strata of a single community, attitudes toward tradition and modernization affected the pace of change. In some places white dresses replaced traditional garb; elsewhere, transitional stages produced unique combinations of the two styles. This transition sometimes took place in the country of origin, but immigration, to Israel or other lands, occasioned rapid change in many communities. Traditional wedding ensembles are enjoying a revival today beside the white wedding dress. The recontextualization of traditional local wedding attire in multicultural Jewish society, whether in Israel or the United States, changes its function: the costume becomes a focus of nostalgia and an ethnic identity symbol.

Morocco

In the cities of Morocco, the traditional Jewish wedding and festive dress was called *kiswah l kebira*, the "great dress," in French *la grande robe*, and in Judeo-Spanish *traje berberisco*, or Berber dress.[6] This outfit consists of several components made of heavy velvet and embroidered with metal thread in couching technique on leather or cardboard cutouts or decorated with gold braids: a wrap-around skirt and a fitted jacket or waistcoat cut low at the front with long or short sleeves. When the sleeves of the jacket are short, wide detachable embroidered muslin sleeves cover the hands. A padded bodice covers the breast and is visible through the large opening of the jacket; a wide, stiff brocade sash, which enwraps the waist, joins the upper and lower parts of the dress. Local variations on this costume differed by color—red was identified more with Rabat, violet and black with Tetouan—or in the embroidery patterns. Each town had a distinctive composite headgear consisting of several scarves, adorned sometimes with pearl diadems. Essential components of the headgear were partial wigs made of silk or false hair in the form of braids joined by woven bands, which fulfilled the halakic requirement that a married Jewish woman cover her hair.[7]

The cut and decorative style of this costume was quite outstanding in Morocco. This sumptuous dress captured the eyes of foreign travelers and painters who visited Morocco and was described and painted by them as a signifier of Jewish culture. Stylistically the Moroccan garb is clearly related to late medieval Spanish costume. Its prototypes had been

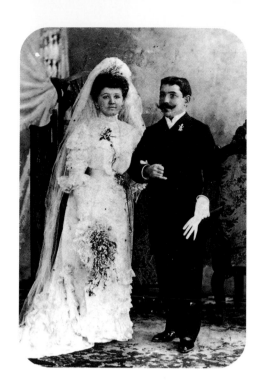

brought to Morocco by Jews after their expulsion from Spain in 1492, and these Spanish traits were preserved until the twentieth century. In Morocco, however, this costume became associated both with the historical heritage of the Spanish Jews and the contemporary urban culture of the Jews.

This dress, earlier a festive dress, had become a bridal costume only in the last generations in Morocco. The bride wore it during the wedding itself, but in other nuptial ceremonies, such as the henna night, the bride and her entourage wore identical dresses, which was intended to confuse any evil forces threatening the bride. Married women wore this outfit again on festive occasions following the wedding.

In Morocco this dress was still worn by brides long after Jewish women had changed to modern dress for everyday clothes. As every family could not afford to own this very expensive outfit, wealthier families sometimes loaned the clothing to brides. Such outfits were passed down in families as cherished heirlooms and became status symbols.

In Israel, France, the United States, and other places to which Moroccan Jews immigrated, a different use of this dress evolved. It is worn today in the henna ceremonies that were revived in the 1970s, but in the wedding itself, brides wear fashionable white dresses. When a bride is of Moroccan origin or when the groom's family is Moroccan, a henna party is celebrated several days before the wedding. At these parties the bride-to-be is clad in the "great dress" (Fig. 108) and the other women are mainly dressed in caftans, full-length, sleeved coatdresses, in a loosely fitted style. Jewish women started wearing these typically Moroccan embroidered dresscoats in Morocco after "great dresses" became scarce. In multicultural societies outside Morocco, the "great dress" has become the symbol of Moroccan origin and heritage side by side with other Jewish traditions. Regional differences, as well as differences between Spanish and other traditions in Morocco, have been wiped out or become much less accentuated by the widespread adoption of the "great dress" and, at least in the eyes of outsiders, the dress in its use at the henna ceremony is a unified symbol and a tribute to the preservation of Moroccan heritage.

Turkey

In the large Sephardi communities in Turkey—Istanbul, Izmir, Edirne, and Rhodes—by the second half of the nineteenth century the traditional wedding dress was the sumptuous *antari*, which the bride brought in her dowry.[8] The *antari* is a typical Turkish garment, a type of coatdress worn over wide *shalvar* (trousers) and a chemise and held by a belt or sash. Its cut did not differ from all the other dresses in the bride's trousseau, but the *antari* was first in the fixed hierarchy of clothes on the dowry list because it was richer in material, embroidery, and trimmings.

Around the 1890s and the turn of the century, Jewish women appropriated a new type of dress from the urban bourgeoisie, the velvet or satin dress embroidered with

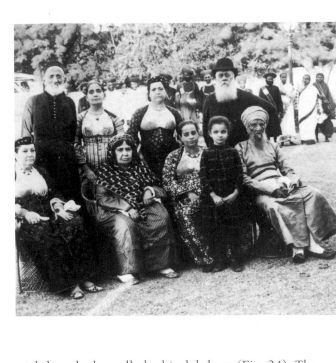

Fig. 37 Bridal costume, Baghdad, early 20ᵗʰ century. On loan from Victoria Ovadia, in memory of her pious mother, Simha Yaacob Haim. Courtesy of The Babylonian Jewry Museum

Fig. 38 Baghdadi women dressed in a ceremonial costume that brides used in their weddings, Calcutta, India, 1852–1897. Courtesy of the Sassoon Family, Jerusalem, and The Israel Museum, Jerusalem, Jewish Ethnography Archive

metal thread, also called a bindal dress (Fig. 34). The heavy couched embroidery covered the dresses with flowers in vases and other stylized, mainly vegetal motifs. The cut of these dresses—with set-in sleeves, darts, and added cuffs—as well as the elaborate embroidery motifs in the so called "Turkish baroque" style show strong European influences. This type of embroidered, fitted dress was worn by the bride in some communities for the *kiddushin* and in some on the morning after the wedding for a ceremony called *sebah*. This dress was one item in a set of lavish gold embroideries, which included ceremonial bedcovers, cushion covers, and wrappers that the bride brought as part of her dowry to be used in life-cycle festivities. During the wedding the bride and groom stood under the *talamo*, a boothlike canopy constructed from these dowry fabrics. Such dresses and other gold-embroidered articles from the dowry were ultimately recycled and converted to Torah ark curtains, mantles, binders, and the like and donated to synagogues. These dresses, adapted from the surrounding culture as a fashionable item with no Jewish specificity, were absorbed into Jewish culture by such use in the synagogue. The gold-embroidered dresses were transitional wedding gowns, between the traditional *antari* dress worn earlier and the white European dress, which replaced it around the beginning of the twentieth century (Fig. 36). Traces of this transitional phase still linger in Sephardi synagogues, long after the generation of brides who wore these dresses has passed away.

Iraq

In Iraq, and especially Baghdad, a large urban community where the modernization process was filled with confrontations between traditionalists and those embracing modern ways, the bridal dress passed through several transitional stages. We can discern three stages in the evolution of the bridal dress from a traditional dress considered typically Jewish; through a dark-colored or white dress with a European cut, but embroidered in metal thread (Fig. 37), the traditional *tel* technique; to the white dress fashionable in European society.[9]

Local custom in Baghdad required a bride's family to pay a very large dowry to marry off a daughter. They had to provide their daughters with sets of jewelry, clothing, and undergarments; the bride's wedding gown was made at home by a seamstress hired to prepare the entire trousseau. If the groom was from a poor family, the bride's family

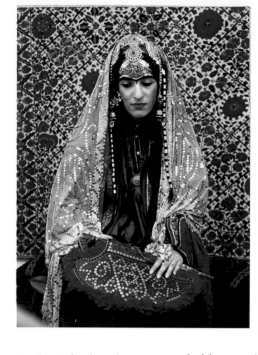

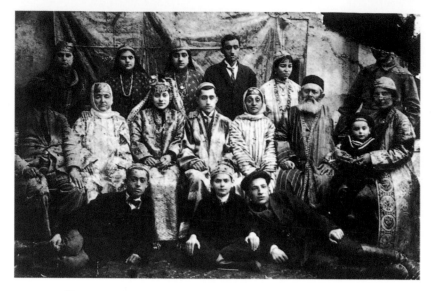

Fig. 40 Bukharan wedding in Bukhara or Jerusalem, early 20th century
Courtesy of Leah Levavi, Ramat Gan, and The Israel Museum, Jerusalem, Jewish Ethnography Archive

52

Fig. 39 Bride adorned with jewelry and sequins (reconstruction at The Israel Museum, Jerusalem, 1997) Photo: Nahum Slapak, Courtesy of The Israel Museum, Jerusalem, Jewish Ethnography Archive

provided him with some clothing and undergarments as well, but as a rule, the groom supplied the shoes for both bride and groom. He had to buy the bride at least two pairs of shoes, one for the henna night and one to wear for the wedding ceremony. The couple anticipated the day when they would go shopping together, chaperoned by other members of the family, to choose the shoes and get to know each other a little.[10] Why did the groom bring the shoes while the bride's family provided the couple with everything else? It has been suggested that perhaps, symbolically, this expressed the husband's rule over his future wife.

The Iraqi Jews who settled in India and the Far East from the late eighteenth century onward, following the commercial activities of the East India Company and David Sassoon, founded new communities there.[11] In such new localities as Calcutta or Rangoon, they preserved their Baghdadi costumes for a long time, but over the course of time adapted elements from Indian costume into their attire (Fig. 38).[12] The bridal outfit (also worn for other festivities) was comprised of the Baghdadi low-cut coatdress, *daryee kassa*, of brocaded silk or tinsel-embroidered silk satin, and worn over very wide pantaloons. A local adaptation to this costume was a tulle or thin cotton underdress, *qamisa*, tinsel-embroidered or decorated with Indian-style white patchwork. The most outstanding item in this attire is the rich-colored embroidered bodice worn under the sheer underdress and visible through the thin fabric; this bodice was probably borrowed from the costumes of Indian dancers. This transitional combination of Iraqi and Indian identities did not last long: under the influence of the British lifestyle in India, it soon gave way to the white wedding dress.

Persia

Those Jewish communities of Central Asia where Persian dialects are spoken also share many marriage customs, but every region has its particular wedding attire. In Isfahan, Iran, the bridal outfit consisted of a gold-embroidered silk skullcap,[13] *araqchin*, and a large tinsel-embroidered tulle veil, *tur-e nakdeh*, which covered the bride from head to toe. A silk or tulle dress in a simple, full cut was worn over a short, gathered embroidered silk skirt, *shelite*, which served as a petticoat/crinoline enhancing the dimensions of the outer dress. A gold-embroidered velvet jacket, *cot* or *yal*, was worn over the dress (Fig. 110). The outfit worn by Jewish brides did not differ from the Muslim bridal costume. It was made by professional embroiderers, traditionally Muslim males, or by the bride and her family if they were skilled in these handicrafts.

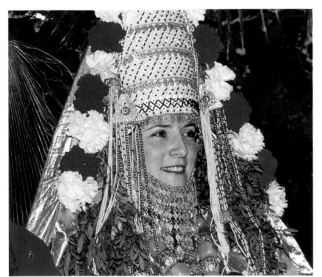

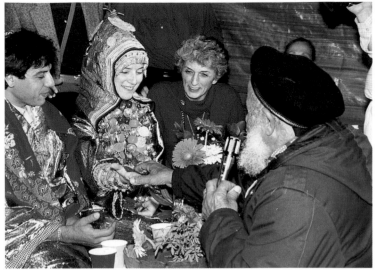

Fig. 41 Jody Anne Garfinkle dressed in the *Tishbuk Lulu*, traditional in Yemenite wedding attire, 1988.
Courtesy of Shirley Garfinkle

Fig. 42 Henna ceremony of Jody Anne Garfinkle and Avihail Zaviv, 1988.
Courtesy of Shirley Garfinkle

In preparation for the wedding, the bride submitted to lavish cosmetic treatments: her hair was combed and plaited into many braids; her facial hair was removed and her face powdered. The bride's eyebrows were blackened and joined; in the early twentieth century, the line of the eyebrows was accentuated with a row of colored sequins.

Afghanistan

A very impressive and harmonious combination of makeup, including elaborate facial decoration with sequins, jewelry, and enveloping scarves, was found in the bridal attire of Herat, Afghanistan (Fig. 39).[14] The small community of Herat included local Jews as well as descendants of the forced converts of Mashhad, in eastern Iran, who fled to Herat in 1839. This community had close cultural and commercial connections with the Jews of Bukhara. The Herati bridal costume incorporated local elements with features from Iran and Bukhara in a unique and original style.

The Herati bride went through a long and ceremonious process of preparation, which occupied the week before the wedding. In these procedures she was guided and escorted by the *mashade*, a beautician and expert in the decorative handicrafts required for the adornment of the bride. The facial sequin decoration, which probably derived from tiaras worn in Uzbekistan, filled the entire enlarged forehead of the bride in concentric rhomboids in a rhythmic repetition of gold, red, green, and blue.[15] The same colors were dominant in the gold-enameled jewels that encircled her face. These jewels, bought in Mashhad, along with other items for the outfit, distinguished the Jewish bride from the Muslim bride. The bride was covered with several scarves upon which lay a sequined tulle shawl, adorned with Hebrew amuletic inscriptions, as well as representations of birds, the tree of life, stars, water jugs, and *hamsa* (hand) and *bote* (paisley) motifs.

Bukhara

Jewish brides of Bukhara also wore shawls of a similar type. The city of Bukhara, once an emirate, lent its name to all the Jewish communities of Uzbekistan. In the Israel Museum collection there is a tulle bridal dress from Bukhara entirely covered in sequins, which was probably worn on top of an opaque silk underdress.[16] But presumably there were other types of wedding dresses: gold-embroidered, loose-fitting velvet dresses, brocaded silk dresses, and a type of metal-woven fabric-lamé called *zarini mawdji*.

Bukharan, Afghan, and Iranian Jews who immigrated to Israel in the 1920s and 1930s settled mainly in a distinctive quarter in Jerusalem. Bukharan families kept many

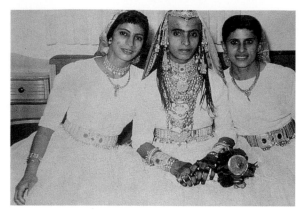

Fig. 43 Habbani bride and her bridesmaids. Although the bride is dressed in white, she still wears the special jewelry and hairdressing associated with traditional ceremonies, Bareket, early 1960s. Courtesy of Carmela Abdar, Jerusalem

54

of their colorful costumes and display them to this day during Jewish holidays such as Pesach or Rosh Hashana, and in life-cycle festivities, including the bar/bat mitzvah and weddings (Fig. 40). Some elderly ladies still keep a special dress to be buried in. The actual bridal gown was the first of the traditional outfits to be supplanted: by the 1940s a modern white dress is seen in many wedding photographs among the colorful Bukharan costumes of the guests. Today at weddings, some members of the family, who come in modern dress, bring along Bukharan garments they put on for the dancing. Although inferior in quality, these garments are still available in Bukhara, and people in the community purchase them for use in festivities. Though the Bukharan ethnic identity is strongly manifested through a display of traditional clothing, the bridal dresses are not included.

Yemen No doubt the best-known bridal outfit from the Jewish communities of the Islamic world is the San'ani costume, the *Tishbuk lulu* from Yemen (Fig. 41).[17] A conical crown decorated with rows of white and black pearls and red beads surmounts this impressive attire. On both sides hang pearl pendants, customarily borrowed from Muslim neighbors, and filigree pendants, sewn onto a white background and arranged in a meticulous geometric order. Flowers and rue branches surround this crown. A thin scarf falls down the bride's back from the peak of her headgear. From her chin to her waist she is bedecked with silver, gilt silver, and coral necklaces. Her arms are covered with bracelets and her fingers with rings. She wears a simple underdress, *tahtani*, covered by a silken red-striped dress and above it all, a brocaded gown. Sumptuous leggings, embroidered in silver cords couched with red silk, cover her ankles and can be seen below the hem of her dress. The general shape of this outfit resembles that worn by Muslim brides of San'a, but several of its components and motifs are different. For instance, Jewish women of San'a embroidered the leggings with the star-shaped motif *mekawkab* for the Jews alone. Individual brides did not own this elaborate outfit: the *shar'eh*, who specialized in dressing the bride, collected its many parts from several families.

San'ani bridal costumes, an icon of ethnicity and ethnic revival, have been immensely popular in Israel. This is due in part to the revival of this dress and its reconstruction in the Israel Museum in the 1960s by Mrs. Bracha Kafih, the wife of the late R. Yoseph Kafih of San'a, and the curator of the department of Jewish Ethnography, Aviva Muller-Lancet. [18] In Israel and the United States, dressing the bride in this San'ani costume is part of the henna ceremonies (Fig. 42) before the wedding, but this elaborate garb is not used for the wedding itself. This is considered the definitive Yemeni costume, and even people who originated in other regions of Yemen have appropriated this symbol and abandoned their own particular traditions.

The costume of the capital city, San'a, had a prestigious status in Yemen, although there it was only one of a variety of regional styles. Bridal attire of the Heidan region in the north and the Habbani costume have also been preserved.[19] The Jews from Habban settled in one place in Israel, Moshav Bareket, where they still keep many of their traditions, especially the bridal costume and headdress. In a very detailed article about the transition of this composite headdress, a unique process of adaptation in the bridal outfits of Habbani brides living in Israel has been documented.[20] The major component of the

bridal outfit is the head dressing, which is a complicated combing of the bride's hair adorned with jewels and ornaments. The Habbani brides in the 1960s wore several combinations of traditional and modern elements. One of them, striking in its appearance to the outsider, is the traditional head adornment combined with a tight-waisted white wedding dress (Fig. 43), with the waist line accentuated by a traditional silver Habbani belt (still worn today by Habbani women). High-heeled white shoes enhance the modern silhouette.

Even this brief look at the variety of bridal costumes in the process of transition, and what they stand for in the Jewish communities of the Islamic world, demonstrates how meaningful they were for the brides themselves, and how they embodied, as ensembles or in their details, a wide array of social, ethnic and religious norms.

1. In some Islamic countries such as Yemen, Kurdistan, and Afghanistan, the Jews adapted from the Muslims the custom of paying a kind of bride's price to the bride's family. As was customary among the Muslims, Jewish fathers used the payment to buy the bride her trousseau and especially some jewelry.

2. Alia Ben-Ami, "Decorated Shrouds from Tetouan, Morocco," *Israel Museum Journal*, vol. 8, 1989, pp. 31–40.

3. Ora Shwartz-Be'eri, *The Jews of Kurdistan, Daily Life, Customs, Arts and Crafts*, Jerusalem, Israel Museum, 2000, p. 90.

4. Carmella Abder, "Dress and Appearance of Jewish Women in a Yemenite Village as an Expression of their Status," *Pe'amim* 41, 1989, pp. 135–153.

5. Most of the information regarding these traditional wedding dresses is based on interviews describing from memory long-bygone customs and costumes. It is not always possible to derive a clear picture of exactly which dress was worn on each occasion.

6. The name *traje de berberisco*, Berber dress, is a paradoxical name, as it is quite the opposite of what this dress in fact was: an imported dress different from the local Berber tribal clothing. On the Moroccan "great dress," see: Jean Besancenot, *Types et costumes de Maroc*, Paris, 1942; Aviva Muller-Lancet, *La Vie Juive au Maroc*, Jerusalem, Israel Museum, 1973 (in Hebrew and French), the chapter on costume, pp. 200–210; Yedida K. Stillman, "The Costume of the Moroccan Jewish Women," *Aspects of Jewish Folklore*, ed. Dov Noy, Cambridge, MA, Harvard University Press, 1980; "Hashp'aot Sefaradiot al ha-tarbut hahomrit shel Yehudei Maroko" in *The Sephardi and Oriental Jewish Heritage*, ed. Issachar Ben-Ami, Jerusalem, 1982, pp. 359–366, and the bibliography mentioned there.

7. The covering of the hair, or the cutting of the bride's hair, before or after the wedding, is done according to different customs.

8. Esther Juhasz, " Marriage" in *Sephardi Jews in the Ottoman Empire, Aspects of Material Culture*, Esther Juhasz , ed. Jerusalem, The Israel Museum, 1989, pp. 197– 217.

9. All three types of dresses are exhibited in the Babylonian Jewry Heritage Center and Museum in Or Israel Yehuda, I am greateful to the curator, Idit Sharoni-Pinhas, for the contextual information.

10. Abraham Ben-Yaacob, *Babylonian Jewish Customs*, Jerusalem, 1993, Vol. 2, pp. 104–5 (Hebrew); Yitzhak Avishur, *The Jewish Wedding in Baghdad and its Filiations*, Haifa, 1991(in Hebrew), vol. 1, p. 76.

11. David Sassoon (1792–1864) was the founder of a large commercial empire with centers in Bombay, Calcutta, Rangoon, Hong Kong, and in other places continued by his descendants.

12. See Orpa Slapak, *The Jews of India*, Jerusalem, Israel Museum, 1995, p. 139.

13. In Isfahan, three techniques of gilt embroidery were used: tinsel embroidery (*narkde*), couched cord embroidery (*melile*), and sequin embroidery (*pulak*).

14. No'am Bar'am-Ben Yossef (ed), *Brides and Betrothals, Jewish Wedding Rituals in Afghanistan*, Jerusalem, Israel Museum, 1998.

15. As part of the preparation of the bride, there is a ceremony of plucking the facial hair, especially the hair above the forehead to enlarge it and make space for the decoration.

16. Aviva Muller-Lancet, "Seker ha levush shel yehudei Bukhara–beayat ha yihud ha zurani" *Fifth World Congress of Jewish Studies*, vol. 4, 1973, pp. 45–49 (Hebrew).

17. Aviva Muller-Lancet, "Tishbuk Lulu. A Jewish Bride's Crown from San'a," in *Harel* (Hebrew), eds. Y. Ratzabi and J. Shivtiel, Tel Aviv, 1962, Ester Muchavski –Schnapper, *The Yemenite: Two Thousand Years of Jewish Culture*, Jerusalem, Israel Museum, 2000, pp. 68–69.

18. On the reconstruction see Aviva Muller-Lancet,"'Returning the Crown to its Glory'—The rehabilitation of the Jewish Bridal Crown from San'a," *Rimonim*, 6–7, 1999, pp.128–130 (Hebrew).

19. Helziba Hilger, "Costumes and Cosmetics among the Jewish Women of Northern Yemen" in *Bat Teiman*, ed Shalom Seri, Tel Aviv, Amutat E'eleh be-tamav, pp. 249–263. No'am Baram, "Embroidered Dresses of the Sharaf district in Yemen," *The Israel Museum News*, 15, 1979, pp. 64–71. Carmella Abder, "Head Adornment of the Habanic Bride in the 1960s in Israel: A Bridge between Past and Future," *Rimonim*, 6–7, 1999, pp. 112–132 (Hebrew).

20. Abder, op. cit.

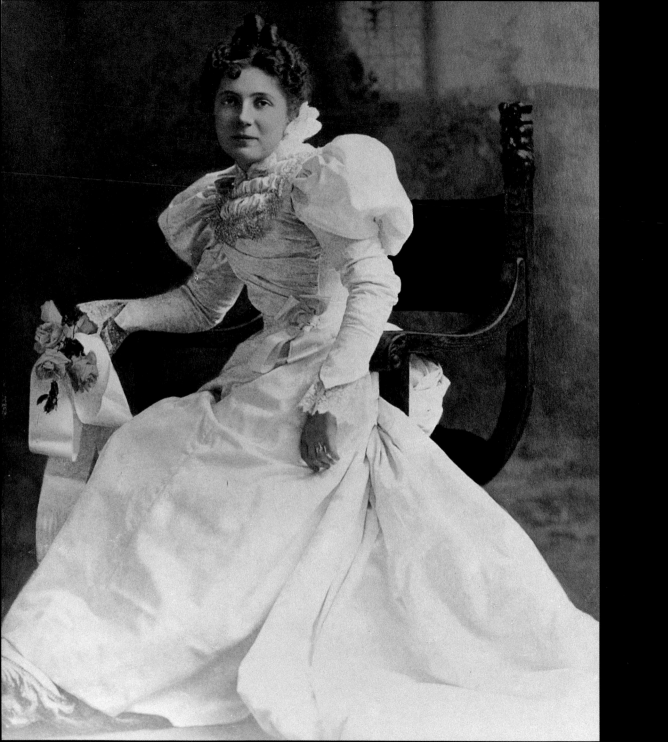

Pomp, Circumstance, and the American Jewish Wedding

Jenna Weissman Joselit

VIRTUALLY EVERY AMERICAN JEWISH FAMILY has at least one wedding story in its private repertoire of domestic dramas. Some stories have to do with the weather or a traffic jam, others with the rabbi or the caterer, and still others with a broken heart. Some center on the wedding ceremony, others on a wedding gift (or its absence), and still others linger on every single detail of a long-ago misunderstanding brought about by a misplaced invitation or a perceived slight. Whatever the circumstances, each tale underscores the premium the American Jewish family has placed on the act of getting married.

The collective record of the American Jewish community is equally rich in nuptial lore. Complementing those wedding stories that attest to the intensity of familial bonds, advertisements, etiquette manuals, newspaper articles, sermons, and pageants—the stuff of history—highlight the impact of modernity on American Jewish wedding celebrations over the past century. Flanked by Cupid on one side and consumerism on the other, American Jews left little of the traditional ritual unaltered. From the venue and the menu to the role of the rabbi, they made sure their nuptials reflected individual visions of the perfect day. That wedding tale of adaptation and change is the subject of this essay.

When Annie Oshinsky (Fig. 44) of Decatur, Illinois, married William Berkson of Chicago in the winter of 1897, their wedding was held at the home of the bride's parents, Mr. and Mrs. Rudolph Oshinsky of West William Street. "It was an elaborate affair and was attended by about seventy-five persons," reported the *Decatur Daily Review,* adding the "residence was beautifully decorated for the occasion with flowers and smilax" and the rabbi came from out of town.[1] No one in either the Oshinsky or Berkson families thought twice about the possibility of holding the wedding outside the precincts of the home. It just wasn't done, not in their social set anyway. The only acceptable alternative was to have the wedding ceremony in the synagogue, followed immediately by a wedding supper at home. Which is exactly what Etta Einhorn did when, a few years later, she married Harry Reinish in Philadelphia. The ceremony took place at "six thirty o'clock," at the Synagogue Halberstam, which was located at Sixth and Green; the "reception" ensued at eight at the home of the bride's parents (Fig. 45).[2]

Little by little, though, things began to change as more and more weddings moved from the home and the sanctuary to commercial venues, a consequence of growing acculturation. "The club and the hotel have usurped the proper function of the synagogue," lamented the Central Conference of American Rabbis, the association of Reform

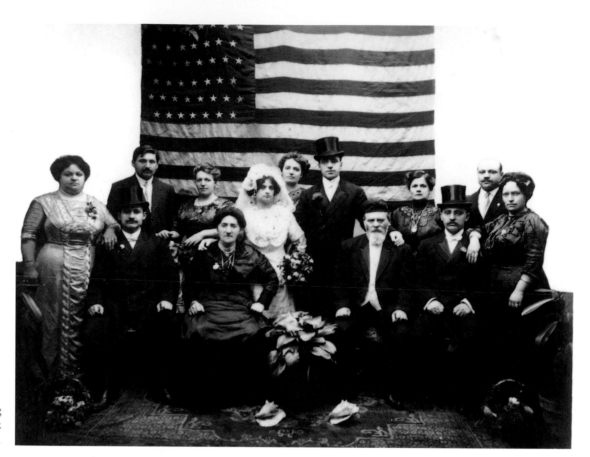

Fig. 46 Wedding of Ana and Jack Merkin, 1911

Fig. 45 Wedding Invitation, Philadelphia, 1907

clergymen, in 1910, alarmed at the growing number of weddings held outside the temple's doors. Concerned lest the celebratory dimensions of the wedding overshadow its sacred elements, the religious organization exhorted its members to see to it that the nuptials they performed in the future would only take place in the sanctuary. "The principle that a wedding is a private affair is unsound socially and untrue philosophically," the rabbinical group cautioned.[3] By then, it was far too late: the extra-synagogal wedding was here to stay.

A ceremony held in a club or a hotel ballroom was considered the hallmark of urbanity; it exuded sophistication and worldliness. A ceremony held in a catering hall, dozens of which dotted America's immigrant neighborhoods, symbolized the bounty of America. In both instances, the extra-synagogal wedding appealed to those eager to display their affluence and their aspirations in equal measure. Practical considerations also had much to do with its popularity. For those whose parlor or synagogue had no room to accommodate more than a handful of guests, the catering hall was a godsend.

From one end of the social spectrum to another, these publicly staged celebrations stretched the imagination as well as the budget. Although many happy couples by the turn of the twentieth century were not married under a *ḥuppah* or bridal canopy—it is "an unknown quantity to American-born Jews," categorically declared a reporter for the

Fig. 47 *First Wedding in the New Land*, Marlene Zimmerman, 1972 (cat. no. 125)

American Jewess in 1898—those American Jews who retained the traditional bridal canopy did so with verve.[4] Attentive to the very latest notions of stylishness, East European Jewish immigrants and their children, for instance, initially favored a *ḥuppah* fashioned out of a vast expanse of plum-colored or burgundy-hued velvet. When velvet fell out of favor, electric light bulbs, the latest novelty, took its place. In 1900, Victoria Hall, a Lower East Side facility, proudly boasted of its "electric *khupe*," hoping to enlarge its clientele. A competitor, the Grand American Hall, responding by touting the virtues of its "thousands of electric lights."[5] When light bulbs became too commonplace, too utilitarian an object to serve as an ornament, elaborate floral displays took their place (Fig. 49).

Bridal attire, too, grew increasingly fancy. By the turn of the century, more and more modern brides began to wear "shimmering, cloud-like" constructions fashioned out of chiffon and tulle, satin and lace, beads, pearls, and rhinestones.[6] Some gowns— such as those worn by Annie Oshinsky in 1897 (Fig. 44), Ida Sylvia Peisachow in 1920 (Fig. 50), and Jeanette Bergman in 1926 (Fig. 91)—were made by a dressmaker. Other brides purchased their dresses at the bridal department of a major department store and still others rented dresses for the day, just as the groom rented his tuxedo. Whatever its source, fabric, or shape, the twentieth-century wedding gown came in only one color: white, or one of its tonal cousins, off-white, cream, or blush. The hallmark of the fashionable "respectable wedding," it set the bride apart from everyone else while also dramatizing the importance of the occasion.[7]

American Jews spent lavishly on food and drink as well as on dress: "Jewish people," it was said, "know how to outdo themselves."[8] Delighting in the opportunity to "*macht a l'chayim mit* [to make a toast with] Calvert," the popular blended whiskey, Jewish celebrants also fancied fountains spraying wine and colored liqueurs"[9] All one had to do was to hold a glass under one of them and select the desired beverage,"

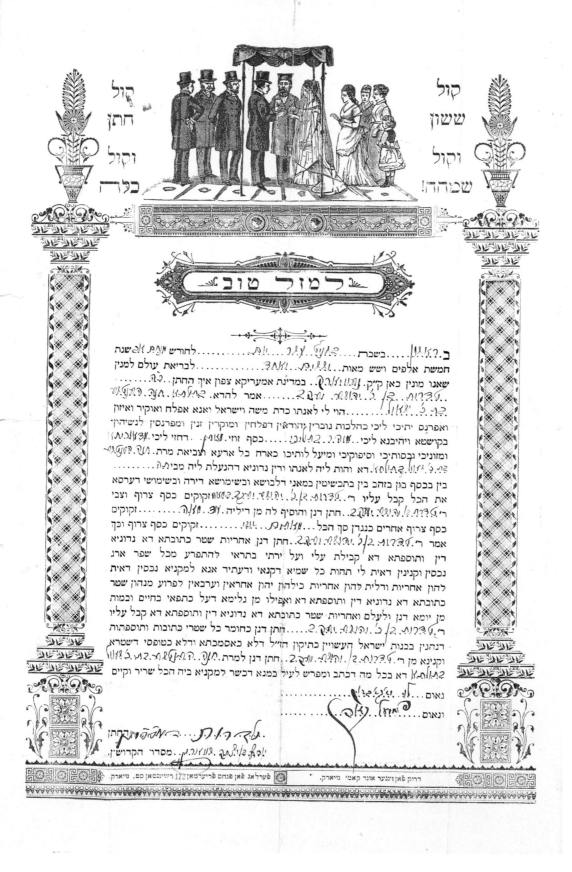

Fig. 48 Providence, Rhode Island, *Ketubbah*, 1901 (cat. no. 129)

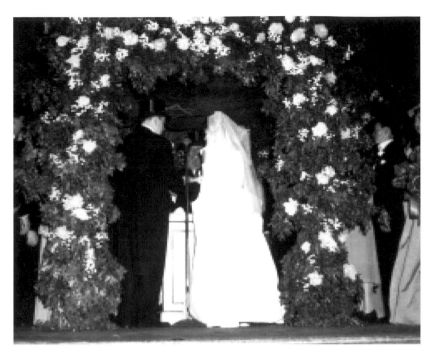

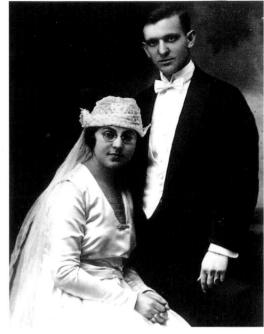

Fig. 49 Floral *Ḥuppah*, Wedding of Naomi Greenberg and Seymour J. Cohen, New York, 1946

Fig. 50 Ida Sylvia Peisachow and Louis Kevitt Wedding Portrait, 1920

recalled a guest who did not know whether to admire or disdain the offering.[10] Chicken tempted the palate, too, especially in Jewish immigrant circles. "I had known chicken exclusively in its austere boiled state, garnished with whole, waterlogged onions or accompanied by masses of noodles. But chicken fricassee was so special a form as to make it seem improbable that it could ever be served in any home, however pretentious," remembered another lucky guest, his mouth watering at the memory.[11] By the interwar years, American Jews had graduated from chicken to duck à l'orange and other French culinary delights. Elaborate desserts like "buche of ices fantaisie," crêpes suzettes, and cherries jubilee were most popular. "Caterers, restaurants, great angle they got….Anything they can set fire to they charge ten times as much. Set fire to a twenty-five cent flapjack, crêpes suzettes for two dollars."[12] Some American Jewish families liked to spend a bit extra on the amenities. "When people are very swell," related the proprietor of a popular catering facility on the Lower East Side of Manhattan, they "hire the hat box" for the entire evening, and "their guests don't have to pay for hat checks."[13]

As pocketbooks grew, so too did American Jewry's appetite for the very latest in modern music, a reflection of the community's growing acculturation. Over time, the raucous sounds of klezmer music, once the mainstay of every *simcha* (happy Jewish occasion), drifted away, replaced by the gentler strains of "Oh, Promise Me," the Barcarolle, and Mendelssohn's "Wedding March." Bezalel Kantor, a writer for *The Jewish Spectator*, recalls attending a wedding in New York in the late 1940s when a relative of the bride tried to get the guests to join him in singing a medley of traditional Jewish melodies. The relative was promptly informed that the guests (most of whom hailed from Eastern Europe) did not know such tunes and that, furthermore, "this was not the place for it." [14]

When it came to selecting the music, the menu, the hall, and the wedding gown, many American Jewish brides and grooms increasingly turned to the caterer and other secular cultural arbiters for advice and assistance; the rabbi, in turn, was relegated to the realm of ritual etiquette. "Parents used to ask the rabbi for specific information" about the wedding, recalled one Minneapolis clergyman in the 1940s. "Today the rabbi will discover, much to his surprise, that either the bride or her mother is carrying a copy of Emily Post's rules of etiquette in much the same manner as if it were the Bible."[15] By the 1950s, the bride and her mother could also turn to Ruth Jacobs, a leading Jewish radio personality and the author of a bilingual (Yiddish-English) pamphlet, *The Jewish Wedding: An Explanation of Its Ancient Rituals and Modern-day Etiquette...*, for guidance. Jacobs, readers were told, was devoted to "preserving in the modern age the beautiful and

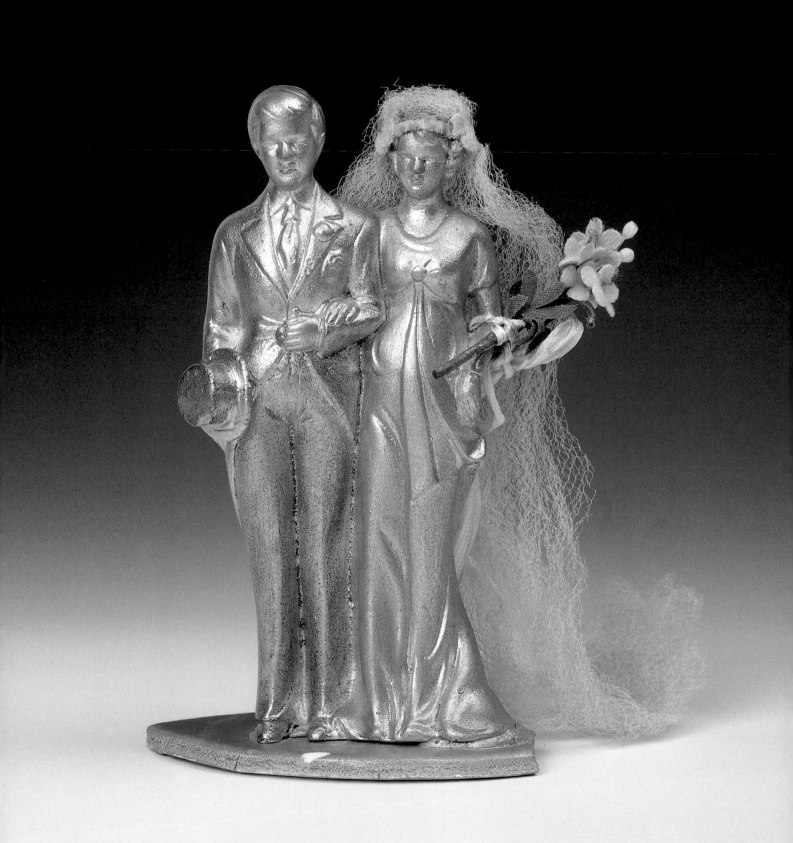

Fig. 52 Joan Felmus
and David Holtzclaw
Wedding Portrait, 1973

sensible 'goodness' of the Jewish way of life."[16] Her text, produced by the Calvert Distill-ers Company ("Another Jewish Community Service"), not only summarized what every bride and groom needed to know about the nature of and rationale behind the tradi-tional Jewish wedding but also made its meaning more contemporary. From the ḥuppah ("Today it is usually provided and set up by your caterer") to the breaking of the glass at the conclusion of the ceremony ("Life is transitory"), Jacob's compendium all but sup-planted the *shulkn arukh,* the traditional Jewish guide to ritual conduct.[17] Some Ameri-can Jews went further still, dispensing with the rabbi as well as his *shulkn arukh.* They made do instead with self-styled "reverends" and "professors," such as "Rev. S., master of the beautiful and concise ceremony," and "Prof. Irving Goldberg, Master of Ceremo-nies."[18] Others dispensed with anything that even remotely smacked of ceremony, let alone religious ritual, by getting married at City Hall.

These developments troubled the Jewish community's cultural custodians. Per-turbed by what it believed to be a growing trend toward secular marriages, the *American Hebrew,* one of American Jewry's leading newspapers, sought to discourage them by pointing out that "marriages which are only civilly performed are not so lasting or satisfactory as those which are sanctified by religious ceremonial." Citing a higher divorce rate among those who tied the knot in a secular service than among those wed by a rabbi, it observed that "persons who are cold-blooded enough to be satisfied with a couple of signatures on a register...are likely to take a much more prosaic and business-like point of view on marriage than those who cannot imagine marriage without a Chuppah and a wedding march performed on a string band."[19]

Others wondered about the future of traditional Jewish ritual. "Are we so deadened and dulled that we cannot appreciate our beautiful traditions?" asked the Women's League for Conservative Judaism, questioning their vitality and staying power in postwar

< **Fig. 51** Wedding Cake
Ornament, 1920 (cat. no.
134)

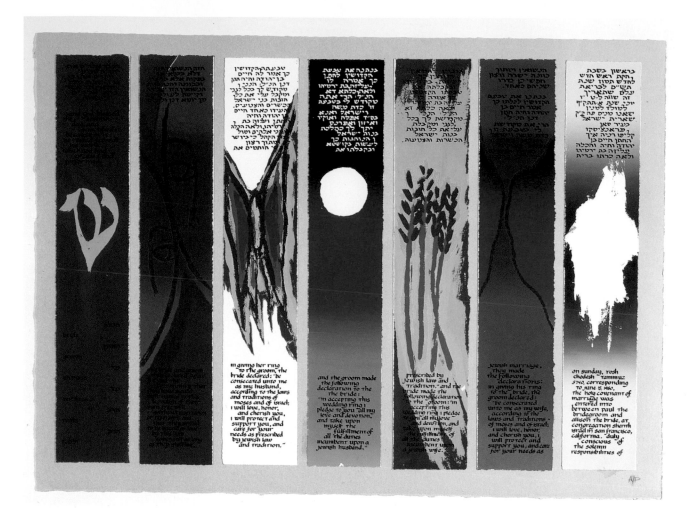

Fig. 53 San Francisco *Ketubbah*, Peretz Wolf-Prusan, 1980 (cat. no. 167)

America. "Are we so indifferent or is there something in modern society that makes our heritage look anachronistic...[and] antique?"[20] Unwilling to take "yes" as an answer, the sisterhood organization staged a wedding pageant in Philadelphia in 1952 that was designed to reacquaint modern-day Jews with the glories of their heritage. We want you to see for yourselves how an authentic Jewish wedding ought to be conducted, explained Mrs. S. Gershon Levi, the pageant's creator, as volunteers from Temple Beth El's Sisterhood and Men's Club filed down the aisle to the sounds of "proper" Jewish music and then stood reverentially under a simple *ḥuppah* as the rabbi went through the motions of a traditional wedding ceremony. "You can have the bridesmaids dressed as you like; that is not our business. You can have any kind of floral decorations; that is your affair. But we would like you to...come back to the old type of wedding. *Ma yafa yerushatenu*—how really beautiful is our original heritage."[21]

Over time, the situation grew even more complicated as modernity and tradition, so often at loggerheads, now actively sought each other out, making a most unusual couple. In the 1960s, at the height of America's love affair with the counterculture, a movement firm in its rejection of established pieties, the Jewish community witnessed a return to some of its traditions, to the days when weddings were held at home, caterers were conspicuous by their absence, dress was simple, and *ketubbot* were made painstakingly by hand (Figs. 52, 53). "Planning a wedding can be an extraordinarily exhilarating experience if you don't let the hassles of parents, relatives and other people's opinions get to you," advised the authors of *The Jewish Catalog: A Do-It-Yourself Kit,* one of the era's most widely-read American Jewish publications.[22] Toward that end, it made a number of suggestions. "A lovely alternative to hiring a caterer is to get some friends together a month or so before the wedding to do a cook-and-freeze thing," recommended the text,

which also sang the praises of klezmer music.[23] Using a prayer shawl as a *ḥuppah* was likewise encouraged. A floral canopy is "elaborate and expensive (and presumably awe-inspiring)" but the loveliest ones we have ever seen are the "plain tallitot [prayer shawls] supported by four poles."[24] Even as it celebrated the virtues of tradition, *The Jewish Catalog* introduced a contemporary note into the proceedings. Mindful of the limited role that women customarily played under the *ḥuppah*, it sought a way to "work some degree of mutuality into the ceremony." Having the wife give her husband a ring was one possibility; a second was to have the couple say *pesukim* (passages from the Bible) to one another and a third was to revise the *ketubbah*. (This is "very tricky and should be approached with great caution," readers were informed.)

Within a generation, the Jewish counterculture had become a part of history and a new practice had taken hold: ritual synthesis, the mixing and matching of religious traditions. Open the wedding section of the *New York Times* on any given Sunday these days and you can read of an interfaith couple who exchanged wedding vows while standing under an old-fashioned, embroidered *ḥuppah*. You may also encounter a Jewish couple who celebrated their union by writing their own service, which combined elements of the traditional Jewish liturgy with several moments of meditation.

Nearly a century ago, a Yiddish etiquette writer threw up his hands in frustration at the prospect of succinctly describing the characteristics of love for his immigrant readers. Why "love is as difficult to describe as God himself," he declared.[25] So too is the American Jewish wedding. It defies easy categorizations and neat equations, especially when it comes to untangling the heart of the matter: the relationship between modernity and tradition. The course of true love may never run smooth, as the old saying has it, but then, neither does Jewish history.

1. Clipping from the *Decatur Daily Review*, n.d., Skirball Museum accession records.

2. Wedding invitation of Etta Einhorn to Harry Reinish, December 12, 1909, Skirball Museum accession records.

3. "Religious," *Yearbook of the Central Conference of American Rabbis*, 1910, p. 59.

4. "Going Under the Chupah," by "An Immigrant," *The American Jewess*, Vol. 7, No. 1, August 1898, p. 13.

5. "Cited in Irving Howe, *World of Our Fathers*, New York, Harcourt, Brace Jovanovitch, 1976, p. 221.

6. "Society's Sphere," *The American Jewish Chronicle*, Vol. 2, No. 24, April 20, 1917, p. 788.

7. Abraham Cahan, "A Ghetto Wedding," in *The Imported Bridegroom and Other Stories of the New York Ghetto*, New York: Houghton, Mifflin and Company, 1898, p. 226.

8. Cited in Howe, op. cit., p. 220.

9. Ruth Jacobs, *The Jewish Wedding: An Explanation of the Ancient Rituals and Modern-day Etiquette with Suggestions for Proper Dress. Procedure. Arrangements*, New York, Calvert Distillers Company, 1955, p. 7.

10. Bezalel Cantor, "Simchas in America," *Jewish Spectator*, Vol. 14, No. 5, March 1949, p. 16.

11. Samuel Chotzinoff, *A Lost Paradise: Early Reminiscences*, New York, Knopf, 1955, p. 154.

12. Herman Wouk, *Marjorie Morningstar*, Garden City, New York, Doubleday, 1955, p. 89.

13. Cited in "Going under the Chupah," p. 13.

14. Kantor, op. cit.," p. 16.

15. Albert Gordon, *Jews in Transition*, Minneapolis, University of Minnesota Press, 1949, p. 135.

16. Jacobs, op. cit., p. 2.

17. Jacobs, op. cit., pp. 8, 10.

18. *The Jewish Times*, September 5, 1930, p. 16. See also Jenna Weissman, Joselit, *The Wonders of America*, New York, Hill & Wang, 1994, pp. 26-28.

19. "Special and Secular Marriages," *American Hebrew*, October 27, 1911, p. 800.

20. "Marriage and the Family: A Wedding Pageant," Tuesday evening, November 11, 1952, *Proceedings of the Biennial Convention of the Women's League for Conservative Judaism*, 1950–52, p. 117ff.

21. "Marriage and the Family," pp. 116–119.

22. *The Jewish Catalog: A Do-It-Yourself Kit*, compiled by Richard Siegel, Michael Strassfeld, and Sharon Strassfeld, Philadelphia, Jewish Publication Society, 1973, p. 159.

23. Ibid. p. 161.

24. Ibid.

25. *Etiquette: A Guide to Proper Behavior, Politeness and Good Manners for Men and Women, Assembled According to the Best Authorities by Tashrak*, New York, Hebrew Publishing Company, 1912 (Yiddish), p. 145.

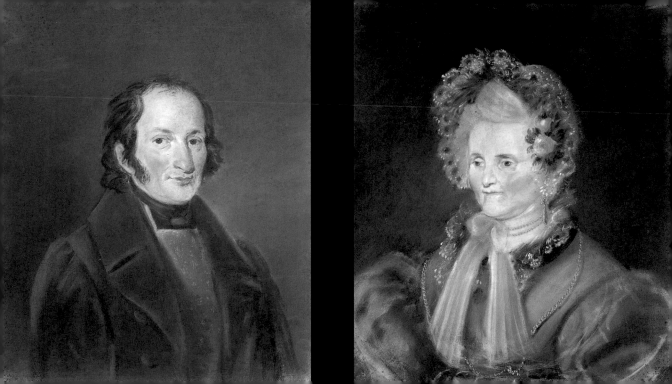

Beloved Companions:

PORTRAIT PAIRS IN THE SKIRBALL COLLECTION

Barbara Gilbert

PAIRED PORTRAITS OF A MARRIED COUPLE, intended to hang as companions side by side, are a tradition with a long history. Full-length portraits of kings and queens—symbolic of exalted status and regal influence—are often suggested as a precedent. It is more likely that the modest portraits of husbands and wives seen in the collection of the Skirball Cultural Center found their prototype in seventeenth-century commissioned portraits of bourgeois men and their wives. Marital portraits of this type, meant as pairs were especially popular with the Dutch middle class in the seventeenth century and were displayed proudly in their homes with such other small-scale paintings as landscapes, still-life paintings, and genre scenes.

Portrait pairs were executed in a variety of media from oil paint on canvas or board to pastels and drawings on paper. Full-length standing figures are unusual; the format more typically ranges from seated three-quarter-length figures to bust-length images. The person of the sitter is always the dominant element in portraits of this type. The background is usually a solid color and rarely provides a context for the sitter. In the late nineteenth century, the growing popularity of photography—a medium less expensive and much faster than painting—made it possible for people of more modest means to document their likenesses. Regardless of the medium of the portrait, people always dressed up in their best finery, acknowledging that they were creating a historical document.

Few Jews had either the means or the motivation to have their portraits painted prior to the late eighteenth century. The rare exceptions from this time were portraits associated with the marriage of a person from a particularly significant family, such as the profile medal cast in Ferrara, Italy, in 1558 of Grazia Nasi, the younger, or the full-length portrait (ca. 1685) of Don Francisco Lopes Suasso, a young man from an aristocratic Sephardic Dutch family. None of these early portraits of Jewish sitters were in pairs; the earliest known portrait pairs of Jewish couples were painted in the early nineteenth century.

Beginning in the late eighteenth century, Jewish burghers, perhaps wanting to emulate non-Jews of their economic class, sat in great numbers for portraits. In the confrontation with the modern world that began in this period of the Prussian Emancipation Edict, Jews in various professions—from rabbis to scholars, from scientists to people in the arts—had their portraits painted. A parallel interest in marital portraits

< **Fig. 54** *Portrait of a Man from Breslau*, Henschel Brothers, circa 1829 (cat. no. 151)

< **Fig. 55** *Portrait of a Woman from Breslau*, Henschel Brothers, circa 1829 (cat. no. 152)

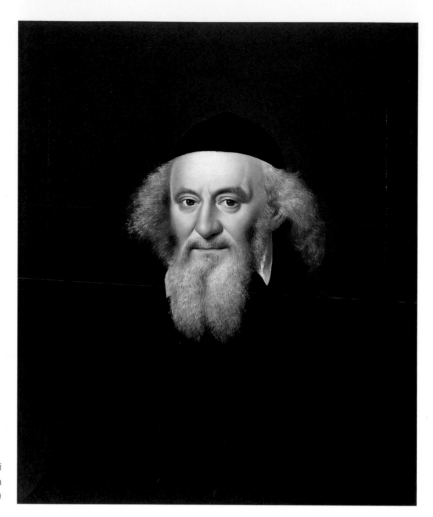

Fig. 56 *Portrait of Rabbi Aaron Chorin*, early 19th century (cat. no. 153)

developed; Jewish couples were usually painted in their later years after they had achieved some wealth. There is little to distinguish most of these portraits from those of non-Jewish subjects. The subjects are usually dressed in the current fashion of the period and placed in a setting devoid of any identifying Jewish content. The sitters for these portraits are identified as Jewish because their names are known or the images have belonged to important collections of Jewish art. Many of the portraits in the Skirball Cultural Center conform to this type: images of well-dressed persons with no indication of his or her religious, cultural, or professional identity. The collection also includes two other types of marital portraits: companion portraits of religious Jewish couples in traditional Orthodox dress and photographs of married couples taken either in the early years of their marriage or at middle-age recording the longevity and strength of their marital union.

The Henschel Brothers, a group of Jewish artists who worked collaboratively in Breslau, Silesia, executed a number of the companion portraits in pastel in the Skirball collection. The four brothers (August, d.1829, Friedrich, d. 1837, Moritz, d. 1862, Wilhelm, d. 1865) had originally worked in Breslau (now Wroclaw, Poland) but moved in 1806 to Berlin, where they continued to work together until August, the oldest brother, died in 1829, after which the three surviving brothers returned to Breslau. They were highly popular artists sought after for portraits in pastel and miniatures. Many of their sitters were newly affluent Jews from the Breslau community. These portraits of Jews are symbolic of the more open environment and the lessening of restrictions Jews experienced in Breslau after the 1812 Prussian Emancipation Edict. Until the mid-seventeenth century, only a few Jews had been allowed the right to settle in Breslau. The capture of Breslau by the Prussians in 1741 and the contribution of Jewish merchants in making Breslau a center of trade worked in favor of the Jewish

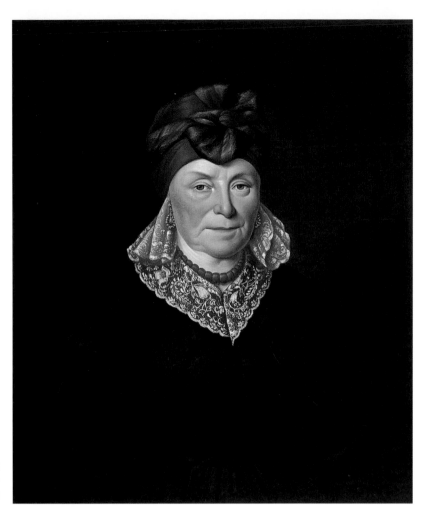

Fig. 57 *Portrait of Mrs. Aaron Chorin*, early 19th century (cat. no. 154)

community. The Jews living in Breslau were permitted to organize a formal Jewish community, and further settlement by Jews was allowed. By the time of Emancipation in the early nineteenth century, the Breslau Jewish community had become a center of Jewish learning in Orthodox terms was well as in terms of movement toward religious reform and assimilation.

A portrait pair by the Henschel Brothers in pastel on paper of an unidentified gentleman and his wife from Breslau (Figs. 54, 55) exemplifies this Emancipationist period. The middle-aged gentleman and his wife are shown waist length, each turned three-quarters to face their partner. They are elegantly dressed, but nothing in their costume indicates Jewish identity. The gentleman wears a brown, double-breasted velvet frockcoat over a blue and gold brocade waistcoat and has a silk cravat wrapped around his neck. His clean-shaven face, bare head, and fashionable sideburns are indications that he does not conform to Orthodox Jewish tradition. His wife does not comply with the traditional requirements of modesty in dress and the full head covering of a married Jewish woman. Her rather flamboyant costume—a jaunty, flower-trimmed hat revealing a broad expanse of her hair, a pastel-colored dress in a sheer fabric, and both a long gold chain and heavy dangling gold earrings —all suggest a woman wanting to be perceived as an affluent member of the larger society rather than as a member of a specific ethnic group or religion. This portrait pair is not dated, but it is likely the paintings were done around 1829 after the surviving Henschel Brothers reestablished their studio in Breslau. Because the portraits of this apparently secular couple came to the Skirball collection from the Berlin businessman Salli Kirschstein, which is known for its Judaica collection, we can assume that the sitters were Jewish despite the lack of any contextual evidence provided by the images.

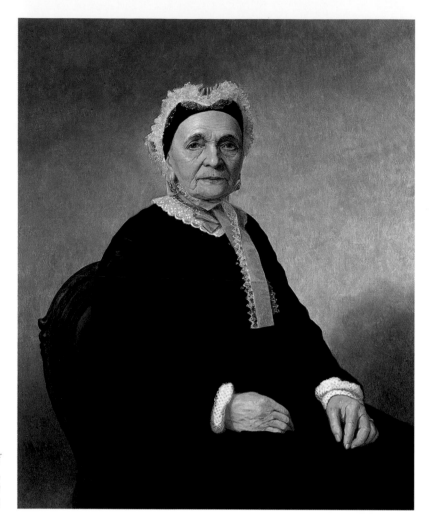

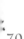

Fig. 58 *Portrait of
Katherine Schiff Illowy,*
Henry Mosler, 1869
(cat. no. 155)

There is a common perception that Orthodox Jews were opposed to having representational likenesses made of them. Yet the Skirball collection contains several portraits of people who can be identified through their dress and setting as observant Jews. Some of the paintings are of well-known rabbis, readily recognizable as their images were often reproduced in engravings to be widely disseminated for the purpose of spreading the teachings and good name of the particular rabbi.[1] Companion portraits of a rabbi and his wife are not as common as the portraits of individual rabbis. It is possible that the portrait of the wife—whose name was often not known and whose face was not identifiable—became separated from its pair and thus eventually lost.

The portrait pair from the first half of the nineteenth century, of Rabbi Aaron Chorin (1766–1844) (Fig. 56) and his wife (Fig. 57), both acquired from the collection of Salli Kirschstein in 1925,[2] was painted in the later years of the couple's life together. Aaron Chorin was a pioneer of Reform Judaism in Arad, Hungary, where he served as rabbi from 1789 until his death in 1844. Although Rabbi Chorin was known as a reformer and even his writings were considered heretical by leading Orthodox rabbis of Arad, he paradoxically is portrayed as a traditional Ashkenazi rabbi. The bearded Chorin is shown in the traditional rabbinic garb of the time: skullcap, plain white collar, and black clerical gown. His wife, whom we cannot identify by name, is wearing a turban that completely conceals her hair in strict adherence to Jewish law and the traditional codes of modesty for Jewish women. Despite her somber black dress, the vivid red and green turban, intricate lace collar, and coral jewelry that she wears acknowledge that beautiful, luxurious items were accepted within traditional Jewish life. It is not known why these portraits were painted or why Rabbi and Mrs. Chorin are portrayed as strictly Orthodox when he, at least, was an outspoken advocate of religious reforms then

Fig. 59 *Portrait of Rabbi Bernard Illowy*, Henry Mosler, 1869 (cat. no. 156)

considered radical such as praying in the vernacular with head uncovered, use of the organ at worship services and permitting riding and writing on the Sabbath. Is it that Chorin's followers wanted to memorialize the rabbi and his wife as adherents of traditional Orthodox Judaism? Or rather, had the portrait pair, like so many other marital portraits, been commissioned by the subjects themselves, possibly in celebration of an anniversary or important life-cycle event in their family?

A second pair of portraits of a religious figure and his wife, Rabbi Bernard Illowy (1812–1871) (Fig. 59) and Katherine Schiff Illowy (1815–1892) (Fig. 58), was painted in 1869 in Cincinnati by the American Jewish artist Henry Mosler (1840–1920).[3] The subjects, seated and in three-quarter view, are dressed according to codes of Orthodox Judaism. Illowy, an ordained rabbi who held a Ph.D. in languages, immigrated to the United States from Bohemia in 1848. When he arrived in the United States, he was the only Orthodox rabbi in the country to hold a doctorate. He served in various communities including New York, Philadelphia, and Baltimore, and he lived in New Orleans during the Civil War, after which the Illowys settled in Cincinnati, where the rabbi continued to be a strict adherent to Orthodoxy and was often at philosophical odds with Rabbi Isaac Mayer Wise and other leading Reform rabbis. Yet, both being scholars trained in Bohemia, Illowy and Wise had much in common and became good friends. Mosler had recently painted portraits of Wise and his first wife, and Wise probably recommended Mosler for the Illowy portrait commission.

Henry Mosler, brought as a young boy to the United States from Silesia by his parents, grew up in the German-speaking community of Cincinnati. Beginning his career as a wood-engraver's assistant, he soon secured work as a war illustrator for *Harper's Weekly*. In 1863 he used his earnings to attend the famous Düsseldorf Art Academy in

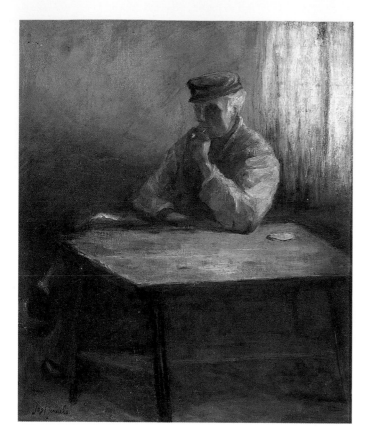

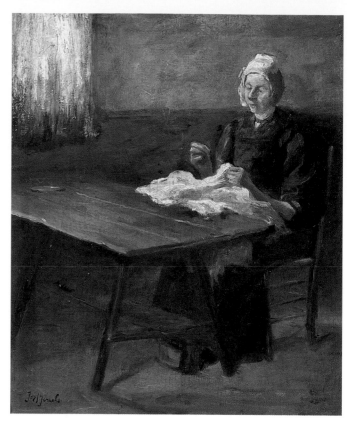

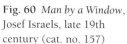

Fig. 60 *Man by a Window,*
Josef Israels, late 19th
century (cat. no. 157)

Fig. 61 *Woman Seated at Table
by a Window,* Josef Israels, late
19th century (cat. no. 158)

Germany for formal training. Students had to show a high degree of skill in realistic
portraiture before they could move on to figure drawing. Upon his return to Cincinnati
in 1865, Mosler was one of the most sought-after artists for portrait commissions. The
images of Rabbi Illowy and his wife—with the carefully observed, almost photographic
details of their faces and aging hands—are the most proficient of Mosler's extant por-
traits. Illowy and his wife sit proudly erect in matching green-upholstered, round-backed
chairs against a modulated gray background. Each is wearing black garb with contrasting
white accessories. The silver tip of the rabbi's cane and the lavender ribbon on Mrs.
Illowy's hat contrast the overall black and gray. The combination of verisimilitude and
subtle painting techniques makes these little-known works significant examples of mid-
nineteenth-century American portraiture.

By the late nineteenth century, photography had become the more common means
for recording married couples. In contrast to Rabbi and Mrs. Illowy, when Harry and
Esther Grossfield wanted to have a lasting image of themselves in the 1890s, they sought
out a photo studio in Warsaw. Their photograph (Fig. 64) was then enhanced with
painting probably done in the same studio. The landscape background and parapet with
a bowl of flowers and greenery to the right was undoubtedly a setting used for many
people who came to this particular photographer. The Grossfields are not shown wearing
wedding attire, which suggests that this portrait was taken some years after their mar-
riage, though while they were still relatively young. Their rigid positions indicate that the
subjects had to stand very still throughout the long exposure time required of early
photographs. Harry Grossfield is seen proudly wearing his military uniform and display-
ing his unsheathed sword. Esther, dressed in black and with her hair in a style of the
period, stands next to him, her body partially hidden behind a mock parapet. The

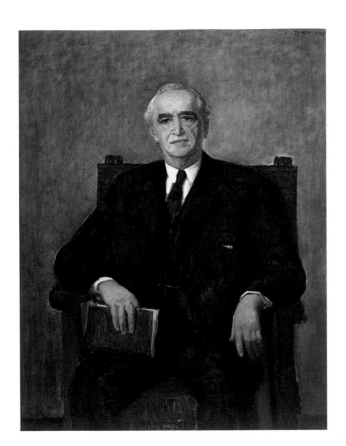

Fig. 62 *Portrait of Moses Rothschild,*
Louis Kronberg, 1935 (cat. no. 159)

Fig. 63 *Portrait of Miriam Moses Rothschild,*
Louis Kronberg, 1936 (cat. no. 160)

portrait provides no indication of their Jewish identity, but does emphasize Mr. Grossfield's pride in serving his country. Mrs. Grossfield, through her stylish clothing, is identified with modern urban life. The Grossfields brought this photograph with them when they immigrated to the United States, and their children, wanting to assure the survival of their parents' story, gave it to the Skirball Cultural Center for its Project Americana collection.

Although photography superseded painting as the most common medium for portraiture, painted portraits are still commissioned. One example is the portrait pair of Moses Rothschild (1863–1937) (Fig. 62) and his wife Miriam (Fig. 63) painted by Louis Kronberg at the height of the Depression.[4] Rothschild, a self-made man who emigrated from Germany in 1882 and eventually became a founder of the Sun Life Insurance Company of America, was also an active member of the Baltimore Jewish community. His wife Miriam Moses, a native of Baltimore, was the daughter of Bernard and Amelia Fried Moses, among Baltimore's oldest and most prominent Jewish families. The Rothschilds were married in 1894, and it is possible that they commissioned Louis Kronberg (1872–1965) to paint their portraits in celebration of their fortieth wedding anniversary in 1934.

Kronberg was highly sought after as a portrait painter, and it may have taken him some time to schedule work on this commission. He painted Mr. Rothschild first in 1935, perhaps because this subject was already in poor health: he died two years later. Although the paintings are the same size and intended as a pair, there are many differences in the compositions and details. The chairs they sit in are different, and Mr. Rothschild is placed in a strictly frontal position, while his wife is turned slightly to her right. He is depicted against a solid background, while a decorative swaged curtain

Fig. 64 *Portrait of Harry and Esther Grossfield,* 1890s (cat. no. 161)

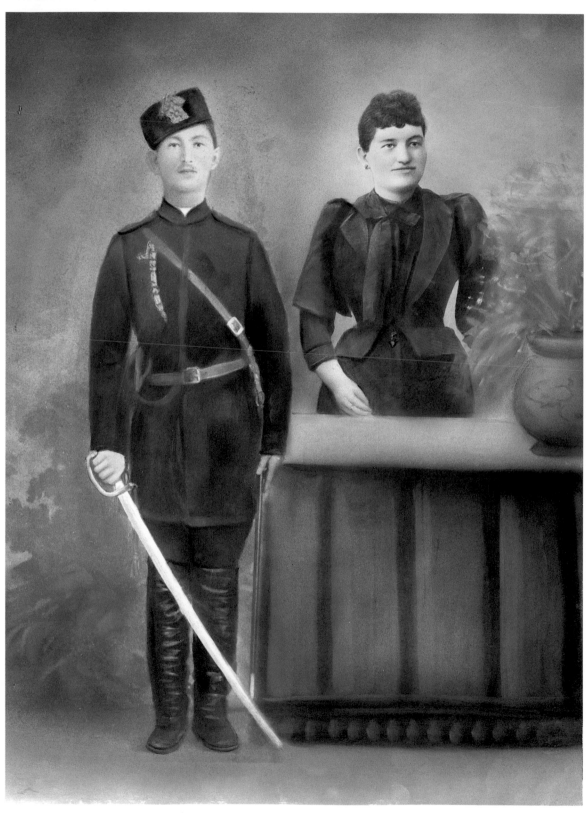

hangs behind her. They are both in somewhat formal dress: he wears a business suit and tie and holds a book; she is shown in a black evening gown with sheer sleeves and a cluster of red flowers on the bodice and a bright blue scarf across her lap. While these portraits provide no overt details that identify this sophisticated couple as being Jewish, the artist asserted his own Jewish identity by inserting a Magen David between his first and last names.

Companion portraits of the type in the Skirball Cultural Center collection can be interpreted on two levels. They exemplify first of all the art style and interests of the time and place of their making. Many are excellent examples of nineteenth-century German portraiture, an area of recent reappraisal by contemporary art historians. Other pairs reflect the range of American portraiture, a genre that has been actively embraced since the colonial period. More than fitting into a particular mode of art, however, these portraits are important historical documents of both well-known Jews and people who no longer can be identified by name. While there is little written information on the experience and success of Jewish marriages, the images of these couples provide some visual proof of their shared lives in marriage.

1. Richard Cohen, "The Rabbi as Icon," *Jewish Icons: Art and Society in Modern Europe,* Berkeley, University of California Press, 1998.

2. Tal Gozani, "The Skirball Collection," *Revealing & Concealing: Portraits & Identity,* Los Angeles, Skirball Cultural Center, 2000, pp. 9-10.

3. Barbara Gilbert, *Henry Mosler Rediscovered: A Nineteenth-Century American-Jewish Artist,* Los Angeles, Skirball Cultural Center, 1995, pp. 33-36.

4. Information on Moses Rothschild provided by Abby Lester, Archivist/Librarian, The Jewish Museum of Maryland, December 1, 2000.

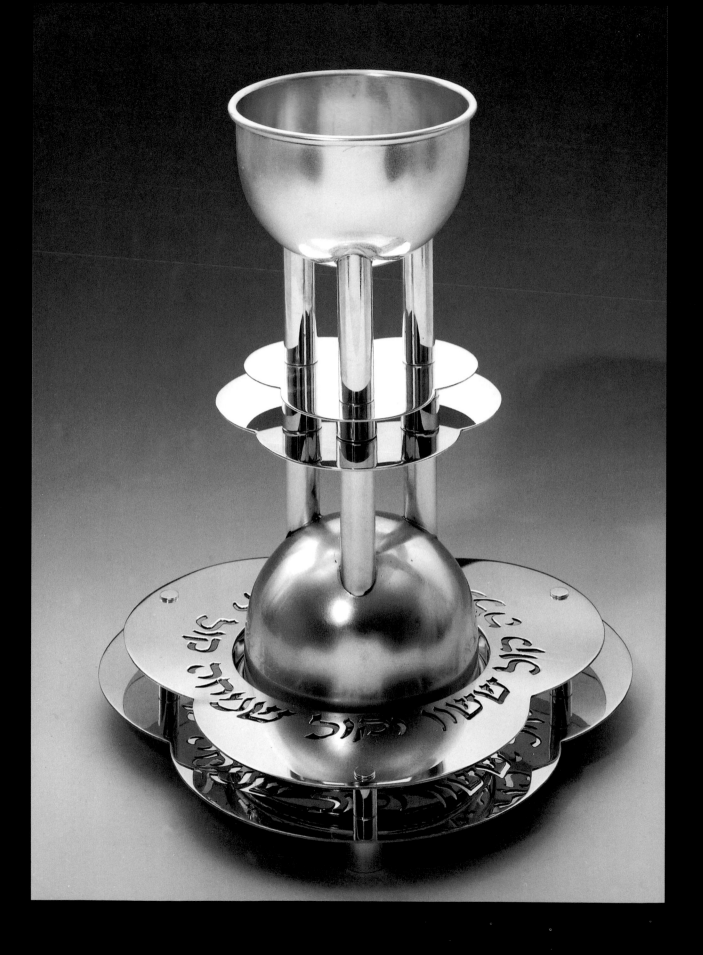

Catalogue of the Exhibition

< **Fig. 65** *Sheva Berakhot* Cup, Rafi Landau, 1998

Ketubbot (Marriage Contracts)

More extensive information on the *ketubbot* is to be found in the volume *Ketubbah, Jewish Marriage Contracts of Hebrew Union College Skirball Museum and Klau Library*, by Shalom Sabar. Because the *ketubbah* is an element in all Jewish weddings, additional examples will be found in other sections of the catalogue.

1. *Ketubbah* (Fig. 4)
Venice, 1649
Ink, tempera, and gold paint on parchment
24¼ x 18½ in. (61.6 x 46.7 cm)
Kirschstein Collection
HUCSM 34.14

This is the oldest *ketubbah* in the Skirball collection: it celebrates the wedding of Menaḥem, son of the late Solomon ha-Levi, and Malkah, daughter of Jacob Sasso, that took place on Wednesday, the first of Sivan 5409 (May 12, 1649). The first witness was Rabbi Simone Luzzatto (1582–1663), who was a very prominent rabbi at the time when Venetian Jewry was at the very height of its prosperity and cultural achievement.

The complex decorative program, blending elements from Jewish tradition with motifs of Italian art, remained popular for a long time. The overall format of the *ketubbah* bears a strong relationship to Venetian architectural prototypes, such as the façade of Santa Maria dei Miracoli, with text and imagery replacing window and doorways.

In the upper corners there are allegorical figures representing the seasons: to the right is *Guadagna*, ("Gain" or "Profit"), a man holding a bag of seeds; to the left *Fama* ("Good Name" or "Reputation"), a female angel blowing a trumphet. Appropriate biblical verses from Ecclesiastes 11:6 and 7:1 accompany the allegories. The use of allegorical figures to signify the seasons is a common motif in Italian art.

The figures are perched astride the main "archway" that is comprised of the signs of the zodiac arranged counterclockwise according to the Hebrew calendar alternating with bands of floral designs and verses from Psalms 128 and Genesis 48:20. The "lunette" contains three intricate interlaced labyrinths containing verses in micrographic script from the Song of Songs 1:1-5:6. The columns that divide the text

into two parts consist of biblical inscriptions set in oval medallions that alternate with angels' heads. Atop the right text column is a scene depicting the Hospitality of Abraham (Genesis 18:6-7) and above the left, the Binding of Isaac (Genesis 22:10-11).

At the center of the *ketubbah*, between the biblical scenes, there are gilt shields with emblems representing the families: the groom's family, Levi, symbolized by a hand pouring water; the bride's family, Sasso, with a rampant lion. The family crests are accompanied by verses from Psalms 60:6 and 18:36. Biblical inscriptions from the prophets Isaiah 60:21 and Jeremiah 17:8 are written on the flowering vine between the blocks of *ketubbah* text, on the right, and the special conditions on the left, beneath which is another gateway with the verse from Psalms 118:20 "This is the gateway to God, the righteous shall enter through it." The *ketubbah* also contains texts from Isaiah 61:9, Genesis 48:16, Proverbs 5:18 and Proverbs 31:10-31, often referred to as "A Woman of Valor."

2. *Ketubbah* (Fig. 13)
Turin, 1731
Paint and ink on parchment
19¾ x 14⅝ in. (50.2 x 37.2 cm)
Kirschstein Collection
HUCSM 34.39

The wedding of Abraham, son of Jehiel Treves and Diana, daughter of Joseph Foà, took place on Friday, the 8th of Second Adar 5491 (March 16, 1731). The decorative program of this *ketubbah*, set within an elaborate architectural framework, represents sources from Jewish tradition and from the surrounding culture. The use of a monumental archway or gateway is a motif familiar from title pages of contemporary books, including Hebrew texts. In this instance, another possible source was an actual triumphal arch, the "Porta Nova," which was designed by Carlo di Castellamonte and erected in Turin in 1620–32.

The figures of Moses and Aaron that flank the text are placed within niches reminiscent of scallop shells, a designation of holiness. The family insignias are set within decorative shields above the niches. The story of the first meeting of Isaac and Rebecca is illustrated above the *ketubbah* text. While biblical figures or scenes used on

ketubbot often refer to the first names of the bride and groom, this story was apparently selected as a reference to marriage, because following their first encounter, Isaac and Rebecca were wed (Genesis 24:67).

3. *Ketubbah* (Fig. 17)
Rome, 1818
Ink and watercolor on parchment
32½ x 20½ in. (82.5 x 52.1 cm)
Kirschstein Collection
HUCSM 34.100

The wedding of Hannah, widowed daughter of Judah Joseph Tagliacozzo, and Isaiah Toscano took place on a Monday, the 14th of Nisan 5578 (April 20, 1818), on the eve of Passover. The Roman-Jewish Toscano family was involved in the banking business, but much of their fortune had been lost by the time of Isaiah's marriage.

The rich and symbolic imagery on many Italian *ketubbot* is inspired by *Iconologia* by Cesare Ripa, the popular illustrated guidebook of allegories first published in Rome in 1603 and subsequently reprinted in many expanded editions. The allegories on the *ketubbot* are frequently labeled in Italian, giving rise to the possibility that some of the contracts were drawn by Christian craftsmen. The imagery in this *ketubbah* does not borrow directly from Ripa, but portrays the allegories in a similar fashion.

The central upper panel in the *ketubbah* features a variation on *Concordia Maritale*, "marital harmony," which is represented by a man and woman, who each hold a heart that has been pierced by an arrow. The allegory *La Costanza*, "steadfastness," shown as a woman leaning on a column, is in the upper right border. The allegory below is unidentified. *La Bontà*, "goodness," depicted on the left side, shows a woman restoring baby birds to their nest. At the bottom left is *Amor*, "love," depicted not with the traditional man and a woman, but personified by two women embracing. The source for this interpretation is not known.

4. *Ketubbah* (Fig. 66)
Pisa, 1790
Ink and watercolor on parchment
34⅞ x 22½ in. (88.6 x 57.2 cm)
Kirschstein Collection
HUCSM 34.111

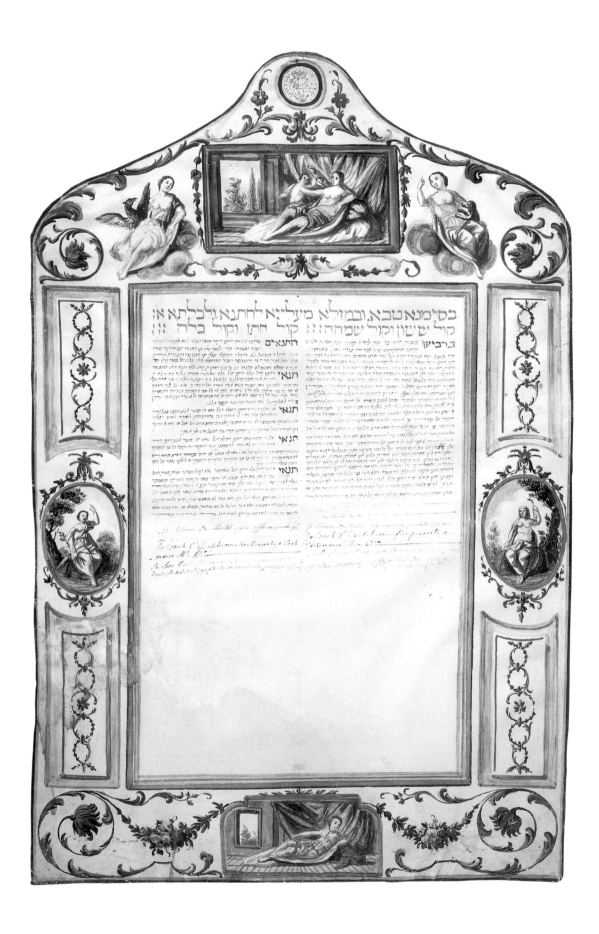

Fig. 66 Pisa *Ketubbah*, 1790 (cat. no. 4)

The wedding of Mazzal-Tov, daughter of Paltiel Zemach, and Solomon, son of the late Moses Raphael De Montel, took place on Wednesday, the 4th of Tammuz 5550 (June 16, 1790). The illumination on this *ketubbah* is particularly significant because its imagery is specific to Venice and northern Italy and to the period. The reclining Venus, accompanied by a dog, is familiar from Titian's *Venus of Urbino,* which was painted in 1538 to commemorate the wedding anniversary of Francesco Maria della Rovere and Elenora Gonzaga. On the *ketubbah,* an allegorical figure of a woman with a dog appears to the right of the Venus image at the top. The dog is used as a symbol of faithfulness and loyalty. From this association, the Venus depicted here is interpreted as Venus Urania, the goddess of noble love which culminates in marriage. According to a note at the bottom of the marriage contract, the *ketubbah* was registered in Pisa on June 16, 1790. An official seal appears within a decorated roundel at the top.

5. *Ketubbah* (Fig. 2, detail; Fig. 67)
Fiorenzuola, 1832
Ink and watercolor on cut-out parchment
31⅞ x 18¾ in. (81.0 x 47.6 cm)
Museum Purchase from Isaiah Sonne
Conserved with funds from Judy Orlansky
HUCSM 34.110

The wedding of Mazzal-Tov, daughter of Abraham Jehiel Soavi, and Zemaḥ, son of the late Zechariah Mazzal-Tov Ottolenghi, took place on Friday, the 11th of Shevat 5592 (January 13, 1832). This extraordinary cut-out parchment *ketubbah* takes the form of a baroque palace façade. The figure mounted on horseback at the top has been identified as Napoleon Bonaparte. When his army entered northern Italy in 1796–97, Napoleon liberated the Jewish community from the ghettos. Some thirty years later, Napoleon was still treated with some reverence by the Jewish community. The *ketubbah* also features the biblical scene of King David spying on the bathing Bath-Sheva. The pool in which she bathes is replenished by a water spouting from a fountain of a mythological grotesque. Below this scene is a winged youth holding a net with two birds; possibly this figure is Cupid, freeing the symbolic doves of love.

6. *Ketubbah* (Fig. 68)
Livorno, 1782
Ink and watercolor on parchment
28½ x 19⅝ in. (72.4 x 49.8 cm)
Lipshutz Collection
HUCSM 34.57

The wedding of Benvenuta, daughter of the late Abraham (and Sarah) Gallichi, and Joseph, son of Samuel Leon, took place on Wednesday the 7th of Kislev (November 13, 1782). The witnesses were Elijah Ḥayyim Valenzin and Jacob Nunes-Vais. Jacob Nunes-Vais, a noted rabbinic scholar, who was a descendent of a *converso* family that settled in Livorno after Jews were expelled from Spain in 1492, was nominated to be chief rabbi of the Livorno Jewish community during the French occupation.

The text of the *ketubbah* is framed within a monumental arcade, which is softened by the pinkish tone of the marble and the lush flowering greenery. The official seal of the city of Livorno has been incorporated into the design as a decorative element above the family crest of the Leon family, the rampant lion, flanked by two putti. The artist has inscribed his initials, N.D.M., at the base of the central column and annotated in Latin, "made in Livorno, 1782." The inclusion of an Italian inscription *Serbin Felicità si dolce patti* (May these sweet terms serve happiness) is also unusual. It is likely that the artist was not Jewish, a hypothesis supported by the typically Italian proverb but the lack of any other characteristic motifs or biblical quotations typical of *ketubbot* of the period.

7. *Ketubbah*
Corfu, Greece, 1781
Ink, watercolor, and gold paint on parchment
31¾ x 20⅞ in. (80.6 x 52.4 cm)
Kirschstein Collection
HUCSM 34.102

This *ketubbah* documents the marriage of Joseph Hai Sinigaglia, son of Moses Judah from Ancona, and Diamante, daughter of Jacob Jacur, which took place on Wednesday the 14th of Tishre 5542 (October 3, 1781), on the eve of *Sukkot* (Feast of Tabernacles). A note in Italian indicates that the wedding was inscribed in the book of *ketubbot* for the Corfu congregation, the Greek synagogue in Corfu.

Richly illuminated *ketubbot* were produced in Greece from at least the mid-

sixteenth century on; during the eighteenth century, the island of Corfu was the most important center of *ketubbah* decoration. Corfu, with its relatively affluent Jewish merchant community, had been part of the Republic of Venice since 1386 and the Jewish community there had close ties with Venetian Jewry. Therefore, many Corfu *ketubbot* are similar to those from Venice, and often *ketubbot* made in Venice were imported to Corfu. The decorative program here represents the influence of *ketubbot* from Ancona, also an important Italian port and mercantile center. This style was likely selected because the groom's family was from Ancona.

The *ketubbah* parchment is cut in the shape of a round trefoil arch. The text is set within a frame encircled with vibrantly colored scrolling and flowering vines. The prominent motif of the *ketubbah* is a lively rendering of the biblical scene of the meeting of Joseph and Benjamin as described in Genesis 45:14. Joseph, a prominent figure in the Egyptian court, is depicted here in the garb of an Ottoman ruler, with an elaborate feathered turban. The scene was no doubt chosen in tribute to the groom, whose name was Joseph.

8. *Ketubbah* (Fig. 69)
Bucharest, Rumania, 1831
Ink and watercolor on paper
25¾ x 20 in. (65.4 x 50.8 cm)
Kirschstein Collection
HUCSM 34.73

The wedding of Solomon, called Bekhor, son of Sasson, son of Solomon and Miriam, called Mercadat (?), daughter of Eliezer, son of (?) Benjamin, took place on Thursday the 5th of Tammuz 5591 (June 16, 1831). The upper half of the *ketubbah* is filled with a carpetlike pattern with a profusion of trees and flowering vines. At the center is an imitation of an Ottoman era *tughra* (royal seal).

9. *Ketubbah* (Fig. 5)
Herat, Afghanistan, 1895
Watercolor, ink and gold paint on paper
17½ x 13¹⁵/₁₆ in. (44.5 x 35.4 cm)
Nancy E. and Herbert A. Bernhard Purchase
 Fund
HUCSM 34.204

The wedding of Samuel, son of Isaac, and Michal, daughter of Jacob, took place on

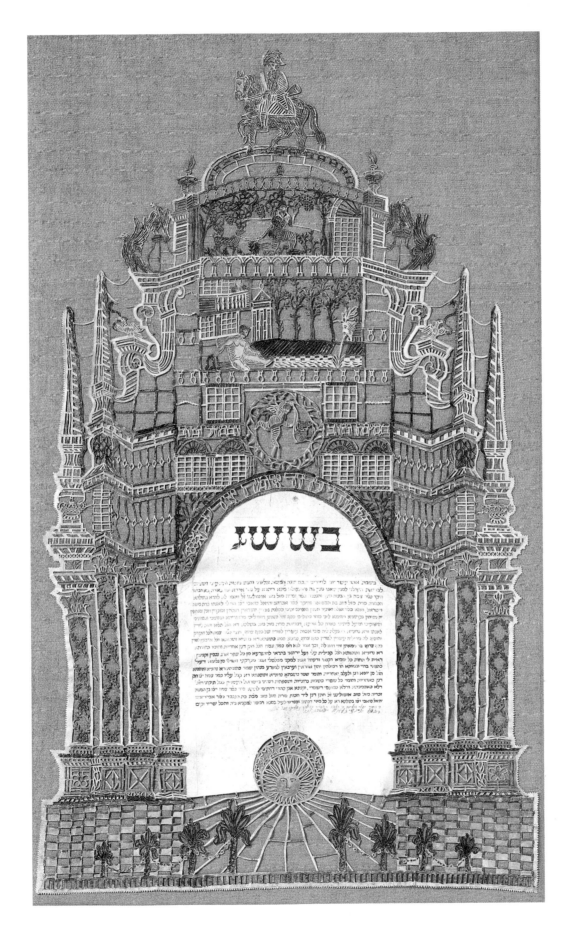

Fig. 67 Fiorenzuola *Ketubbah*, 1832 (cat. no. 5)

Friday the 26th of Av 5655 (August 16, 1895). The format of this *ketubbah* follows the standard configuration from Herat in the second half of the nineteenth century. A floral frame encloses the text, which is surmounted by an arcade with pointed or trefoil arches. Within the arcade, arches with text alternate with arches containing vases with flowers. Cartouches at the bottom of the contract provide space for the witnesses to sign.

10. *Ketubbah* (Fig. 16)
Scribe: Solomon Ben Baruch (?)
Pará de Brazil, 1911
Ink on lithograph
24⅜ x 18⅝ in. (61.9 x 47.5 cm)
Henry Kaner Memorial Purchase Fund
HUCSM 34.195

The wedding of Makhluf, son of Abraham, son of the late Makhluf, called Elkharrat (Eljarrat), and Rachel, daughter of Isaac, son of the late Moses, son of the late Mordechai, called Ben Shimeon, took place on Wednesday the 17th of Shevat 5671 (February 15, 1911). The groom signed the *ketubbah* in Latin letters. The text follows the formula of Sephardi marriage contracts from Gibraltar and Morocco and makes reference to the Castilian exiled community. The hands represent the Priestly Blessing and are inscribed with that text from Numbers 6:24-26. The flask of wine and cup refer to the wedding ceremony and the *sheva berakhot* (Seven Benedictions). The scribe added three amuletic abbreviations within the arch above the text.

11. *Ketubbah* (Fig. 70)
Artist: H. Burgh
London, 1861
Ink on engraved parchment
16 x 12½ in. (40.6 x 31.7 cm)
Gift of Rabbi Jacob Nieto
HUCSM 34.19

The wedding of Abraham Hayyim, son of Jacob Nieto, and Hannah, daughter of David Belasco, took place on Wednesday, the 24th of Adar 5621 (March 6, 1861). Details about the couple and the wedding are found in the record book of the Bevis Marks Synagogue in London, where the wedding is listed as number 347 in the period 1837–1901. The groom, a *shoḥet* (ritual slaughterer), was twenty-two years

old; the bride was nineteen. He resided at 10 Bevis Marks and she at 39 Duke Street, Aldgate. Nieto's father was deceased, according to the record, although curiously that fact is not mentioned in the *ketubbah*. Hannah's father is described as being a "general dealer." The wedding took place at Zetland Hall on Mansel Street. The registrar was S. Almosnino.

The *ketubbah* is written on an engraved parchment form that was first popularized in Amsterdam in the seventeenth century. London artist H. Burgh copied the print in the second half of the eighteenth century. The central section contains an arched portal supported by entwined columns. Inside the arch, a pair of cherubs hold a drapery inscribed *be-siman tov* (with a good omen). The images in the top corners represent the bridal couple and the allegory of the virtue "Charity" (*Carita* or *Caritas*), represented by a female figure with two children. The text is bordered by a pair of urns holding luxuriantly flowering vines on which birds and butterflies perch. Pots with tulips flank the base of the urns. In the bottom center, beneath the *ketubbah* text is a large cartouche reserved for special conditions. On this *ketubbah*, where no such conditions are stipulated, the scribe has written in the dates of the wedding according to the Jewish and general calendars. There is also a printed inscription with blanks, which were not filled, from the synagogue registry. The details are known only from the official record book.

12. *Ketubbah* (Fig. 71)
Scribe: Abraham Hayyim Nieto
San Francisco, 1894
Ink on parchment
14⅜ x 10⅜ in. (36.6 x 26.4 cm)
Rabbi William M. Kramer Collection
HUCSM 34.381

The wedding of Rabbi Jacob Nieto (1863–1930) and Rose Frankel took place on Tuesday, the 17th of Elul (September 18, 1894). One of the witnesses was Michael Goldwater, grandfather of United States Senator Barry Goldwater of Arizona (who was the Republican presidential candidate in 1964). The groom's father, Abraham Hayyim Nieto, officiated at the wedding. The elder Nieto came to the United States from London and served as a cantor in New

York. It is thought that he was also the scribe who wrote this *ketubbah*, which includes text bordered by biblical quotations. Crownlets ornament some of the letters as is done on Torah scrolls; below the text, the place and date of the wedding and names of the bride, groom, and witnesses are written in English. A draft of the *ketubbah,* which was a gift of Jacob Nieto (HUCSM 34.116), is also preserved in the Skirball collection.

13. *Ketubbah* (Fig. 72)
New York City, 1819
Watercolor, pencil, and ink on parchment
13⅞ x 14⅛ in. (35.2 x 35.9 cm)
Gift of Mr. and Mrs. William M. Daniel in honor of the 75th Birthday of Mr. Bernard Gordon
HUCSM 34.304

The wedding of Meir, called Meyerstone, son of Abraham and Rebekah, daughter of Abraham De Meza took place on Sunday the 19th of Heshvan 5580 (November 7, 1819). This *ketubbah*, one of the earliest wedding contracts known to have been illuminated in the United States, is an example of ninteenth-century folk art. The location of the wedding is described as "New York, which is situated on an island surrounded by seas in North America." The amount of the dowry is listed in "New York coinage." The witnesses are well-known figures in American Jewish history, including Ephraim Hart (1747–1825), a wealthy stockbroker who had immigrated from Bavaria just before the American Revolution. Although he was apparently Ashkenazi, Hart served as president of Congregation Shearith Israel, the Spanish-Portuguese synagogue in New York that is the oldest continuously existing synagogue in North America. The second witness was Moses Levi Maduro Peixotto (1767–1828), who was a merchant by trade, but also served as the hazan of Congregation Shearith Israel from 1818 to 1828.

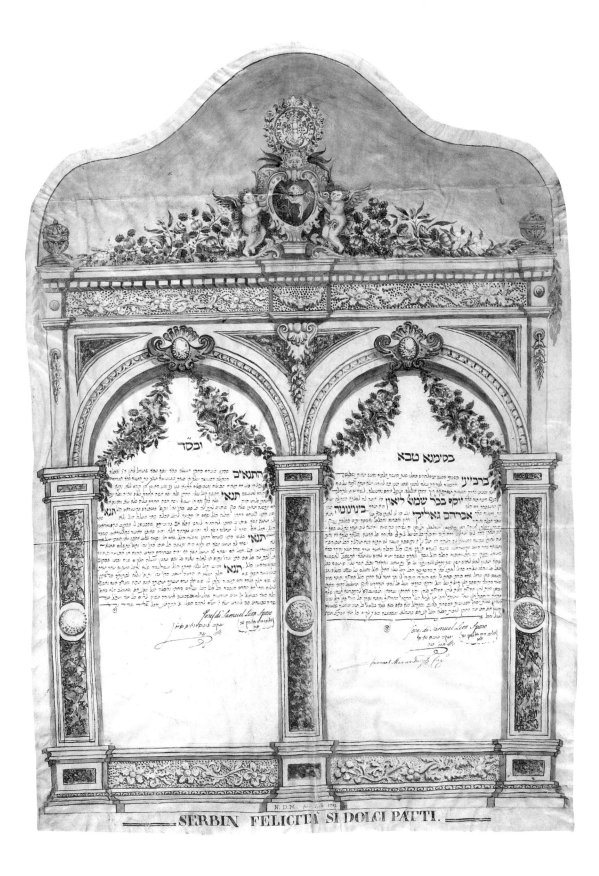

Fig. 68 Livorno *Ketubbah*, 1782 (cat. no. 6)

84

Fig. 69 Bucharest *Ketubbah*, 1831 (cat. no. 8)

Fig. 70 London *Ketubbah*, 1861 (cat. no. 11)

Fig. 71 San Francisco *Ketubbah*, 1894 (cat. no.12)

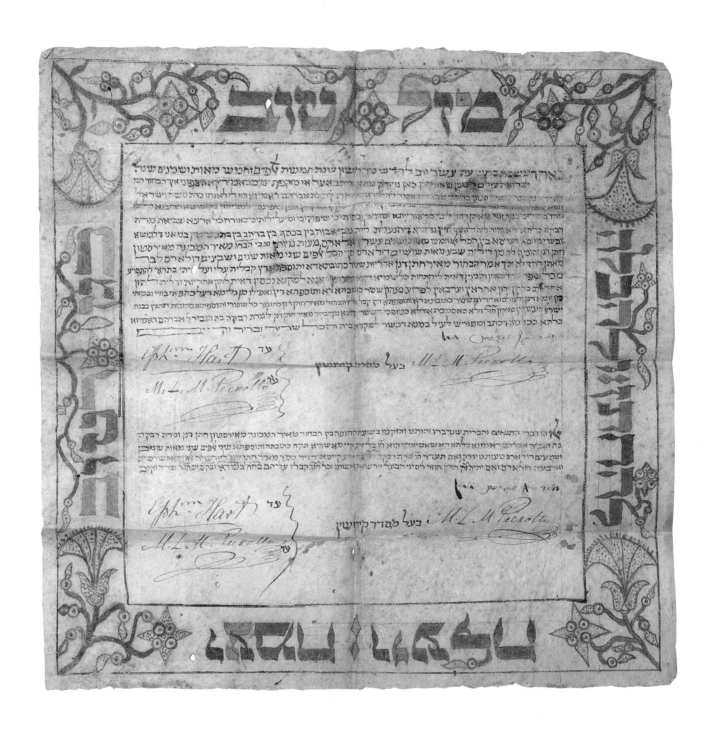

86

Fig. 72 New York *Ketubbah*, 1819 (cat. no. 13)

Wimpeln (Torah Binders)

14. *Das Schultragen* (Fig. 19)
Moritz Oppenheim
Germany, 1882
Photoengraving
15⅝ x 11¼ in. (39.7 x 28.5 cm)
HUCSM 66a.392n

The illustration of the baby presenting his *Wimpel* to the synagogue is from Moritz Oppenheim's series *Bilder Aus Dem Altjüdischen Familienleben* (Scenes from Traditional Jewish Life). The artist's name is found on a partly unrolled *Wimpel* that rests on the edge of the *bimah*, an elevated platform in the synagogue.

15. Ḥuppah (Fig. 74)
Germany, 19th century
Linen, embroidered with silk thread
Kirschstein Collection
HUCSM 56.512

Eighteen *Wimpeln* that date from 1750 to 1890 were stitched together to make this unique *ḥuppah*. Because it includes a *Wimpel* made late in the nineteenth century, it is possible that Salli Kirschstein, who had formed a collection of over five hundred *Wimpeln* and was in the textile business, had this *ḥuppah* fabricated.

16. *Wimpel* (Fig. 20)
Germany, 1719
Linen, embroidered with silk thread
8 x 133 in. (20.3 x 337.8 cm)
Kirschstein Collection
HUCSM 56.474

Wimpel of Benjamin Wolf, son of Solomon, born 24 Elul 5479 (September 8, 1719). Benjamin's zodiac sign of Virgo is depicted along with birds and other animals. The elaborately embroidered *Wimpel* was likely made by a professional textile artist for the child of a Court Jew, an individual who served one of the imperial courts of Central Europe. Court Jews, whose positions were generally related to finance, commerce, and diplomacy, often used their privileged status to act on behalf of the Jewish community.

 The *ḥuppah* is held by four attendants in livery. The bride and groom are both elegantly dressed. The bride wears a *fontage*—a crownlike headdress. The bearded rabbi, who holds an oversize goblet, is traditionally clad in a long black robe with a deep white collar and the distinctive *barretta*, a flat black felt round hat.

17. *Wimpel* (Fig. 23)
Germany, 1726
Linen, embroidered with silk thread
7½ x 149 in. (19.0 x 378.5 cm)
Kirschstein Collection
HUCSM 56.58

This *Wimpel* was made for Abraham, son of Mordecai, born 19 Ḥeshvan 5487 (November 13, 1726).

18. *Wimpel* (Fig. 73)
Halberstadt, Germany, 1733
Linen, embroidered with silk thread
123½ x 7½ in. (313.7 x 19.0 cm)
Kirschstein Collection
HUCSM 56.5

This *Wimpel* was made for Zvi Hirsch, son of Elhanan Speyer, who was born on the Sabbath, 28 Tammuz 5493 (July 11, 1733). *Hirsch* means deer in Yiddish and a deer is featured prominently on the *Wimpel*, along with zodiac symbols for Cancer, which corresponded to Zvi's birthday. That members of the Speyer family were wealthy Court Jews is indicated by the elaborate design of Zvi's *Wimpel*, which was likely professionally made, and by the inclusion thereon of two men in livery holding the *ḥuppah*.

19. *Wimpel* (Fig. 75)
Germany, 1758
Linen, embroidered with silk and metallic thread
7¾ x 143 in. (17.8 x 363.5 cm)
Kirschstein Collection
HUCSM 56.4

This *Wimpel*, created for Zalman, son of Isaac, born 2 Adar 5518 (February 10, 1758), includes an elaborate hunting scene, a traditional element in folk art of that time period.

20. *Wimpel*
Germany, 1768
Linen, painted
9 x 129 in. (22.9 x 327.7 cm)
Kirschstein Collection
HUCSM 56.42

The *Wimpel* of Isaac, called Koppel, son of Naphtali, born 13 Adar 5528 (March 2, 1768), includes imagery of the child's zodiac sign, Pisces. Not only are fish depicted, but a man holding a fishing net

is shown. This Torah binder was one of the few in the collection that was identified with a note handwritten by Kirschstein giving his collection number and the name of the child, date of birth, and the blessing.

21. Wimpel (Fig. 29)
Germany, 1777
Linen, painted
7 x 119 in. (17.8 x 302.3 cm)
Kirschstein Collection
HUCSM 56.344

The *Wimpel* of Yekutiel, son of Kaufmann, born 17 Kislev 5538 (December 17, 1777), shows an elaborate landscape and town scene above the *ḥuppah*. The imagery also includes figures of two *kohanim* (priests), signifying the religious lineage from which Yekutiel descends, and the zodiac sign of Sagittarius represented by a mermaid with a bow and arrow reminiscent of Cupid.

22. Wimpel (Fig. 27)
Germany, 1778
Linen, embroidered with silk thread
7 x 118½ in. (17.8 x 301.0 cm)
Kirschstein Collection
HUCSM 56.29

This *Wimpel* was made for Menahem, son of Abraham Katz, born on the first of Adar 5538 (February 28, 1778).

23. Wimpel (Fig. 31)
Germany, 1793
Linen, embroidered with silk thread
8 x 153 in. (20.3 x 388.6 cm)
Kirschstein Collection
HUCSM 56.258

This *Wimpel* was made for Lemle (Asher), son of Rabbi Moses, who was born 9 Sivan 5553 (May 20, 1793).

24. Wimpel (Fig. 32)
Germany, 1830
Painted linen
6½ x 121 in. (16.5 x 307.3 cm)
Kirschstein Collection
HUCSM 56.10

This *Wimpel* was made for David, son of Abraham, who was born 21 Elul 5590 (September 9, 1830). David's family was from Marfelden.

25. Wimpel (Fig. 24)
Germany, 1834
Linen, painted; and silk binding
7⅜ x 133 in. (18.7 x 337.8 cm)
Kirschstein Collection
HUCSM 56.341

The *Wimpel* made for Gershon, son of Abraham Seltz, the kohen, born on 27 Av 5594 (September 1, 1834), depicts the blessing "May he grow to the Torah" with a man wearing a *tallit* (prayer shawl) holding up an open Torah scroll, as is done in the synagogue after the scroll is read. He stands, with his back towards the congregation, on a hexagonal *bimah* (platform) with two lit candlesticks. Graceful scrolled textiles form the *ḥuppah,* which is surmounted by the Hebrew letters for the word *mazal tov.* The bride is dressed in a white gown with blue sash that is very much of the period. The groom and rabbi have retained more traditional clothing with a sleeveless cape and flat round hat. The *Wimpel* also includes a stork carrying a baby in bunting, a familiar image borrowed from European folklore.

26. Wimpel (Fig. 30)
Germany, 1837
Linen, painted; and green silk edging
7½ x 131 in. (19.1 x 332.7 cm)
HUCSM 56.323

This *Wimpel* was made for Herschel, son of Jacob Hirtz who was born 4 Tishre 5598 (October 3, 1837). He was also given the secular name Heinrich Gustav, which is written on the *Wimpel.* The fact that the family was from Weilburg is also recorded, which is information only rarely given on the *Wimpeln.*

27. Wimpel (Fig. 25)
Germany, 1854
Linen, painted
8¼ x 137 in. (20.9 x 350 cm)
Gift of Rabbi Samuel Schwartz
HUCSM 56.20

This *Wimpel* was made for Solomon Herrmann, son of Moses, who was born 13 Tammuz 5614 (July 9, 1854). He was called Zalman.

28. Wimpel (Fig. 76)
Germany, 1914
Linen, silk embroidery thread
4¼ x 126 ¹³/₁₆ in. (18.4 x 322.2 cm)
Museum Purchase with funds provided by
 Ruth and Allen Orbuch in honor of their
 grandson, Ryan Stern Orbuch
HUCSM 56.623

Benjamin (nicknamed Benna), son of Judah Halevi Freimann, was born 4 Av 5674 (July 7, 1914). The German and Zionist flags shown on this *Wimpel* represent the dual loyalty characteristic of many German Jews at this period. The often-used wedding verse "the sound of mirth and gladness, the voice of bridegroom and bride" from Jeremiah 7:34 is presented here, with *mazal tov* in Hebrew inside a six-pointed star.

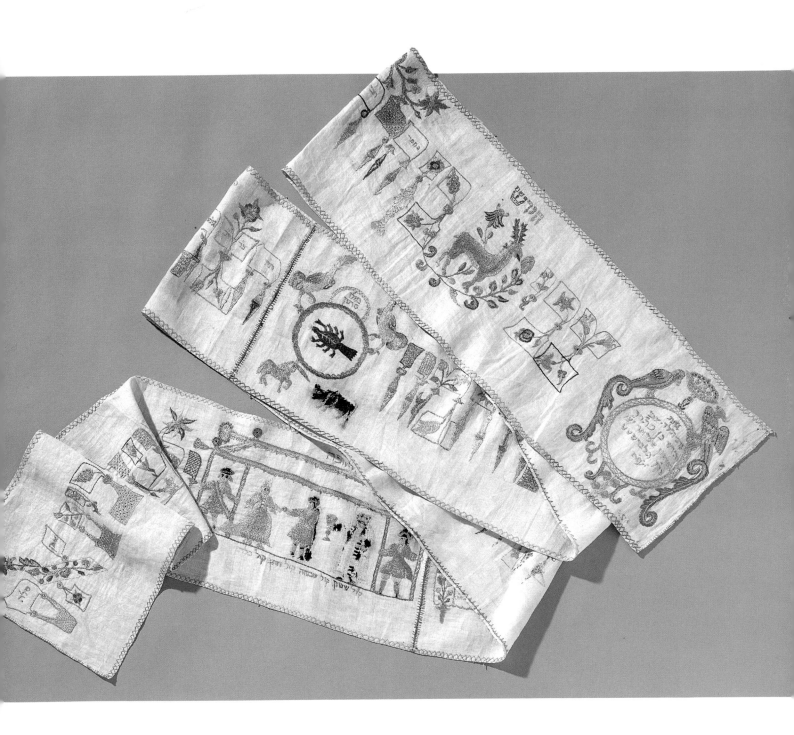

Fig. 73 *Wimpel*, 1733 (cat. no. 18)

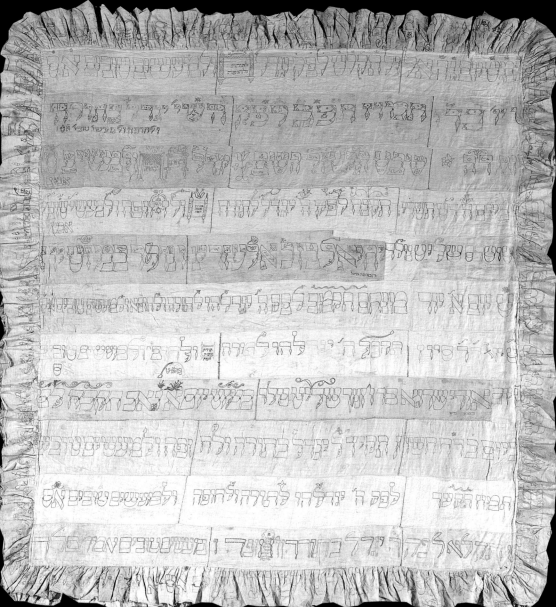

91

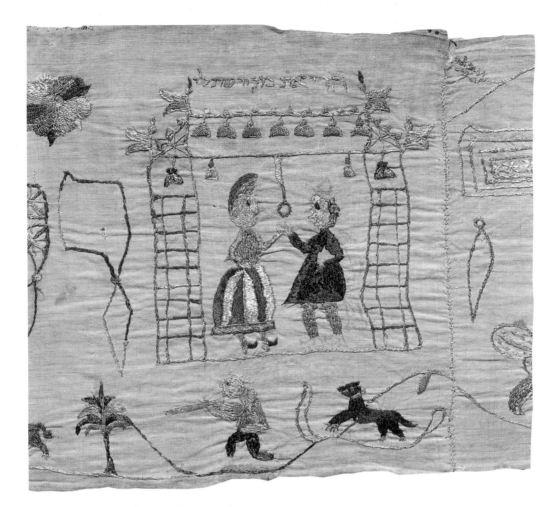

Fig. 75 *Wimpel* (detail), 1758 (cat. no. 19)

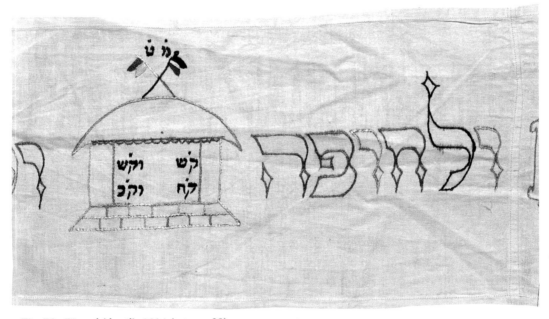

Fig. 76 *Wimpel* (detail), 1914 (cat. no. 28)

< Fig. 74 Ḥuppah, composed of eighteen *Wimpeln*, 19th century (cat. no. 15)

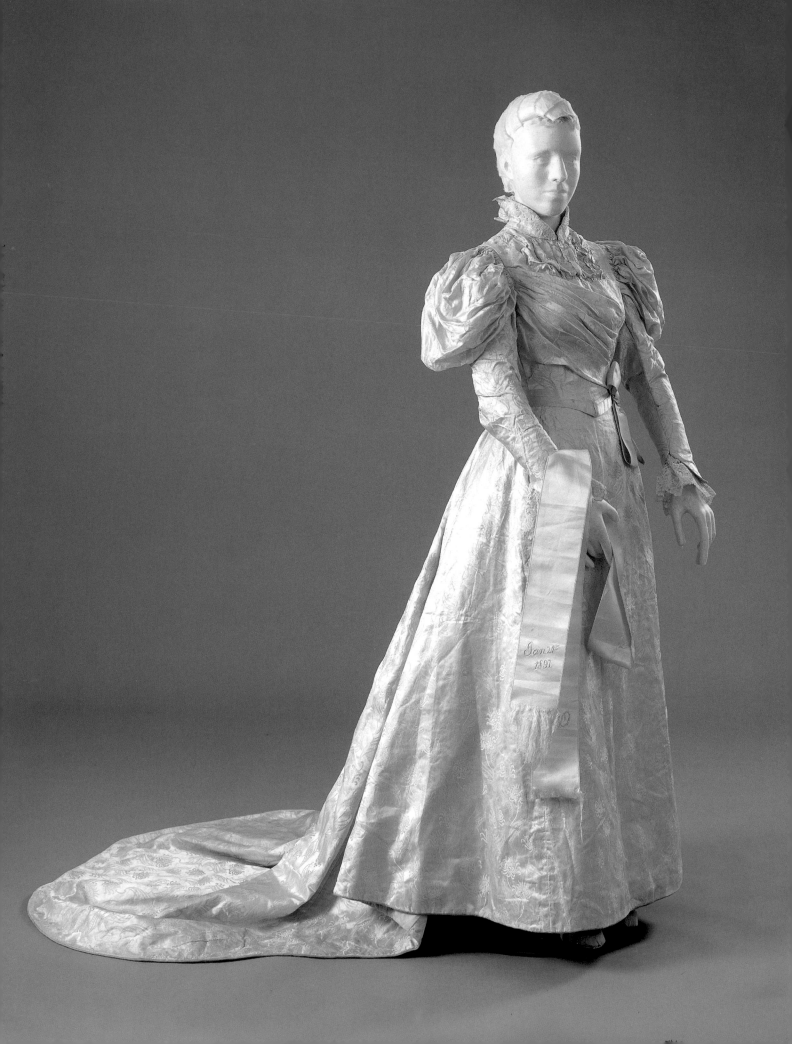

Annie Oshinsky

Annie Oshinsky was born in New York City on July 4, 1876 to parents of Polish descent, Rudolph and Esther Oshinsky. The family later settled in Marinette, Wisconsin. William Berkson was born on May 19, 1868, in Russia. Arriving in America, William first earned his living as a peddler, described more genteelly in a newspaper account of the wedding as a "commercial traveler."

Annie Oshinsky was married to William Berkson on January 24, 1897, in Decatur, Illinois, at her parents' home. The ceremony, conducted by Rabbi Nessig, of Indianapolis, took place under a *huppah* of white silk, trimmed with lace and flowers. The *ketubbah* includes an engraving of an American Jewish wedding of the period.

Annie's silk floral-patterned damask gown with its separate ruched bodice and skirt with long flowing train was made for her in a fashionable 1890s style. Although she hailed from a small town, Annie kept abreast of Paris fashion as interpreted in popular weekly periodicals, which included detailed pictorial plates and copious commentary. Her dress has a Renaissance flair, a reflection of the interest in costume history at the time. The asymmetrical draped bodice emphasizes her tightly corseted small waist, and the high, covered neckline indicates modesty appropriate to a young bride. Her closely fitted sleeves with "melon" puffs at the shoulders and satin waistband with soft bow at the side were very stylish at the time. Interestingly enough, Annie seems not to have worn a veil, or at least did not pose with a veil for her wedding portrait. She is pictured holding a commemorative ribbon with her initials and the date of the wedding, which may have been a local custom.

Annie and William settled in Chicago, started a family, and eventually moved to Clinton, Illinois, where they opened a general store and clothing shop known as the Famous Cash Store. After William died in 1921, Annie ran the store with her daughter Saretta and son-in-law, Sam Cohen (cat. no. 33-34). Active in the community, she founded a group for business and professional women. In the 1940s, the business was sold, and the family moved to California.

29. Annie Oshinsky Wedding Dress (Fig. 77)
Decatur, Illinois, 1897
Dress: ivory silk damask with ivory lace
Sash: ivory silk satin
Gift of Willyne Bower and Saretta Berkson Cohen
HUCSM 9.66a-c

30. *Ketubbah* (Fig. 78)
Decatur, Illinois, 1897
Ink on printed paper
20 x 13 in. (50.8 x 33.0 cm)
Gift of Willyne Bower and Saretta Berkson Cohen
HUCSM 34.365

31. Marriage Document (Civil License) (Fig. 79)
Decatur, Illinois, 1897
Ink on printed paper
8½ x 5¾ in. (21.6 x 14.6 cm)
Gift of Willyne Bower and Saretta Berkson Cohen
HUCSM 34.366

32. Remembrance Card (Fig. 80)
Chicago, 1897
Printed paper
2¾ x 3½ in. (7.0 x 8.9 cm)
Gift of Willyne Bower and Saretta Berkson Cohen
HUCSM 13.108a

33. Saretta Berkson's Bride Book
Chicago, 1914
Book bound with vellum
8¾ x 6½ x ¾ in. (22.2 x 19.1 x .9 cm)
Gift of Willyne Bower and Saretta Berkson Cohen
HUCSM 9.71

34. Wedding Announcement
Chicago, 1920
Printed paper
3½ x 5½ in. (8.9 x 14.0 cm)
Gift of Willyne Bower and Saretta Berkson Cohen
HUCSM 13.115a,b

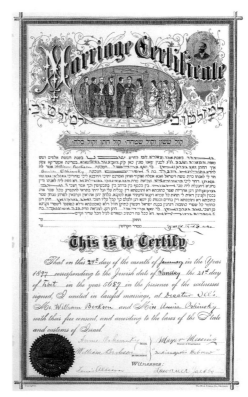

Fig. 78 Decatur, Illinois *Ketubbah*, 1897

Fig. 79 Civil Marriage Document, 1897

Mr. & Mrs. William Berkson
return their thanks
for your kind remembrance of
January 24th, 1897.
473 South Paulina St., Chicago.
February 24th, 1897.

Fig. 80 Remembrance Card, 1897

< **Fig. 77** Bridal Costume of Annie Oshinsky

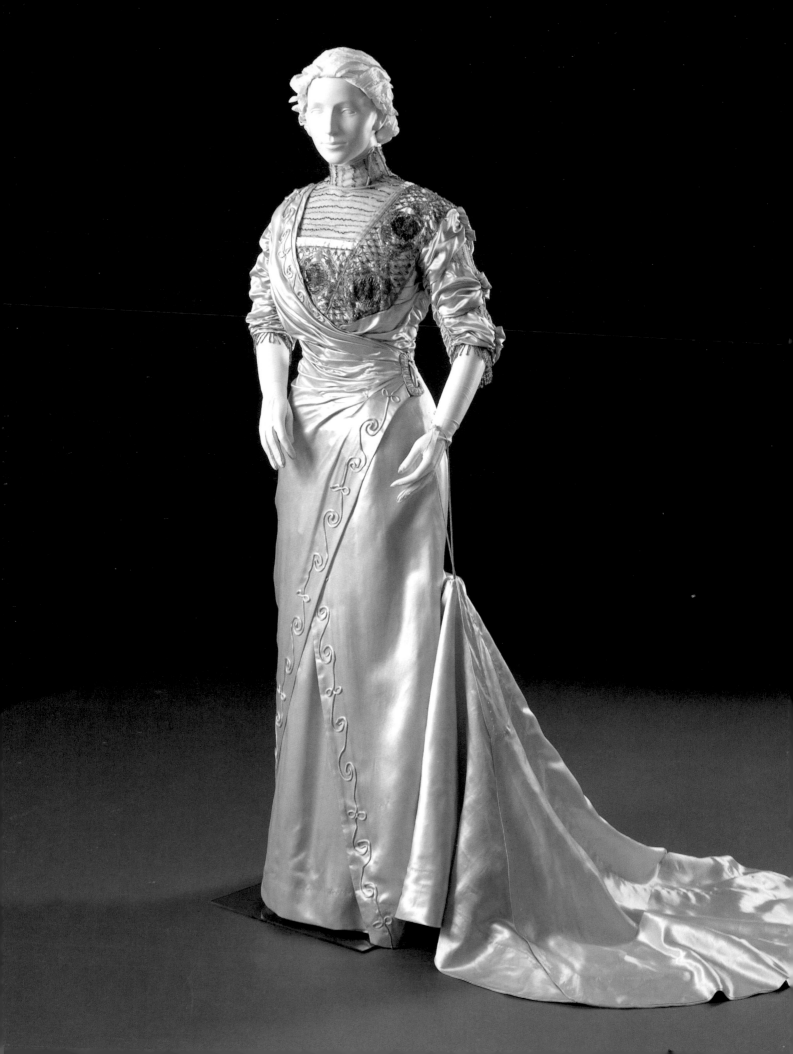

Etta Einhorn

Both Etta Einhorn and Harry Reinish were Polish immigrants whose families settled in Philadelphia. The groom's father was a women's dress manufacturer in Philadelphia: Etta found a job at his factory and there she met Harry. Etta's lavish bridal gown was made for her by seamstresses at the dress factory.

Looking at Etta's elegant, lavish gown without knowing her background, one would assume she was a woman of society, for this dress reflects the height of fashion. The influence of Parisian design made its way to the United States through plates in fashion magazines like *Harper's Bazaar* and couturier gowns sent to New York and quickly copied. Etta's gown of silk satin with a long train and bodice elaborately embellished with glass beads, paillettes, and even a few pearls, was very costly to make. The beaded surface embellishment was also very much influenced by the French style. The glass beads would have sparkled in candlelight or gaslight.

The dress featured the "mono bosom" look—a fully rounded form draped asymmetrically in creamy satin and caught with a faux buckle at the side of her waist. The high net collar and net-covered bosom create an illusionary nod to modesty, yet the use of materials demonstrates a decorative celebration of the female form. The spectacular gown was clearly made to have Etta feel like a princess and not a working-class immigrant girl.

Etta and Harry were married on December 12, 1909, at the Halberstam Synagogue. The ceremony was conducted by Rabbi B. L. Levinthal, assisted by Rabbi H. Cahan. Unfortunately, no wedding photograph exists. After Etta passed away, her husband kept the dress until his own death in 1957. At that time, his daughter stored the dress in a cedar closet, using it twice in fashion shows.

35. Etta Einhorn Wedding Dress (Fig. 81)
Philadelphia, 1909
Cream silk satin dress with beaded and
 sequined bodice
Gift of Florence R. Robins
HUCSM 9.19

95

< Fig. 81 Bridal Costume of Etta Einhorn

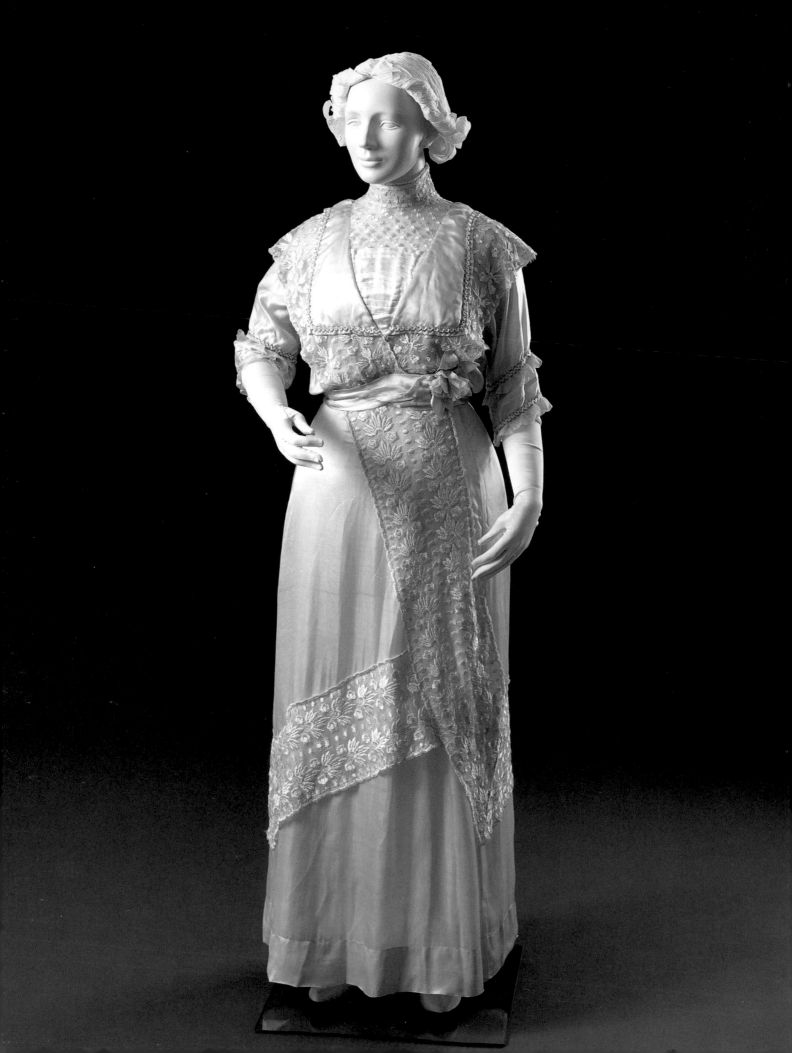

Eva Selbin and Mary Stein

Eva Selbin was born in Boslov, Russia, in 1895. When she was twelve she ran away from an unhappy home situation: her widowed father had remarried, and she did not get along with her stepmother. Arriving in London, she was adopted as a ward. In 1910 Eva came to the United States to stay with relatives in Philadelphia. Leon K. Stein was born in Vilna, Lithuania, in 1887 and immigrated to the United States as a young man. Eva and Leon married in Minneapolis on March 17, 1912. Leon was in the wholesale fruit business. Like many other immigrants, he had started out selling from a pushcart on the North Side of Minneapolis, the Jewish neighborhood. Their daughter Mary was born in Minneapolis on June 22, 1913. Leon passed away in 1937 while on a business trip to New Orleans.

Sydney Green was born in Duluth, Minnesota, on July 31, 1910. He married Mary Stein at her family home on March 22, 1936. Sydney had attended the University of Minnesota for two years, but had to drop out during the Depression when he was needed to help support his family. He subsequently owned a liquor store in Minneapolis. In 1965 the Steins decided to relocate to Los Angeles to escape the cold winters and to join other members of Mary's family, including her mother who had settled there in 1948. Mary passed away in 1988.

This gown is a lovely example of a family heirloom, worn first by Eva Selbin in 1912 and then altered for use by her daughter for a second generation of wear in 1936. The style of the silk satin dress with high collar and asymmetrical bands of lace is typical of the Belle Epoque period, prior to World War I. It has a romantic, ethereal look. Women's fashion trends at the time shifted away from elaborate draping and embellishment to relatively more practical clothing with fewer frills and flounces. The new ready-to-wear phenomenon in clothing manufacture, embraced by young working women, featured the skirt and a shirt-waist—which became emblematic of their newfound freedom and independence. Eva's dress, with its popular middy collar and vertical shirtwaist style reflects this transitional period in fashion.

36. Eva Selbin and Mary Stein Wedding Dress (Fig. 82)
Minneapolis, 1912; altered for reuse in 1936
Cream silk satin dress with beaded and machine-lace embellishment
Gift of Mary and Sidney Green
HUCSM 9.26

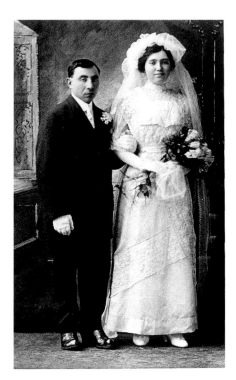 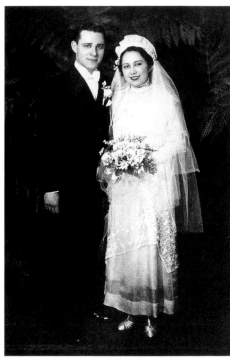

Fig. 83 Eva Selbin and Leon Stein Wedding Portrait, 1912

Fig. 84 Mary Stein and Sydney Green Wedding Portrait, 1936

< **Fig. 82** Bridal Costume of Eva Selbin and Mary Stein

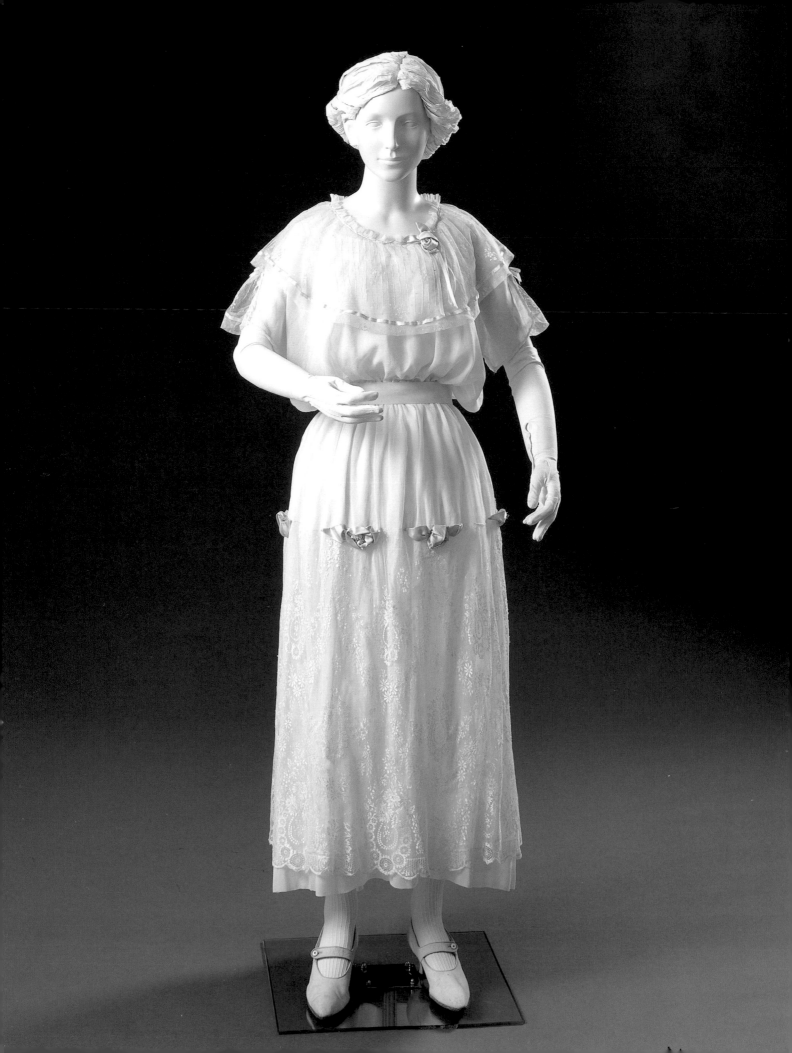

Matilda Cadron

Mazal Tov (Matilda) Cadron was born on the Turkish (now Greek) island of Rhodes in July 1896. She worked there in her father's shop, a job she enjoyed because it enabled her to use her language skills and be a more "modern" woman. Matilda spoke French, Italian, Yiddish, Greek, and Sephardic Spanish; she was extremely bright and relished the chance to learn about her father's business at a time when women were rarely allowed to work outside the home.

Matilda's older sister Rosa immigrated to the United States first, and then Matilda followed with a younger sister, Eleanor. A family story explains that Matilda fell in love with an Italian soldier, so she was sent away to the States. In America, Matilda welcomed any newly immigrated family members with open arms, loaning them money, and feeding and housing them. For example, when her sister Flora immigrated to Los Angeles after spending time in the Belgian Congo, Matilda helped her in every way that she could. She was an extremely generous woman who never expected to be paid back.

Matilda was married to Samuel Caraco in Los Angeles on September 16, 1918. Matilda's two-piece gown, comprised of a blouson top and softly gathered skirt, is made of machine-embroidered lace net over silk chiffon and has the appearance of an ethnically influenced costume. Perhaps for Matilda the style was reminiscent of regional elements from her background. The shorter skirt length and the unstructured and uncorseted shape are characteris-

tic of the trend toward more practical women's clothing of the era. The delicate sheer fabric and simple silk ribbon borders give the gown an ethereal, ingenue quality. The silk satin rosebuds, popular on fashionable dresses of the time, add a romantic touch.

Sadly, Matilda's husband Samuel died of tuberculosis on March 5, 1946, and her daughter Dorinne died a month later in Los Angeles from the same disease. Matilda mourned the loss of her husband and daughter throughout her life; she never remarried and never attended family celebrations on Mother's Day.

Matilda was known for her culinary skills and always made cookies and special Sephardi foods for her nephews and nieces, many of whom were named Dorinne after her departed daughter. She was active in the Rhodelisi Temple in Los Angeles and worked as a decorator in the area for many years. After her sister Rosa died, Matilda, or "Auntie" as she was known in the family, became the matriarch.

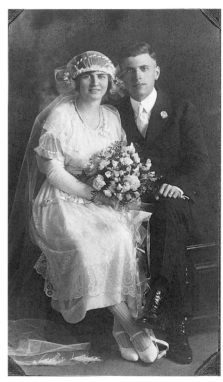

Fig. 86 Matilda Cadron and Samuel Caraco Wedding Portrait, 1918

99

37. Matilda Cadron Wedding Dress (Fig. 85)
Los Angeles, 1918
Cream silk "tissue" chiffon with lace overlay and silk satin roses
Gift of Julie and Louis Breitstein
HUCSM 9.68 a, b

The shoes used as an accessory for Matilda's gown are on loan courtesy of Paris 1900, Santa Monica.

< **Fig. 85** Bridal Costume of Matilda Cadron

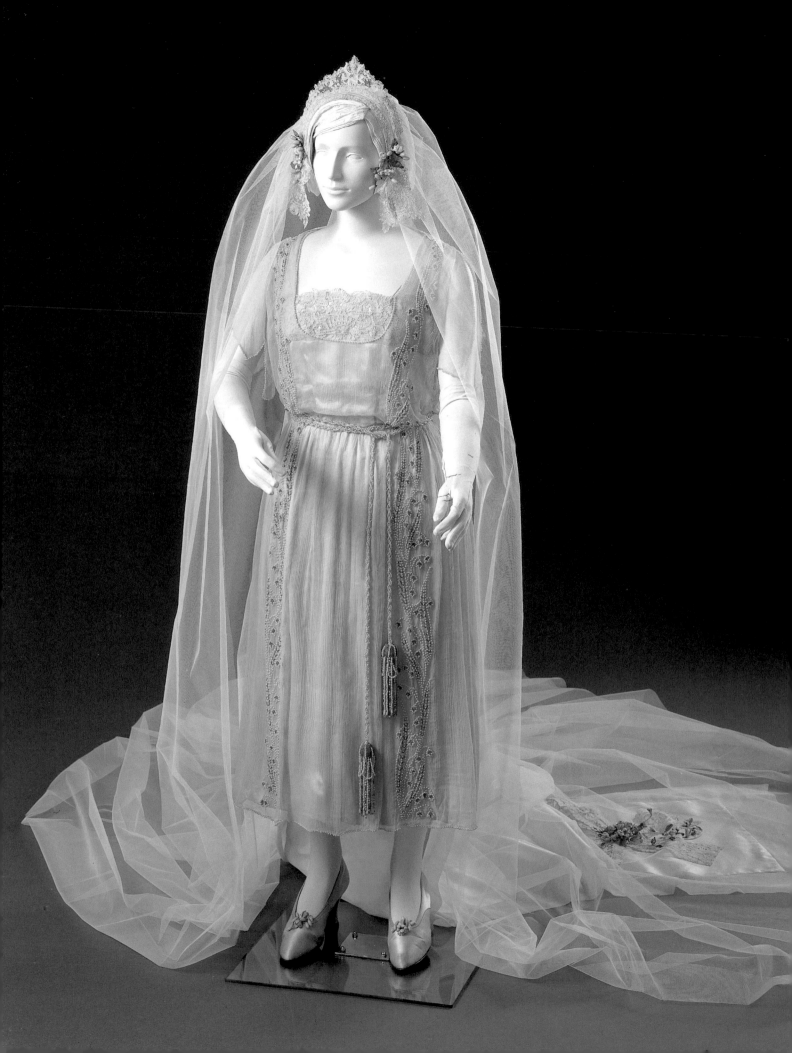

Marion Rheinstrom

Marion Rheinstrom was married to George Washington Rosenthal on June 20, 1920, in Cincinnati, Ohio, where both the bride and groom were born. Rabbi David Philipson officiated at Rockdale Temple. The bride was a 1917 graduate of the University of Cincinnati; the groom was a 1913 graduate of Cornell University and served as a naval ensign during World War I. He was employed in the family printing business, S. Rosenthal, established by his grandfather shortly after the Civil War.

Marion's grandson, Dr. George M. Goodwin, wrote about the marriage:

> George had proposed to Marion at Mecklenburg's, a favorite downtown beer garden established in 1865. A family story has it that after he asked for her hand, a pear fell from an arbor and struck him on his balding head. George and Marion lived in a three-story manse in a park-like setting, located coincidentally, at 991 Marion Avenue. Built around 1895, it had belonged to George's parents since 1906.

Marion's dress, by Joseph of New York, was the height of elegant fashion, influenced by French design in the post-World War I era. Her gown was probably inspired by Delphos gowns, introduced by Mariano Fortuny in Paris in 1907 and first worn at home as "tea gowns," referring to the time before dinner when a woman could remove her corset before dressing formally once again for the evening. By 1920 variations of this popular look were worn in public.

The dress of silk chiffon over soft silk satin has a very sheer gossamer quality enhanced by embroidery in glass beads and seed pearls. The tasseled rope-of-pearls belt, typical of the early 1900s, reflects French influence on embellishment style. The overall shape of the dress, with square-cut bodice and short sleeves and the linear embroidery pattern, suggests a more independent 1920s bride. A long train is attached along the shoulder line at the back of the dress. A lace bow is sewn at the end of the train. Unlike any of the other elements on the dress, the lace bow may have been a family

heirloom. The lace headpiece, which completes the ensemble, is inspired by the Greek *stephane*, a crescent-shaped diadem, and has a long flowing veil. Waxed-cloth orange blossoms, a traditional symbol of fertility, add rich detail to the headpiece and bow on the train.

38. Marion Rheinstrom Wedding Dress (Fig. 87)
New York City, 1920
Dress: cream silk satin and lace with beaded ecru silk chiffon overlay
Train: matching cream satin and ecru chiffon, trimmed with waxed-cloth orange blossoms
Headpiece: ecru lace with tulle veil attached; replaced with polyester tulle
HUCSM 9.89

39. Fashion Doll (Fig. 88)
Carved and painted wood fashion doll with miniature version of dress
Gift of Madeline Rosenthal Goodwin

This doll is dressed in an exact replica of Marion's wedding costume, and was apparently made as a model for the bride.

40. Janet Choynski Wedding Shoes (Fig. 90)
San Francisco, 1928
Gift of Delia Fleishhaker Ehrlich, and Mortimer and David Fleishhaker
HUCSM 9.67

Janet Choynski and Mortimer Fleishhacker Jr. were married at the Palace Hotel on May 1, 1928. Her satin shoes trimmed with orange blossoms are being used as an accessory for the wedding costume of Marion Rheinstrom Rosenthal.

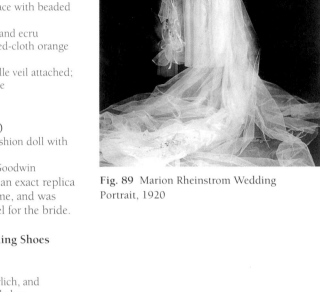

Fig. 89 Marion Rheinstrom Wedding Portrait, 1920

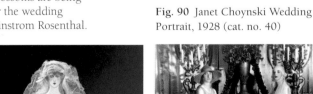

Fig. 90 Janet Choynski Wedding Portrait, 1928 (cat. no. 40)

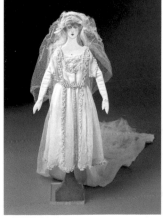

< Fig. 87 Bridal Costume of Marion Rheinstrom

Fig. 88 Rheinstrom Fashion Doll (cat. no. 39)

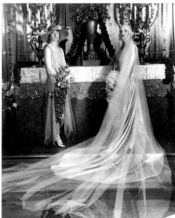

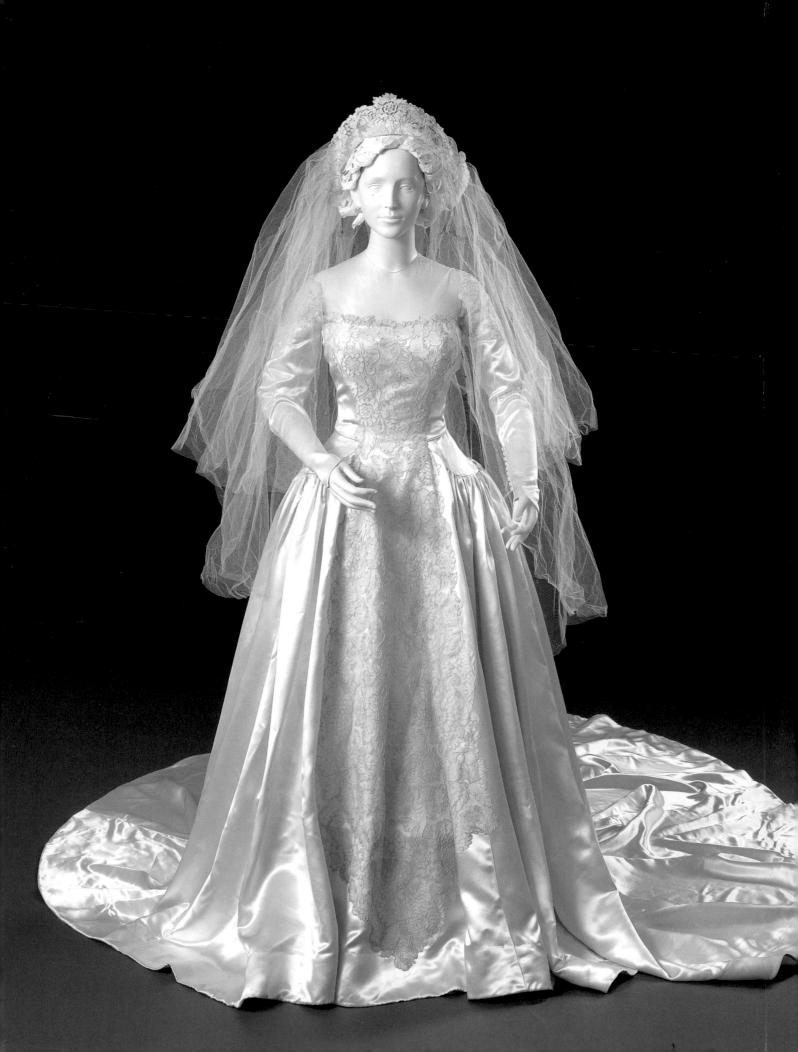

Peachy Kalsman

Peachy Kalsman and Mark Levy met at UCLA, where they were both undergraduates. Mark had served in an armored division in Europe during World War II, reaching the rank of first lieutenant by age nineteen. He returned to the United States in 1946 and, like many returning soldiers, took advantage of the opportunity to attend college. When he met Peachy, Mark was already a senior and she was an eighteen-year-old sophomore.

When Peachy's family took a month-long summer vacation, the couple kept in touch by writing almost daily letters. Peachy has saved every letter that Mark ever wrote to her, including those from that first summer. On October 10, while they were parked outside her neighbor's house in Mark's prized Ford coupe, he proposed and the next day gave her an engagement ring. Peachy remembers coming to school proudly wearing her new engagement ring—she felt as if she were "living in a fairy tale." They set a wedding date of June 19, 1949. Mark was unsure what he would do for a living, but Peachy's father offered him a job in the construction business. Now, with a steady income and in a hurry to start their life together, they decided to move the wedding from June to March 20, 1949. In time, Peachy became a fiber artist who specializes in creating Judaic ceremonial textiles.

The ceremony was held in the Crystal Room of the Beverly Hills Hotel. Rabbi Samuel Chomsky officiated. They were wed under a floral ḥuppah, and Mark clearly remembers smashing the glass. The couple was part of the American mainstream, and their wedding was very much of the times—with elegance being the hallmark in the ceremony and reception that followed. In that era, for example, it was not

customary to have "Jewish" music: instead, conventional wedding music was played during the ceremony and popular music by the band during the reception.

The bride's silk satin and lace gown with its long train and matching lace headpiece is a wonderful example of the elegant new style for the demure bride in the postwar period. In April 1942, *Women's Wear Daily* published a list of restrictions on feminine apparel mandated because of shortages of wool, silk, rayon, cotton, and linen due to the war effort. While bridal gowns were considered an exception to the rule, most were not elaborate and with fabrics scarce because of rationing, gowns tended to be simpler and lines closer to the body. When a large number of women joined the work force during the war, society de-emphasized "high" style.

Soon after the war, enormous changes occurred in American society. Once again women's role as homemakers predominated, and many women strove to attain the new idealized feminine image. Parisian designer Christian Dior's "New Look" created a sensation in the 1946 world of women's clothing—as did his philosophy, "Fashion comes from a dream and the dream is an escape from reality." The "New Look" emphasized a tiny cinched waist with a curved hipline. To achieve this look, the voluminous folds of the satin skirt are supported by a hoop or skirt, petticoat and *pannier* (which is made of stiff material and resembles a short tennis skirt puffed out at the sides). Peachy's wedding ensemble, purchased at Saks Fifth Avenue in Beverly Hills, was designed by Tafel Gowns in New York. Sewn discreetly in the gown is a small blue posy, to fulfill the verse "something blue." The bridesmaids, friends of Peachy's from UCLA, wore ice-blue dresses with short veils and carried yellow roses. The men in the bridal party all wore morning suits.

For their fiftieth wedding anniversary-invitation, Peachy and Mark chose a picture of themselves taken in the Ford coupe as they left for their honeymoon. Peachy and Mark are collectors of antique and contemporary Judaica. In honor of their fortieth and fiftieth wedding anniversaries, their three children and six grandchildren commissioned new and unique Jewish ceremonial items in their honor (see cat. nos. 144–146).

43. Peachy Kalsman Wedding Dress (Fig. 94)
Los Angeles, 1949
Dress: Cream satin dress with lace embellishment
Headpiece: Lace and veiling
Gift of Peachy and Mark Levy
HUCSM 9.27a-d

Fig. 95 Peachy and Mark Levy coming down the aisle

105

Fig. 96 Irving and Lee Kalsman, parents of the bride

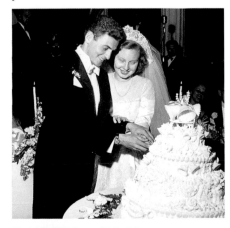

Fig. 97 Peachy and Mark Levy cut the wedding cake.

Fig. 98 Peachy and Mark Levy leave for their honeymoon.

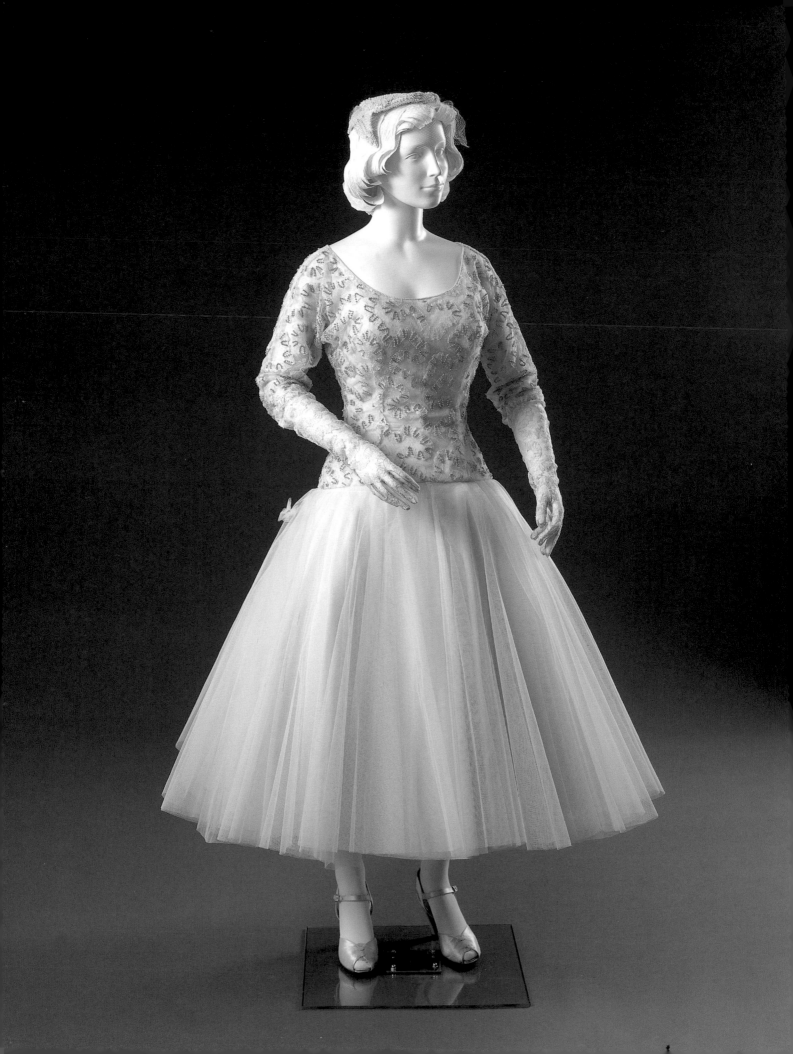

Judith Moss

Judes Moszkowski was born in 1928 in Zhetel, Poland, a small town near Grodno, now in Belarus. Her father, known as Tzale (1902–1942), was the namesake of the biblical artisan Bezalel. Tzale ran a dry goods store. Judes's mother was Necha (1904–1942).

Judes was fourteen years old when the German occupation destroyed her community in 1942. While the German soldiers were gathering up people to transport them away in trucks, Judes ran into the forest, subsequently hiding in the attic of an abandoned synagogue. When she learned that her family had been killed, she joined the partisans and at the end of the war was sent to a displaced-persons camp near Munich. Relatives from Providence, Rhode Island, discovered her whereabouts and brought her to the United States.

In the United States, Judes anglicized her name to Judith Moss. She remained on the East Coast for several years, graduated from Bryant Business College in 1951, and then moved to Los Angeles.

Her future husband Richard Tobias Cowen (1924–1991) was born in Cleveland, Ohio. He had studied to be a dentist before serving in the Air Force. When he finished his military service in 1954, he came to Los Angeles to visit his grandmother and decided to stay. Judith and Richard met on a double date. Her date, a physician, received an emergency call and Richard offered to escort her home. After a brief courtship, they were engaged on Judith's birthday in December 1954 and married the following February.

Judith and Richard had planned to be wed in Las Vegas, but Harry and Joan Mier, Richard's uncle and aunt, who had no children of their own, wouldn't hear of it. They made all the arrangements for the couple to be married in an elegant ceremony at Wilshire Boulevard Temple in Los Angeles. Rabbi Edgar Magnin officiated and the wedding reception was held at Hillcrest Country Club.

Judith's dress, purchased at Saks Fifth Avenue, was designed by Don Loper, a well-known Southern California dress designer, popular in the 1950s and 1960s. Likely because it was an afternoon wedding, the design is a dressy version of a day look, with a somewhat more relaxed A-line shape, in contrast to the constricted waist of the "New Look" popular ten years earlier. The skirt, in gores of rayon faille, falls from the hip with three over-layers of tulle. The pearl-embroidered bodice of machine made-lace with a sinuous ribbon pattern is woven to look as if it were hand appliquéd. The bride wore elbow-length gloves in a matching lace and her "pancake" hat of faille embroidered with seed pearls and rhinestones completed the ensemble.

The Cowens moved to the San Fernando Valley in 1959 and lived there for more than thirty-three years. Harry and Joan Mier, who provided the dream wedding, were generous philanthropists. They established two children's camps in Malibu: Camp Hess Kramer, for Wilshire Boulevard Temple, and Camp Joan Mier, now operated by the Los Angeles County Crippled Children's Society.

44. Judith Moss Wedding Dress (Fig. 99)
Los Angeles, 1955
Champagne colored silk faille dress embroidered with seed pearls and beige tulle
"Pancake" Hat: faille covered buckram embroidered with seed pearls and rhinestones
Gloves: beige lace
Gift of Judy M. Cowen
HUCSM 9.28 a-d

The shoes used as an accessory for Judy's gown are on loan courtesy of Paris 1900, Santa Monica.

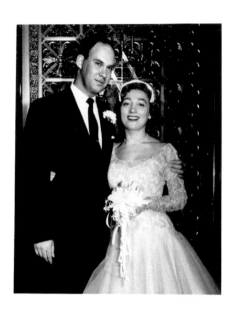

Fig. 100 Judith Moss and Richard Cowen Wedding Portrait, 1955

107

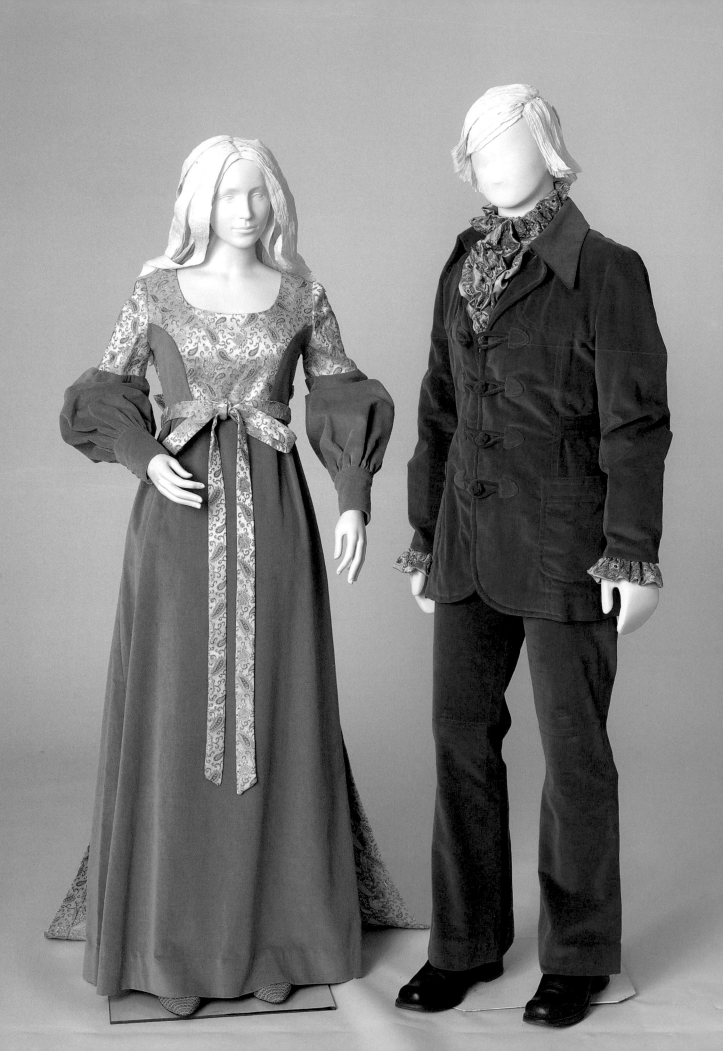

Joan Felmus and David Holtzclaw

Joan Felmus attended the University of California at Berkeley for two years and then left school until she found her calling as a textile artist. She pursued her dream of studying art at San Francisco State University while her future husband, David Holtzclaw, attended medical school at the University of California at San Francisco. While at art school, Joan worked in several media including drawing and glass, but soon specialized in weaving.

Joan Felmus was married to David Ray Holtzclaw on March 25, 1973, in the garden of her parents' home in Beverly Hills. The bride wore a Renaissance-inspired gold velvet gown of her own creation, and she also designed and made the groom's suit. The wedding was performed by a judge. Joan's designs for wedding clothing evoke a romantic mood—to capture a "time gone by" and reflect the hippie sensibility, a kind of love-child approach to the world. Her empire waist gown is made of gold cotton velveteen and synthetic brocade with the train made in matching fabrics. David's suit is loosely based on Edwardian style, influenced by the Beatles "Sergeant Pepper" album, and results in a 1970s look typified by the turquoise velveteen jacket with wide-cut collar and bell-bottomed trousers. His shirt is made of synthetic satin embroidered with polychrome cotton floss on the ruffled *jabot* and cuffs. The carefully executed embroidery with flowers and butterflies, also a favored 1970s type of embellishment, was completed just the day before the wedding.

Joan, born in Pasadena on May 30, 1952, died on September 9, 1984. She had suffered from juvenile rheumatoid arthritis from the age of twelve and, although she was determined to stay healthy and strictly followed her doctors' advice, she died of complications from the disease when she was just thirty-two years old. Joan's gown and David's suit were given to the museum by her mother as a tribute to Joan's talent and creativity.

45. Joan Felmus Wedding Dress (Fig. 101)
Los Angeles, 1973
Gold cotton velveteen dress with cream and gold synthetic damask, with damask train
Gift of Ruth Felmus and Family
HUCSM 9.42 a,b

46. David Ray Holtzclaw Wedding Suit (Fig. 101)
Los Angeles, 1973
Jacket and Trousers: blue cotton velveteen
Shirt: blue synthetic satin embroidered with polychrome cotton floss
Gift of Ruth Felmus and Family
HUCSM 9.44 a-c

47. Wedding Invitation
Beverly Hills, 1973
Printed paper
6⅛ x 4⅝ in. (15.50 x 11.75 cm)
Gift of Ruth Felmus and Family
HUCSM 9.43

< **Fig. 101** Wedding Attire of Joan Felmus and David Holtzclaw

48. Anita Cohen Flower Girl Dress
Peoria, Illinois, 1927
Silk
Gift of Anita Segalman
HUCSM 25.44 a,b

Five-year-old Anita Cohen was the flower girl at the wedding of Ethel and Jack Kahn in Peoria, Illinois, in November 1927. The wedding was held at the Reform Temple on the corner of Monroe and Hancock streets. Jack Kahn was the cousin of Anita's mother, Clara Kunitz, whom his father, Zavel Kahn, brought to the United States from Slonim, Byelorussia (now Belarus), in 1913.

Anita's mother, who had apprenticed to a tailor when she was just twelve, made the flower girl dress, which was worn with white shoes and white stockings. Anita carried a basket filled with petals as she walked down the aisle. There are no photographs from the wedding because the bride was displeased with them, but Anita was photographed later, wearing the dress, with her little brother Mischa.

The Kahns had a daughter Sonia, who became a professional musician and played second harpist with the New York Philharmonic. She decided to change careers and studied medicine. Dr. Sonia Kahn Simenauer returned to Peoria where she established a practice as a pediatrician.

Anita met Ralph Segalman when he came to Peoria as a newly minted social worker with the Child and Family Service. They were married in 1940. The Segalmans settled in Los Angeles in 1970. Ralph Segalman became a professor of sociology at Cal State Northridge, where Anita later received a master's degree. They have three children and four grandchildren.

49. Ruth Rosen Flower Girl Dress (Fig.103)
Minneapolis, 1935
Silk crepe on net
Gift of Ruth Rosen Orbuch
HUCSM 9.94

Ruth Rosen was just five years old in 1935 when Ann Segal asked her to be the flower girl at her wedding to Israel Steinberg, Ruth's cousin. Ruth's family lived next door to her mother's aunt Laura and her husband Morris, their five daughters Zelda, Mollie, Sarah, Tyba, and Tema—and one son, Israel—Iz. The family had just moved back

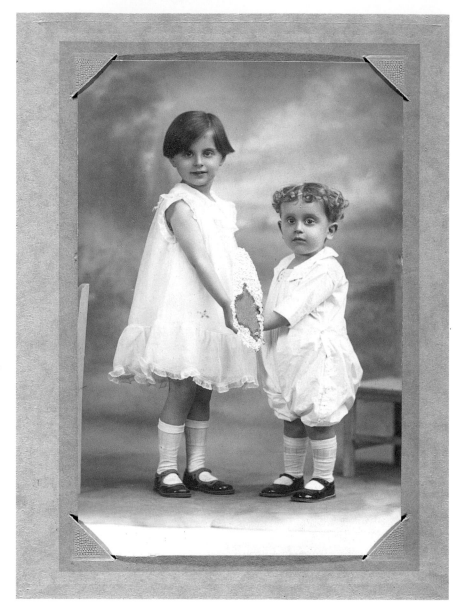

Fig. 102 Anita and Mischa Cohen, 1927 (cat. no. 48)

to Minneapolis from Red Lake Falls, a small town in northern Minnesota.

Ruth loved being in the big city and going on excursions downtown with her mother. Often, they stopped by to see Ann, who was then a college student and who worked part-time at Power's Department Store demonstrating vacuum cleaners. Ruth was fascinated by the way Ann sprinkled debris on a small strip of carpet to show how powerful the vacuum could be!

When it was time to buy the dress for the wedding Ruth's mother found a ruffled peach silk dress that was perfect for the Shirley Temple look. She wore her blond curls with a blue-velvet ribbon embellished with small silk rosebuds. Ruth also took tap dancing lessons, so she really fit the part. Ann's brother Edward was the ring bearer.

Ruth married Allen Orbuch on December 21, 1952. While living in St. Paul,

Minnesota, both Allen and Ruth attended the University of Minnesota. Allen studied law and Ruth studied art. In 1956, they moved to Los Angeles. Ruth and Allen have three children and three grandchildren.

50. Elaine Kaufman Flower Girl Dress
Los Angeles, 1975
Cotton embroidered with polychrome cotton
 thread
On loan from Elaine Kaufman

Elaine Kaufman was five years old when she was the flower girl at the wedding of Anne Kaufman and Gerry Reissman. The wedding was held in the garden of the Statler Hilton in downtown Los Angeles in June 1975. The flower girl dress was made to match the bride's dress, which was designed by Joseph Areno. Later, both Elaine and her sister Marcie wore the dress as their Queen Esther costume for Purim.

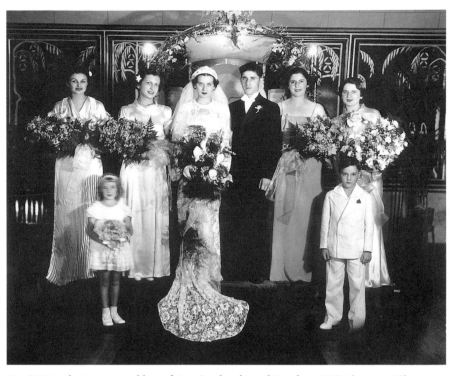

Fig. 103 Ruth Rosen at wedding of Ann Segal and Israel Steinberg, 1935 (cat. no. 49)

51. Marcie Kaufman Flower Girl Dress
Los Angeles, 1985
Silk taffeta
On loan from Marcie Kaufman

Marcie Kaufman was eight years old when she was the flower girl at the wedding of Debby Siperstein and Wally Bain on June 15, 1985. The ceremony took place at Temple Emanuel in San Bernardino, California. The bride had been the flower girl in Marcie's parents wedding in 1964. This flower girl dress was made to match the bridesmaids' dresses. Marcie later wore it to her cousin's bar mitzvah party. A matching dress was made for Marcie's Cabbage Patch Kid doll.

52. Anya Kester Flower Girl Dress
New York, 1995
Polyester organdy over synthetic faille with
 appliqued organdy flowers, sequins, and
 pearl beads
On loan from Anya Kester

53. Shiri Kester Flower Girl Dress
New York, 1995
Polyester organdy over synthetic taffeta with
 iridescent sequins and pearl beads
On loan from Shiri Kester

Anya and Shiri Kester wore these dresses in 1995 when they were ages six and four and were flower girls at the wedding of family friends Barbara and Larry Bolles in Saint Louis. They wore them again at the 1996 wedding of Dr. Steve Slobodsky and Ivetta Krol in Brooklyn. The girls were particularly admired for their efforts to spread the rose petals on the aisles and among the guests.

54. Rowland Markheim Ring Bearer Tuxedo
Los Angeles, 1999
On loan from Rowland Markheim

Rowland Markheim was three years old when he was the ring bearer at the wedding of Karen Segal and Ron Brigel on February 14, 1999. The wedding was at the Sephardic Temple Tifereth Israel.

Growing up, Karen Segal always wanted to be a flower girl, just like her older sister. She also knew exactly whose wedding she should be flower girl for—her next-door neighbor Stephen Markheim. Unfortunately, the timing did not work out, but when Karen started to plan her

wedding she decided that the appropriate thing was to invite Stephen's children, Rowland and Alexandra, to be the ring bearer and flower girl.

55. Jacob Lavin Wedding Suit
Ukraine, Russia, circa 1900
Wool; cotton; and metal buttons
Gift of Thelma Geller
HUCSM 9.21a-c

Jacob Lavin (1879–1948), ordained as a rabbi at the Tolnoi Yeshiva, was a scholar and a businessman. He wore this hand-tailored suit to be married in the Ukraine about 1900. When he immigrated to the United States in 1911, he brought the suit with him and wore it to synagogue services here as he had in the Ukraine.

56. Albert Mueller Wedding Vest
San Francisco, 1888
Brocaded silk, and cotton
Gift of Lou H. Silberman
HUCSM 9.70

Albert Mueller wore this vest at his wedding to Augusta Ash, the daughter of Jacob Ash. The wedding took place in the home of the Meyer Davidsons: Mrs. Davidson was a sister of the donor's grandmother; Meyer Davidson had been president of the Taylor Street Synagogue (Sherith Israel) in San Francisco. The rabbi of the congregation, Rabbi Vidaver, officiated.

Professor Silberman wrote,

I believe that my grandfather, who was a fashionable lady's tailor most likely made

this vest. One of my friends with connections in San Francisco once told me that if a young lady's going away suit was not made by my grandfather, she was not properly dressed.

Albert Mueller was born in Ostrowo, Province of Posen, Prussia, on March 17, 1856, and came to the United States in 1871. He stayed with an uncle in New York and received his American education in Cooper Union. He was well-educated, knowing Latin, Greek, and Polish (Ostrowo was a border town). He lived in Baltimore for a few years and worshipped in Eutaw Place Temple—Rabbi Szold's synagogue. At some time during his youth he voyaged by sailing ship to South America—one of the Guianas. He was injured in a street-car accident early in this century and received a pension and was not active in the tailoring business after that. He and my grandmother were avid opera and theater-goers—learning about and seeing all the great who came to San Francisco. He made the Torah covers and parochet for Sherith Israel that were still in use when I was a boy. He died in 1937 at the age of 81.

My maternal grandmother's family As[e]h began to arrive in Nevada and California in the late 1850s and early 1860s. She, her father, and a younger brother—Isadore—who had a general store in Tonapha, Nevada, during the gold strike there, were late-comers to San Francisco arriving in 1906 after the earthquake.

Rhodes – the bride's trousseau

57. *Mikveh* Clogs (Fig. 104)
Rhodes, 19th century
9⅜ x 3 x 2¼ in. (23.9 x 7.6 x 5.7 cm)
Gift of the Family of Louie and Behora
 Benveniste
HUCSM 49.3a,b

58. Cup Holders
Rhodes, ca. 1900
Silver, filigree and cast
3 x 2 in. diam. (7.6 x 5.1 cm)
Gift of Shirlee Benveniste Peha
HUCSM 14.395a-f; 14.396a-c

59. Pitcher and Bowl
China, ca. 1900
Engraved copper
Pitcher height at handle 9⅞ in. (24.8 cm)
Bowl diameter (top) 8⅛ in. (20.7 cm)
Gift of Shirlee Benveniste Peha
HUCSM 3.7a, b

60. Kerchief for *Baño de Novia*
Rhodes, ca. 1900
Linen, linen lace and metal sequins
22½ x 47 in. (57.0 x 119.5 cm)
Gift of Shirlee Benveniste Peha
HUCSM 25.227

61. Kerchief for *Baño de Novia*
Rhodes, ca. 1900
Silk, beaded linen lace
23 x 43½ in. (58.5 x 110 cm)
Gift of Shirlee Benveniste Peha
HUCSM 25.228

62. Pillow Cover
Rhodes, ca. 1900
Silk sateen, linen with drawn work and silk
19 x 18½ in. (48.2 x 47 cm)
Gift of Shirlee Benveniste Peha
HUCSM 25.231

63. Furniture Textile Cover
Rhodes, ca. 1900
Brocaded satin (silk?) and cotton with metallic
 cord
14¼ x 13¼ in. (36 x 33.5 cm)
Gift of the Family of Louie and Behora
 Benveniste
HUCSM 25.229

Behora (Rae) Benveniste married Leachon
(Louie) Benveniste on September 10, 1916,
in Los Angeles. Rae and Louie were both
born on the Island of Rhodes. Louie arrived
in New York in May 1909 and had

eventually settled in Los Angeles in 1912.
Rae came to the United States in August
1916 a month before the wedding. Before
leaving for the United States, Rae had her
baño de novia, the celebration with the
women of the family at the *mikveh*, in
Rhodes. She brought important objects
from this ritual with her including these
mikveh clogs, worn before and after the
immersion, as well as special embroidered
towels. Several other kitchen items often
included in a trousseau were also brought
over by other members of Rae's family.

64. Furniture Covers
Rhodes, early 20th century
Makers: Family of Luna Peha Capeloto
Filet crocheted, pearl cotton yarn (?)
Head rests: 13⅛ x 20 in. (33.3 x 50.7 cm)
Arm rests: 10¾ x 11 in. (27 x 28 cm)
Gift of Frances and Leon Franco
HUCSM 25.220a-d

65. *Mikveh* Towel (Fig. 104)
Rhodes, early 20th century
Makers: Family of Luna Peha Capeloto
Linen, embroidered with silk and metallic
 thread
13 x 98 in. (33 x 248.9cm)
Gift of Frances and Leon Franco
HUCSM 49.4

66. Bed Sheets
Rhodes, early 20th century
Maker: Luna Peha Capeloto
Plain woven cotton
Gift of Frances and Leon Franco
HUCSM 25.221; 25.224

Luna Peha and Esther Capeloto made the
journey together from their native Rhodes
to the United States about 1913. They went
to Seattle, Washington, to join their fiancés,
Asher (Harry) Capeloto and Yahiel (Harry)
Franco, who had immigrated to the United
States about a year earlier. Both couples
were married in 1914. Luna was an expert
dress designer and seamstress and was well-
known in Rhodes for making clothing for
trousseaus. Luna Peha also taught other
young women, who became her apprentices
to help in making the textiles.
 Luna brought many trousseau items
that she had made with her when she came
to the United States, as well as some that
she had made for Esther. Luna also
designed and made both of their wedding

gowns. Esther too brought along trousseau
items and textiles that she had made.
 Esther and Harry Franco remained in
Seattle, where Harry owned a jewelry store
and pawn shop. Luna and Asher (Harry)
Capeloto moved to Los Angeles in 1923,
but Harry passed away that same year. Later
the Francos and Capelotos would become
in-laws when the Francos' son Leon
married the Capelotos' daughter Frances.
Both families were very active in Sephardic
activities in their respective communities.

**67. *Tavla de Dulsé* (Tray of Sweets)
(Fig. 11)**
Izmir, Turkey, 1920
Silver, cast, die-stamped and pierced
Central container: 9⅛ x 5¼ in. diameter
 (24.4 x 13.5 cm)
Dishes: 1¾ x 6 in. diameter (4.5 x 15.2 cm)
Museum purchase with funds provided by the
 Maurice Amado Foundation at the behest of
 the Tarica Family
HUCSM 14.357 a-o

Among the gifts brought by the bride to her
marriage were silver items for household
use. It was the custom in Izmir, Turkey, to
bring a *tavla de dulsé*, a serving set for
sweets, in the European style. This set
became symbolic of the warm welcome
given to visitors.

68. Scroll of Esther and Case
Turkey, late 19th–early 20th century
Case: silver, filigree and parcel-gilt; and coral
Scroll: ink on parchment
Case: 16½ x 1¾ in. (42 x 4.5 cm)
Scroll: 5½ in. (14.1 cm)
HUCSM 22.19

In Izmir it was customary to give *megillah*
cases of this type to a bridegroom in honor
of his engagement.

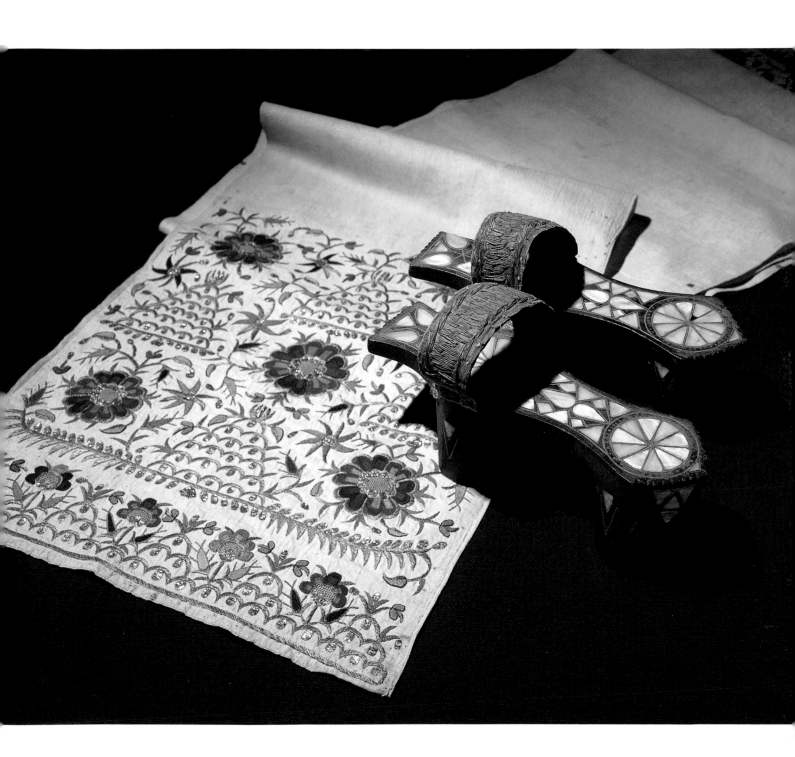

Fig. 104 *Mikveh* Clogs and *Mikveh* Towel (cat. nos. 57, 65)

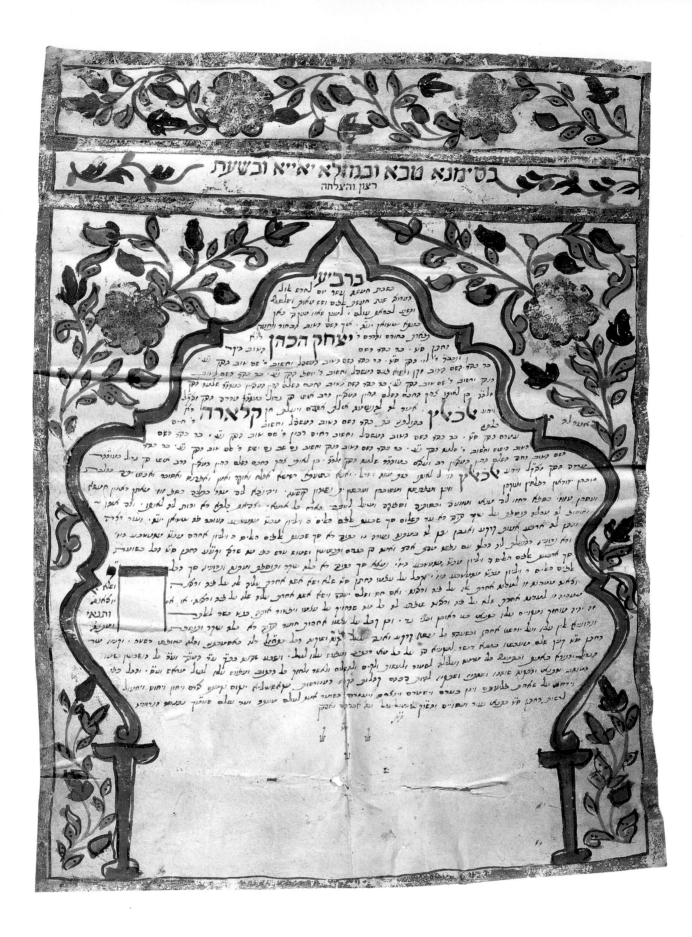

114

Fig. 105 Tetouan *Ketubbah*, 1879 (cat. no. 69)

Morocco~henna, a tradition renewed

69. *Ketubbah* (Fig. 105)
Tetouan, Morocco, 1879
Ink and tempera on parchment
18¼ x 13⅝ in. (46.4 x 34.6 cm)
Henry Kaner Memorial Purchase Fund
HUCSM 34.192

The wedding of Isaac ha-Cohen, son of Levi ha-Cohen, and Clara, daughter of Hayyim Amram ha-Cohen, took place on Wednesday the 15th of Elul 5639 (September 3, 1879). The bride and groom were second cousins. Their mutual lineage is traced through three generations to the distinguished Rabbi Mordecai, known as Alkhallas. The well-known rabbinic family were descendants of the Castilian exile community in Tetouan. The illumination of the *ketubbah* with the text framed by a Moorish archway surrounded by flowers, is a standard type of decoration in Tetouan.

70. Kiswah l kebira (Great Dress)
Rabat, Morocco, 19th century
On loan from Sarah Guerrero

71. Pitcher and Candlesticks
Morocco, 19th century
On loan from Sarah Guerrero

These objects belonged to Sarah Elkabas Guerrero's great-grandmother, Mendi Ben Shabbat.

72. Caftan
Morocco, after 1950
On loan from Sarah Guerrero

Sarah Elkabas was born in Mogador, Morocco. At age sixteen she was married, but the marriage was an unhappy one. Sarah was working for an American nursery school and hospital. She requested a transfer to Paris, where she moved at age nineteen in 1955. At that time her parents moved to Kiryat Gat in Israel. Sarah was photographed (Fig. 106) dressed in a *kiswah l kebira* that belonged to her family when she went to visit them in Israel. Unfortunately, parts of this dress were later dispersed to different family members, but Sarah acquired another dress in Rabat (cat. no. 70), which she lends to brides (Fig. 108). Sarah remained in Paris and at age twenty-six she married Pablo Guerrero, a diplomat, and they lived in several different countries.

73. Caftan
Morocco, ca. 1955
Silk brocade embroidered with metal thread
Gift of Thérèse Chriqui
HUCSM 9.79 a,b

This caftan was worn by Thérèse Chriqui when she was the maid-of-honor at a wedding in Morocco. She is also pictured (Fig. 107) wearing a *kiswah l kebira* for her own wedding celebration. Thérèse and Andre Chriqui were married in Casablanca on December 26, 1955.

74. Morocco Tableau
Furniture, decorative glass and ceramic ware
On loan from Corinne Benloulou of Kenza Imports

In celebration of an upcoming wedding, the families of the bride and groom and their friends join together and share a festive dinner. Among the special delicacies are cakes made with almonds, symbolic of wishes for the couple to have a sweet life. After dinner, *henna*, a type of plant with a burnt orange color, is put on the hands of the bride and groom. The bride wears the traditional *kiswah l kebira*, great dress, for the ceremony. The groom wears a *djellaba*, caftan, and a hat called *terbouche*.

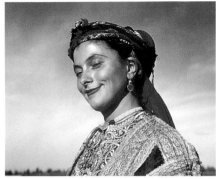

Fig. 106 Sarah Elkabas wearing *kiswah l kebira*

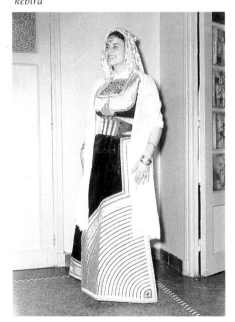

Fig. 107 Thérèse Chriqui wearing *kiswah l kebira*, 1955

Fig. 108 Henna Ceremony for Michelle Horowitz and Robert Cait, Los Angeles, 1995

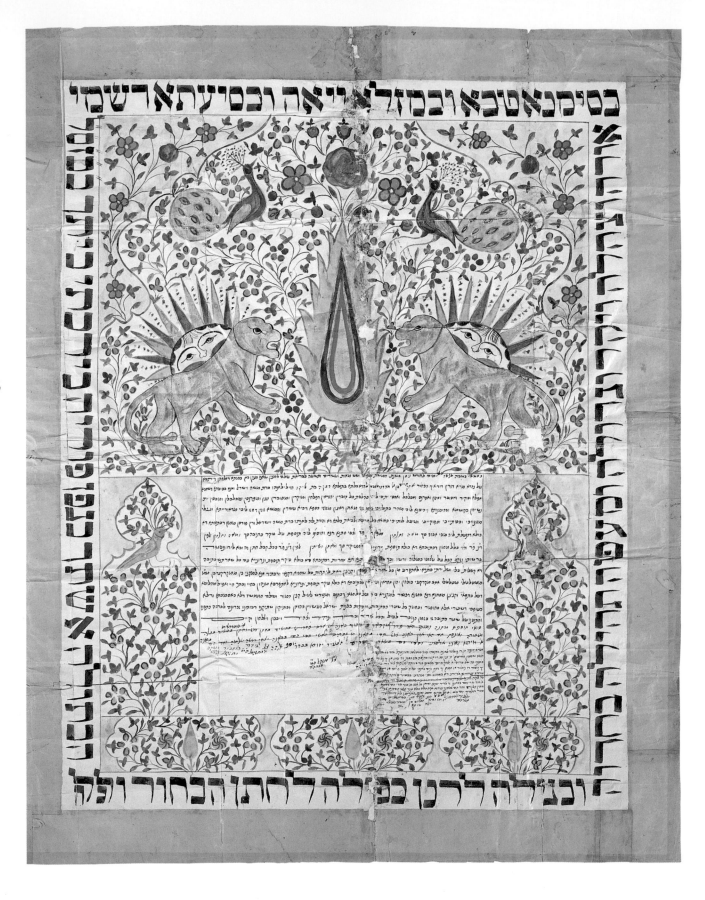

Fig. 109 Isfahan *Ketubbah*, 1869 (cat. no. 75)

Iran—a traditional wedding in Persia

75. *Ketubbah* (Fig. 109)
Isfahan, Persia, 1869
Ink and watercolor on paper; and applied
 paper
33⅜ x 26¾ in. (84.8 x 67.8 cm)
HUCSM 34.114

This marriage contract is illluminated with
the distinctive Isfahan decorative program.
The upper section is colorfully decorated
with a pair of peacocks and floral motifs
framed by a multifoil arch. In the center is a
flowering cypress tree, flanked by lions, that
have a human face-sun on their backs—a
Persian national symbol. The *ketubbah* text is
bordered on each side with an archway filled
with more flowering vines. The entire *ketubbah*
is framed with Hebrew inscriptions.

76. Candelabra and Mirror
On loan from Bijan Raphael and Nora Raphael
 Ghodsian

77. Canopy/Wall Decoration
On loan from Jaleh Kamran

78. Persian Rug
On loan from Homa Sarshar

79. Make-up Box
On loan from Yehuda Sadighpour

80. Rosewater Pitcher, *Sang-e Paa*
(Pumice), and *Sormeh Dan*
(Make-up for Eyes)
On loan from Homa Sarshar

81. Bridal Cap and Veil (Fig. 110)
On loan from Farahnaz Safaie-Kia

82. Bride's Dress and Jacket (Fig. 110)
On loan from Bahram Hayempour

83. Man's Cap (Fig. 110)
On loan from Nejat Sarshar

84. *Ghaba* (Robe for Groom) (Fig. 110)
On loan from Moussa Soomekh

Weddings traditionally took place at the
home of the bride's parents. The *khoupah*
(transliteration of the Hebrew term for
wedding canopy) was a *tallit* (prayer shawl)
held above the couple. Influenced by the
sophisticated Persian book arts, the
ketubbah was often elaborately decorated.
The ceremony was followed by a meal with

music and entertainment. Though they
were married, the bride and groom each
returned to spend a last night in their
parents' home.

The next evening, the groom, accom-
panied by family and friends, would come
to escort the bride to his house. A mirror
was placed in front of the bride and a
candlestick was carried to "light her life."
After an elder from the groom's family
welcomed the bride, the couple entered the
bridal chamber. It was customary for the
bride's mother to prepare a meal for them.
On the Saturday following the wedding, the
couple would go to the synagogue for
blessings. Following services, the groom's
parents entertained with a festive meal, thus
concluding the celebration.

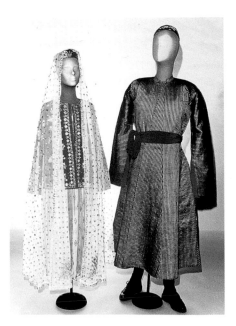

Fig. 110 Traditional wedding costumes
from Persia (cat. nos. 81–84)

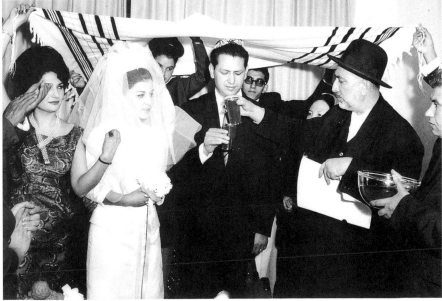

Fig. 111 Wedding of Homa and Nejat Sarshar took place in Tehran, March 24, 1966.

85. Khatoon Joseph Wedding Ensemble (Fig. 112)

Baghdad, Iraq, 1908
On loan from Sally Joseph, Seeman Menashy, and Diana Saul

This wedding outfit made in Baghdad, Iraq, was worn by Khatoon Joseph at her wedding to Ezra Meyer Joseph in Rangoon, Burma, in 1908. The bride, who was born in Iraq, took a wedding outfit with her when she left Baghdad to marry Ezra. The outfit consists of four pieces: silk pantaloons, a bodice embroidered with sterling silver, a long net gown with sleeves and neckline embroidered with velvet and sterling silver sequins, and a long pink silk gown with all-over sterling silver embroidery. The buttons of the pink gown were originally solitaire diamonds, which were removed after the wedding. The bride also wore an emerald starburst pin that was stolen on the night of the wedding. Seventy years after her wedding, Khatoon Joseph posed in her wedding dress for her granddaughters Sally, Seemah, and Diana.

Fig. 112 Khatoon Joseph in her wedding costume, circa 1978 (cat. no. 85)

86. Marriage Document (Fig. 6)

Shanghai, 1940
Ink on printed paper, stamps
14¼ x 20¼ in. (16.5 x 51.5 cm)
Gift of Irma Kent
HUCSM 34.427

The marriage document records the wedding of Irma Lotte Bielshihowsky and Albert Elias Less. Both the bride and groom were refugees from Nazi Germany who had escaped to Shanghai and both had been widowed. After the war, they emigrated to the United States and first worked as domestics until Albert Less was able to reestablish himself as a pharmacist.

The text is written in Chinese characters, but the document has the seal of the Communal Association of European Jews in Shanghai. The printed form is illustrated with traditional Chinese imagery including flowering trees and brightly colored birds and butterflies, and is framed by a decorative border with dragons.

87. Ḥallah Cover (Fig. 113)

Shanghai, 1899
Silk, embroidered with polychrome silk thread
29 x 29 in. (73.7 x 73.7 cm)
Gift of Regina Ezra
HUCSM 33a.39

The ḥallah cover was a gift from E.M. Ezra to his bride, Rose Haimovitch, in honor of their wedding on January 24, 1899. The inscription in Hebrew and English from Proverbs 31:29 reads: "Many daughters have done virtuously but thou excellest them all." This verse from the text referred to as "A Woman of Valor" is traditionally recited by the husband to his wife on Friday evening before the kiddush is recited over wine.

88. Ketubbah

Shanghai, 1918
Ink on printed paper
26½ x 14 in. (67.3 x 35.6 cm)
Gift of Rose Jacob Horowitz
HUCSM 34.431

The *ketubbah* celebrates the wedding of Menaḥem Salah (S.I.) Jacob and Miriam Nissim on 12 Tishre 5679 (September 18, 1918). Both the Nissim and Jacob families were originally from Iraq. Miriam's family came to China via Calcutta in the mid-1800s. When their son was just eight, after he experienced an anti-Semitic incident, the Jacob family moved to Bombay. In 1906 he moved to Shanghai to work for the Sassoons and there met Miriam. After the Communist Revolution in 1949, they left China, received temporary asylum in Canada, and moved to San Francisco in 1951.

Fig. 113 Ḥallah Cover, Shanghai (cat. no. 87)

89. Candlesticks

Shanghai, early 20th century
Silver
On loan from Maureen Donnell Winick

These candlesticks were a wedding gift to Linda Haim and Albert Cohen. The dragon decoration on the candlesticks was the insignia of the family who gave them the gift; their own family insignia was bamboo. The Cohens were the paternal grandparents of Maureen Donnell Winick. She was presented with this family heirloom on the occasion of her wedding in 1968.

A Nuptial Fortnight in Djerba

Keren Tzionah Friedman

90. Djerba Tableau (Fig. 115)

Traditional wedding attire of a bride and
 groom; basket with jewelry and amulets,
 Hanukkah lamp, and carpet
On loan from Keren Tzionah Friedman.

The Jews of Djerba, Tunisia, are known for
elaborate wedding celebrations unique to
North Africa. Weddings in this ancient
community span fourteen days and nights,
blending local customs shared by Muslims
and Jews with the requirements of Jewish
marriage law. More than a private ritual
between two individuals, the wedding is a
union of two families. In this gender-
segregated culture it is an important social
event that provides an excellent occasion
for unmarried young people to glimpse one
another, if only from a distance.

Jewish marriages on Djerba are arranged
through the parents of the couple; because a
family's honor depends on a bride's chastity,
contact between the engaged pair is forbidden.
(The engagement of at least one couple has
been called off because they conversed by
telephone.) According to a saying popular
among Djerban Jews, "Marriage comes first,
love afterward."

Most days of the celebration bear
names that tell of that day's most important
event, such as, Fattening Up Night, Cake
Night, Little Henna, Fingertips, Big Henna,
Turban Night, and Seven Blessings. Rituals
are performed with specific purposes in
mind, either to ward off the evil eye, to
beautify or purify the bride and groom, to
commemorate the destruction of the
Temple in Jerusalem, or to bring good luck
and ensure fertility.

Preparation and presentation of food
play a major role. Some foods are believed
to have magical properties or symbolic
significance and are served in specific
numerical portions to bring good fortune.
Guests are fortified with endless rounds of
boiled eggs and fava beans to ensure
fertility, large portions of couscous (a North
African staple served with meat, vegetables
and sauce) and other Tunisian delicacies.

Following an engagement that may last
for three years, a wedding date is selected:
always a Monday night during the bride's
fertile period. The women of both house-
holds get busy attending to every detail of
the food gifts, food exchanges, and food
sharing that take place in the village.

Fig. 114 Wall paintings herald the celebra-
tion of a Jewish wedding, Djerba, 1980. The
symbols are amulets to safeguard the home,
bring good luck, and fertility. Courtesy of
Keren Tzionah Friedman

Women's joyous ululations can be heard as they come and go, delivering food, escorting the bride to the *mikveh* (ritual bath), and visiting the bride when she is on display in all her finery or when guests arrive.

Evening celebrations begin late at night and may last until two or three in the morning. Some events are attended exclusively by women, others only by men. When both genders celebrate concurrently, they usually occupy different areas of the home. On one evening, Muslim guests are invited.

The bride is all but smothered with attention. Her feet are ritually washed and henna, a rust-orange plant dye, is applied in ornate patterns to hands and feet. She is dressed in the island's traditional Jewish costume, laden with gold and silver jewelry made by local Jewish craftsmen, and is continually provided with choice foods while her friends keep her company and sing to her.

Symbols popular among both Jews and Arabs in Tunisia appear in the bride's jewelry, in her silver-embroidered dress, and in the blue wall paintings that herald the wedding. The most prevalent motifs, the *ḥamsa* (hand) and fish, serve as amulets and ornamentation.

During the first week of celebration women occupy center stage. The following week, men play a more active role and the groom also becomes a focus of attention. During one particularly lively event, each guest wraps a red cloth forming a turban around the groom's head, unwraps it, and then tosses it into the air to be caught and tossed by the next guest.

Professional musicians are hired for at least three evenings. They entertain with *oud* (a stringed instrument), *darabukeh* (drum), and tambourine, playing secular Arabic music as well as singing *piyyutim* (religious hymns).

On the tenth day, the groom and his companions paint blue images of menorahs and a hand holding a string of fish on the façade of the groom's house. After dusk, the pitch of excitement reaches its zenith when the veiled bride is guided by a crowd of women and girls through the sandy streets of the village toward her bridegroom. The musicians and the bride's menfolk lead the procession. The bride makes several stops along the way, each marked by ululations

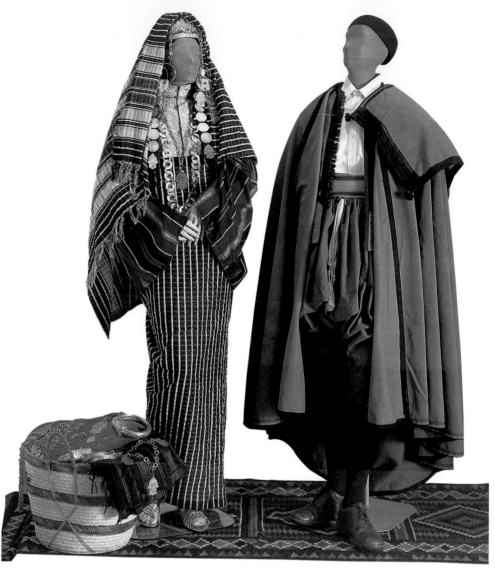

Fig. 115 Bride and groom dressed in traditional wedding attire from Djerba. On loan from Keren Tzionah Friedman. Acquired by her when she lived in Djerba where she did field research during the 1980s.(cat. no. 90)

and a shower of candy pounced on by swarms of children.

Just as the bride and her entourage arrive at the groom's home, he pushes a large clay jug of water off the rooftop where he has been waiting. It shatters on the street below, commemorating the destruction of the Temple. Her hand guided by a sister-in-law, the bride breaks a raw egg under the *mezuzah* on the doorway and enters the courtyard.

The groom now has his hair trimmed while his male friends stick paper money (later donated to charity) on his forehead. He dresses in his wedding clothes, a modern suit and tie, and is led in a public procession to the synagogue for evening prayers under a large prayer shawl held aloft by the men. Finally, he returns home, enters the room where his veiled bride is seated with all the women, places the wedding ring on her finger, and returns to the central courtyard. After the rabbi chants the *sheva berakhot* (the

Seven Blessings of the religious ceremony), the groom takes a sip of wine, enters women's quarters to offer the cup to his bride, and once again retreats into the courtyard. He then breaks the fast begun the night before, and he and his male friends join the musicians in chanting *piyyutim*. At no time does the couple stand together under a *ḥuppah* (wedding canopy) as in the Ashkenazi tradition.

Assembled in their separate areas, men and women are served a sumptuous meal. Once again the *sheva berakhot* are chanted, the bride's veil is removed, and the couple pose for photographs and speak to each other, very likely for the first time. When the guests leave, a married couple escorts the newlyweds to their living quarters, offers instruction, and finally leaves them alone to consummate the marriage.

During the succeeding days, the newlyweds attend a series of festive meals

120

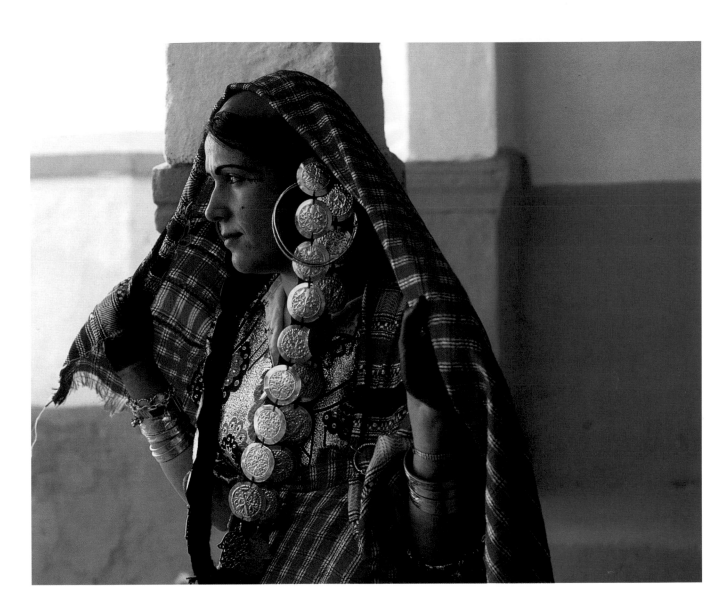

Fig. 116 Jewish Bride of Djerba, Tunisia, 1983. Courtesy of Keren Tzionah Friedman

and go with their families to light the silver oil lamp at *La Ghriba*, the island's most famous synagogue. Some brides also have studio photographs taken in a rented white wedding gown. On *Shabbat*, the *sheva berakhot* are repeated several more times by honored guests.

At last, on the morning of the fourteenth day, the bride changes out of her ceremonial clothes and is presented by her mother with a "farewell pan" of couscous. In a lighthearted ceremony the groom purposely lets a dish slip from his hand and his bride then sweeps up the broken pieces, possibly to commemorate the destruction of the Temple, possibly as a reminder of the wife's subservient status.

Not surprisingly, shortly after a wedding takes place it is not uncommon for new engagements to be announced. During the fourteen-day celebration the young people of the village and Jewish guests from other towns and even abroad do not waste their time.

Courtship and Engagement

91. *Tena'im* (Engagement Contract) (Fig. 15)

Chicago, 1937
Ink on paper
18¾ x 12 in. (47.6 x 30.5 cm)
Gift of Mr. and Mrs. Harry S. and Shirley E.
Weiner
HUCSM 34.307

This is the engagement contract between Shirley E. Richman and Harry S. Weiner that was signed on Nov. 7, 1937 at the Midwest Athletic Club, Chicago. Shirley and Harry were married at the same location on June 19, 1938.

92. Markowitz Family *Tallit* Bag

Rumania, 1905
On loan from Sharon Jacobson

Max Leon Markowitz (Marcovici) and Deborah Goldstein were wed on November 25, 1905 in Berlad, Rumania. The marriage was arranged by their families. Max, who had a grocery business in Vaslui, Rumania, decided to leave for America in 1907 to make a better life for his family. Max emigrated to Sacramento where his sister-in-law's family had a clothing store and he expected he could find a job. A year later he brought over his wife and daughter Anne, the first of the three daughters and one son born to the couple. Max quickly established himself in Sacramento with an entire block of stores including a pharmacy, grocery, and real estate business.

Deborah loved to embroider from a very young age. She brought several pieces with her when she emigrated. Deborah made the *tallit* (prayer shawl) bag for Max upon their engagement and inscribed it with his initials, MLM.

93. Smith Family Pocket watch

Eisheshuk, Lithuania, 1888
Gold, paper, metal
Watch: 1½ in. diameter (3.8 cm)
Chain: 27 in. (68.5 cm)
Gift of Lillian Smith, daughter
HUCSM 31.281a-c

Philip Smith (Schmidt) bought this gold watch as an engagement gift for Mere Soloway, who was then just sixteen years old. Mere and Philip were married in 1895

in Dauge, Lithuania, and immigrated together to the United States, where their two children were born. The watch originally had a rose gold chain that Mere sold during the Depression for $30.00 to pay the family's mortgage. Afterwards when she wanted to wear the watch, she would pin it to her blouse.

Postcards

94. Romantic New Year's Greeting: Airplane Ride (Fig. 8)

Williamsburg Art. Co., New York
Printed in Saxony, circa 1915
Printed paper
5½ x 3 ½ in. (13.9 x 9 cm)
HUCSM P2044

The little airplane moves us quickly.
And the view is dizzying.
Say, it is her that is flying,
Is it the joy of love?

95. Romantic New Year's Greeting: Talking on the Telephone (Fig. 118)

Williamsburg Post Card Co., New York
Printed in Germany, circa 1915
Printed paper
5½ x 3½ in. (13.9 x 9 cm)
HUCSM P2258

The sun sends its warm ray
The wind freshens the day
In your arms I long to be
To mix your breath with mine

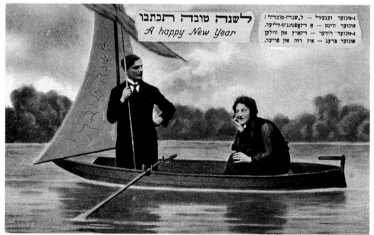

Cat. no. 96

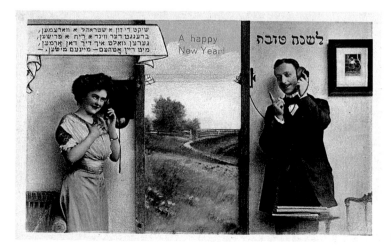

Cat. no. 95

122

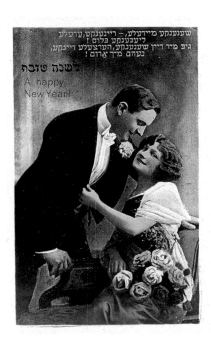

Cat. no. 98

Cat. no. 99

96. Romantic New Year's Greeting: Boat Ride (Fig. 117)
Williamsburg Art Co., New York.
Printed in Germany, circa 1915
Printed paper
5½ x 3½ in. (13.9 x 9 cm)
HUCSM P2155

Our sail – a New Year's greeting
Our wind – a song of hope
Our paddle – heart and will
Our shore – peace and joy

97. Romantic New Year's Greeting: Balcony Scene (Fig. 121)
Williamsburg Post Card Co., New York
Printed in Germany, circa 1915
Printed paper
5½ x 3½ in. (14 x 9 cm)
HUCSM P2172

Soar high and quick, my blessing
A New Year is on its way
Bring comfort and hope to my beloved
And bring good fortune too

98. Romantic New Year's Greetings: A Happy Couple (Fig. 119)
Williamsburg Post Card Co., New York
Printed in Germany, circa 1915
Printed paper
5½ x 3½ in. (14 x 9 cm)
HUCSM P2255

My pretty little girl, my pure and gentle one
My darling flower
Give me your pure, lovely heart
Take me in your arms

99. Romantic New Year's Greetings: A Grieving Woman (Fig. 120)
Publisher: Synaj, Warsaw
Printed in Poland, circa 1915
Printed paper
5 ½ x 3 ½ in. (13.9 x 8.8 cm)
HUCSM P2181

Not a drop of rain is falling,
cries my beloved,
it is a trickle of mourning for you

Sheet Music

100. *Song of Love* Sheet Music (Fig. 125)
New York, 1912
Publisher: Hebrew Publishing Company
Printed paper
14 x 10⅝ in. (35.6 x 27 cm)
Museum Purchase with funds provided by the Lee Kalsman Project Americana Acquisition Fund
HUCSM 70.131

101. *A Brivele Von Chosen* (A Letter from Sweetheart) Sheet Music (Fig. 123)
Publisher: Hebrew Publishing Company
New York, 1915
Printed paper
14 x 10½ in. (35.6 x 26.7 cm)
Gift of Abigail Gumbiner
HUCSM 70.2c

102. *Der Yüdisher Soldat* Sheet Music from the play *Jewish War Brides*
Publisher: Hebrew Publishing Company
New York, 1917

Printed paper
13¾ x 10¾ in. (35 x 27.3 cm)
Museum Purchase with funds provided by the Lee Kalsman Project Americana Acquisition Fund
HUCSM 70.126

103. *My Man (Mon Homme)* Sheet Music
Artists: Channing Pollock and Maurice Yvain
Publisher: Leo. Feist, Inc.
New York, 1921
Printed paper
12¼ x 9¼ in. (31.2 x 23.2 cm)
Museum Purchase with funds provided by the Peachy and Mark Levy Project Americana Acquisition Fund
HUCSM 80.2z

104. *All by Myself* Sheet Music
Publisher: Irving Berlin, Inc.
New York, 1924
Printed paper
12¼ x 9¼ in. (30.9 x 23.3 cm)
Museum Purchase with funds provided by the Peachy and Mark Levy Project Americana Acquisition Fund
HUCSM 80.1f

105. *Because I Love You* Sheet Music
Publisher: Irving Berlin, Inc.
New York, 1926
Printed paper
12¼ x 9¼ in. (30.9 x 23.3 cm)
Museum Purchase with funds provided by the Peachy and Mark Levy Project Americana Acquisition Fund
HUCSM 80.2v

Cat. no. 97

Cat. no. 107

Cat. no. 101

Cat. no. 100, verso

106. *Blue Skies* **Sheet Music**
Publisher: Irving Berlin, Inc.
New York, 1927
Printed paper
12¼ x 9¼ in.(30.9 x 23.3 cm)
Museum Purchase with funds provided by the
 Peachy and Mark Levy Project Americana
 Acquisition Fund
HUCSM 80.1w

107. *When My Dreams Come True* **Sheet Music (Fig. 122)**
Maker: Irving Berlin, Inc.
New York, 1929
Printed paper
12¼ x 9¼ in. (30.9 x 23.3 cm)
Museum Purchase with funds provided by the
 Peachy and Mark Levy Project Americana
 Acquisition Fund
HUCSM 80.2p

108. *Reaching for the Moon* **Sheet Music**
Publisher: Irving Berlin, Inc.
New York, 1930
Printed paper
12¼ x 9¼ in. (30.5 x 23.3 cm)
Museum Purchase with funds provided by the
 Peachy and Mark Levy Project Americana
 Acquisition Fund
HUCSM 80.2g

109. *The Little Things in Life* **Sheet Music**
Publisher: Irving Berlin, Inc
New York, 1930
Printed paper
12¼ x 9¼ in. (30.5 x 23.3 cm)
Museum Purchase with funds provided by the
 Peachy and Mark Levy Project Americana
 Acquisition Fund
HUCSM 80.2o

110. *I Found a Million Dollar Baby (in a five and ten cent store)* **Sheet Music**
Artists: Billy Rose, Mort Dixon, and Harry
 Warren
Publisher: Remic Music Corp.
New York, 1931
Printed paper
11¾ x 9⅛ in. (30 x 23.2 cm)
Gift of Jacqueline Levy Fuhrman and Millicent
 Levy Small
HUCSM 70.97

Wedding Objects

111. Marriage Belt
Johann Conrad Freudenberger (active 1695–
 1732)
Frankfurt am Main, early 18th century
Silver, cast and chased
36 x 1⅛ in. (91.4 x 2.8 cm)
HUCSM 8.5

It was customary among German Jews for
the bride and groom to exchange gifts of
wedding belts.

112. Wedding Ring
Italy, 18th–19th century
Gold, filigree and engraved
⅝ x 1¼ in. diameter (1.6 x 3.2 cm)
HUCSM 9.6

These Italian rings are known to be
wedding rings. The so-called community
marriage rings with tall house-like
structures that have come on the market in
recent decades are not authentic.

113. Wedding Ring
Italy, 18th–19th century
Brass, cast, filigree, engraved and gilt
¾ x ⅞ in. diameter (1.8 x 2.3 cm)
HUCSM 9.7

Cat. no. 100

124

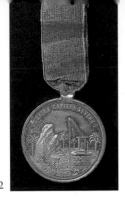
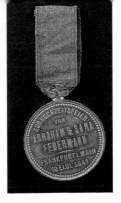

Cat. no. 122

114. Wedding Ring
Italy, 18th century
Gold, filigree and engraved
⅜ x 1 in. diameter (1 x 2.6 cm)
Gift of Mrs. Otto V. Kohnstamm
HUCSM 9.8

115. Wedding Cup and Saucer
Germany, mid-19th century
Porcelain
5 x 6 ¾ in. diameter (12.7 x 17 cm)
Kirschstein Collection
HUCSM 14.38a, b

The cup is inscribed *mazal tov* in Hebrew.

116. Rothschild Hanukkah Lamp (Fig. 10)
Maker: Johann Heinrich Philip Schott
Frankfurt am Main, ca. 1850
Silver, repoussé, cast
21 x 19 in. (53.3 x 48.3 cm)
Gift of the Jewish Cultural Reconstruction, Inc.
HUCSM 27.98

This Hanukkah lamp is thought to have been a wedding present from Baron Wilhelm Karl von Rothschild (1829–1901) to his wife Hannah Mathilde von Rothschild (1832–1924). The Rothschild family coat of arms is emblazoned on the base of the magnificent neoclassical lamp.

Medals

117. Wedding Medal
Germany, 1889
Silver
34 mm diameter
From the Collection of Joseph Hamburger
HUCSM 36.56

This medal commemorates the wedding of Fanny Heymann to Gustav Thalmessinger which was celebrated on September 15, 1889. On the obverse side are coats-of-arms representing Ulm, the bride's home, and Regensburg, where the groom was a banker. Above are two clasped hands and *mazal tov* in Hebrew. On the reverse is the dedicatory inscription in German.

118. Wedding Medal (Fig. 128 a,b)
Germany, 1882
Copper, gilt
28 mm diameter
From the Collection of Joseph Hamburger
HUCSM 36.66

Lina Jaffe and Jakob Alexander, celebrated their wedding in Berlin on October 17, 1882. The medal includes the two family coats-of-arms surmounted by two clasped hands and *mazal tov* in Hebrew. On the top left and right sides, respectively, "Posen" and "Hamburg" are written beneath the inscription, "Dedicated by E. and R.M." in German. On the reverse is the dedicatory inscription in German.

119. Wedding Medal (Fig. 127 a,b)
Germany, 1898
Silver
39 mm diameter
From the Collection of Joseph Hamburger
HUCSM 36.122

The medal commemorates the wedding of Siegmund Rosenbaum and Dora Hamburger, which was celebrated on January 24, 1898. On the obverse side two coats-of-arms, crested with garlands are depicted; within a *ḥuppah* at the bottom are two clasped hands. The Hebrew inscription around the raised rim reads, "As a lily among thorns, so is my love among the daughters. Thou art beautiful O my love, as Tirzah." (Song of Songs 2:2) Tirzah was the bride's Hebrew name. On the reverse center of the medal, is the dedicatory inscription from the parents of the bride, K. and L.H. The groom's Hebrew name, Samson, is included in the dedication. The inscription is enclosed by a circle with the city names Frankfurt a/m, Mannheim, and Grebenstein separated by branches. On the raised rim is a Hebrew inscription, "On the marriage and the day of rejoicing of hearts, the first day of the evening of the new moon, in the month of Shevat, 1898." Copies of the medal were made in silver, bronze, pewter, and aluminum.

125

Cat. no. 119

Cat. no. 118

Cat. no. 126

Cat. no. 127

120. Wedding Medal
Germany, 1896
Copper
33 mm diameter
From the Collection of Joseph Hamburger
HUCSM 36.129a

The medal commemorates the wedding of Clara Weiskopf and Moses Schnerb, celebrated at Merzig on August 10, 1896. On the obverse is a ḥuppah, supported on spiraled columns and surmounted with a six-pointed star finial, enclosing a Hebrew inscription, "I am my beloved's, and my beloved is mine." (Song of Songs 6:3) Below are two clasped hands. Around the rim is a Hebrew inscription with the names of the bride and groom: Moses, the son of Hayyim Gershom and Clara, the daughter of Eleazar. On the reverse, within a wreath, is the dedicatory inscription in German, which identifies that the groom was from Frankfurt.

121. Wedding Medal
Germany, 1905
Maker: Lauer, Nuernberg
Silver
35 mm diameter
From the Collection of Joseph Hamburger
HUCSM 36.137a or b

The medal commemorates the wedding of Julie Selz and Dr. Eugen Szkolny in Munich on March 26, 1905. On the obverse is a boy symbolically forging two hearts together on an anvil, which rests on a tree stump. On the reverse is a dedicatory inscription in German above a rose branch.

122. Anniversary Medal (Fig. 126 a,b)
Frankfurt, Germany, 1881
Tin, plated
32 mm diameter
From the Collection of Joseph Hamburger
HUCSM 36.33

The medal commemorates the anniversary of Abraham and Sarah Federmann celebrated in Frankfurt on 10 Elul 5641 (September 4, 1881). On the obverse is an allegorical scene of a desert with palm trees, a rock, and a well as an inscription in German referring to Isaiah 51:1 "Look to the rock from which you were hewn." On the obverse is the dedicatory inscription in German.

123. Anniversary Medal (Fig. 7)
Maker: Karl Maria Schwerdtner
Vienna, 1900
Bronze
70 mm. diameter
From the Collection of Joseph Hamburger
HUCSM 36.90

This medal commemorates the sixtieth wedding anniversary of Moses and Miriam Leah Luria who were married in Pinsk, Belorussia (now Belarus), in the spring of 1840. It features portrait busts of the couple on the obverse with the dates of their wedding and anniversary in Roman numerals. On the reverse is a Hebrew inscription, "On the 8th of Adar, the year 5660, celebrated in Pinsk, Moses Luria from the seed (Herschel)... and his wife Miriam Leah from the house of Eliasberg from the family of the esteemed Rabbi Ezechiel Landau, on the occasion of their sixtieth wedding anniversary." Above the inscription, there is a Star of David.

124. Anniversary Medal
Germany, 1907
Silver
28 mm diameter
From the Collection of J. Hamburger
HUCSM 36.143

The medal commemorates the silver wedding anniversary celebrated by Joseph and Amalie Wisloch in Frankfurt on April 2, 1907. The dedicatory inscription is on the obverse and the reverse bears the dates 1882/2 April/1907.

Wedding Day Souvenirs

125. *First Wedding in the New Land* (Fig. 47)
Marlene Zimmerman
Los Angeles, California, 1972
Oil and wallpaper on canvas
24 x 30 in. (60.9 x 76.2 cm)
Donated in loving memory of Rose Merkin Kabrins by her children, Sondra K. Bayley, Ronald M. Kabrins and Howdy S. Kabrins
HUCSM 41.396

First Wedding in the New Land was commissioned by the descendants of the Merkin family pictured in the wedding photograph of Ana Danzig and Jack Merkin. Although the couple were recent immigrants, the wedding which took place on June 13, 1911, was celebrated in grand style. The bride wore a lovely white gown and carried a beautiful bouquet and some of the men wore frock coats and top hats. Only grandfather William Merkin wore a traditional tall skullcap.

126. Jonas Family Wedding Invitation (Fig. 129)
San Francisco, 1888
Printed on paper
7 x 4½ in. (17.2 x 10.8 cm)
Gift of Mrs. Felix Jonas
HUCSM 9.93

127. Wedding Invitation (Fig. 130)
Oakland, California, 1920
Printed on paper
8½ x 5½ in. (21.5 x 14 cm)
Gift of Mrs. Felix Jonas
HUCSM 9.92

Cat. no. 132

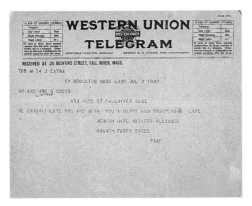

Cat. no. 135

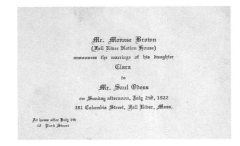

Cat. no. 136

128. Candlesticks

United States, 1920
Sterling silver
Height: 6¼ in. (15.9 cm)
Gift of Mrs. Felix Jonas
HUCSM 11.33a, b

In the late 1980s, Jeanette Jonas presented the Skirball Museum with a *shofar* (ram's horn) which her father had brought with him to the United States in 1870 when he immigrated to California from Bavaria. When Marcus Jonas arrived in the United States, he crafted a wooden box to protect his precious family heirloom, which is preserved in the museum collection along with the *shofar*.

Subsequently, Jeanette Jonas donated other family memorabilia including an album with the wedding invitation of her parents, Sara Drossner and Marcus Jonas, as well as the invitation to her wedding to her cousin Felix Jonas. Her parent's wedding

was held on May 13, 1888 at Saratoga Hall in San Francisco.

Jeanette Jonas was married on January 18, 1920 in Oakland. When she reached age 100 and had no immediate family living, Jeanette decided to present the Skirball with the candlesticks she had received as a wedding gift and used for almost seventy years to kindle the lights for the Sabbath and holidays.

129. Grossfield Family *Ketubbah* (Fig. 48)

Publisher: Zenger and Co., New York
Providence, Rhode Island, inscribed 1901
Ink on paper
15 x 9⅞ in. (38.1 x 25.1 cm)
Gift of Vera S. Hoffman Grossfield
HUCSM 34.306

This is the marriage contract for Hannah and Thomas Hoffman. At the top of the printed form is an illustration of a bride and groom standing under the *huppah* together with the officiating rabbi who holds a cup of wine. The wedding party, separated into male and female groups, stand on either side. The men wear frock coats and top hats; the women, too, wear elegant clothing. However, their apparel dates to about a decade earlier than the wedding, suggesting that this printed form may have been used over a number of years.

A photograph of Harry and Esther Grossfield (Fig. 64), the donor's in-laws, who emigrated from Poland, is preserved in the Skirball collection, in addition to several ritual objects they brought with them when they came to the United States.

130. Levy Family *Ḥuppah*

Salt Lake City, 1906
Silk, appliquéd with ribbon
77 x 77 in. (195.6 x 195.6 cm)
Gift of Eleanor Davidson
HUCSM 9.14

The *huppah* was commissioned by the donor's grandfather, Morris Levy, for his daughter Celia's wedding to Abraham Davidson of Portland, Oregon. The wedding, which took place on October 16, 1906 at the Montefiore Synagogue in Salt Lake City, where Morris Levy was the first president, was the first wedding held at the synagogue. The *huppah* was used again for several family weddings; it was used last for the

wedding of the Davidsons' son David and his bride Charlotte in Los Angeles in 1939.

131. Rosenblum Family *Ketubbah*

Cheyenne, Wyoming, 1913
Ink on printed paper
18 x 23 in. (45.7 x 58.4 cm)
Gift of Barbara Rosenblum Cohen and
　Martha Rosenblum Cooper
HUCSM 34.335

132. Wedding Telegram (Fig. 131)

Cheyenne, Wyoming, 1913
Paper
5¼ x 8 in. (13.3 x 20.3 cm)
Gift of Barbara Rosenblum Cohen and
　Martha Rosenblum Cooper
HUCSM 19a.76

Anna Rebecca Gellman was born on Mary 12, 1897 in New York City. Jacob Topchevsky was born in Poland on May 2, 1892. He immigrated to the United States about 1907–1908, joining his brothers who had come earlier. Like many new immigrants with difficult-to-pronounce names, when they arrived at Ellis Island, the brothers were given the name Rosenblum. Jacob adopted this name in the United States as well. Anna and Jacob met in New York, when she was only about twelve years old; he left shortly thereafter for Cheyenne, Wyoming, where his brother Harry had settled.

When Anna was just sixteen years old, her mother Rose took her to visit Jacob, affirming the family intuition that this would be a good match. Indeed, they decided to be married. The wedding was performed by Judge S.B. Schein, who was not a rabbi, but who could perform Jewish weddings. The *ketubbah* form was sent from New York and was a popular type with an illustration of a wedding scene.

The Rosenblums lived in Cheyenne for more than fifty years and raised six children, three sons and three daughters. Jacob became a paint contractor and in 1924 obtained one of the first real estate licenses in Wyoming. Both were very active members of the community. Anna was a founder of B'nai B'rith and Hadassah chapters in Cheyenne and served as president of those groups as well as the Sisterhood of their synagogue and the Pythian Sisters, the women's auxiliary of the Knights of Pythias.

 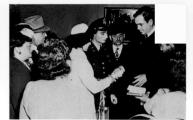

133. Kevitt Family *Ketubbah*
Buffalo, New York, 1920
Printed ink on paper
12 x 9½ in. (30.5 x 24.1 cm)
Gift of Shirley Kalish
HUCSM 34.339

134. Wedding Cake Ornament (Fig. 51)
Japan, 1920
Painted porcelain
5½ x 3½ in. (14 x 8.9 cm)
Gift of Mrs. Ida Kevitt
HUCSM 9.36

128

Ida Sylvia Peisachow was born in New York City on May 1, 1895 and moved to Buffalo, New York in 1913. Louis Israel Kevitt was born in Buffalo on April 15, 1894. They were married in the groom's parents' home on the sixth of Shevat 5680 (25 January 1920). The three-tiered wedding cake was topped with this ornament. The Kevitts moved to Los Angeles in 1945.

135. Odess Family Wedding Telegrams (Fig. 132)
Boston and Brockton, Massachusetts and Baltimore, Maryland, 1922
Printed paper
6½ x 8 in. (16.5 x 20.3 cm)
Gift of Rachel R. Perlitsh, daughter of Saul Odess
HUCSM 9.76a- e

136. Wedding Announcement (Fig. 133)
Fall River, Massachusetts, 1922
Printed paper
Gift of Rachel R. Perlitsh, daughter of Saul Odess
HUCSM 9.77

Clara Brown was born in Russia about 1895 and immigrated to the United States around 1915 with her mother and sister. Saul Odess was born about 1892 in Latvia and came to the United States shortly before World War I. His passage was sponsored by a cousin who had emigrated earlier and was living in New York. Saul got a job at a shoe factory in Brockton, Massachusetts, but enlisted in the Army when the United States entered the war—even before he became a citizen; he served in France.

After Saul was discharged and returned to the United States, he met Clara, who was working as a salesgirl in Fall River, where they were married in 1922. Saul established

a business as a "dry goods peddler," serving people who lived on farms and out-of-the-way communities. They both attended school, learning to read and write English so they could become citizens.

Saul was very active in the Zionist Movement helping to raise money to help establish a Jewish State. He won a trip to Palestine, where he purchased land and hoped to settle the family, but their plans were thwarted by World War II. In 1954 they retired to Los Angeles to be near their daughters, Rachel Odess Perlitsh and Minnie Odess Berkovic, and their five grandchildren.

137. Weiner Family Mirror
Chicago, Illinois, 1938
Metal, photo, glass
1¾ x 2¾ in. (4.4 x 7 cm)
Gift of Harry S. and Shirley E. Weiner
HUCSM 31.60

Harry S. Weiner and Shirley E. Richman were married on June 19, 1938. This mirror, with a wedding portrait of couple, was a souvenir of their marriage. The Weiners also donated their ten'aim (cat. no. 91).

138. Berkus Family "Miss Ileen" B-24 Decoration
from *B-24 Liberator in Action* catalogue.
On loan from Ileene and Don Berkus

Ileene Rosenberg and Don Berkus met as students at UCLA in 1941. In 1943 Don joined the army and became a pilot flying B-24s. He decorated his plane with his fiancée's picture. On display is a catalogue with an illustration of Don's plane "Miss Ileen." Don returned home on August 9, 1945; two weeks later he and Ileene were married in a festive ceremony that also celebrated the end of World War II. Don and Ileene have three children and six grandchildren.

139. Krischer Family Wedding Memorabilia
On loan from Ruth and Sidney Krischer

Ruth Levin and Sidney Edward Krischer met when both were serving in the Armed Services during World War II. They were married on June 25, 1944 in Orlando, Florida. On display are their ketubbah, an announcement of the wedding, and congratulatory cards.

Anniversaries

140. Golden Wedding Anniversary Cup
Vienna, 1891
Silver, cast and engraved
10¼ x 3 ⅞ in. diameter
26 x 9.7 cm
Gift of the Jewish Cultural Reconstruction, Inc. (No. 258)
HUCSM 18.17

The cup is inscribed in German "To our dear relatives in memory of your golden wedding anniversary from the Family Friedman, Arad, 1841–1891." The cup was looted by the Nazis during World War II. When its owner could not be identified after the war, it was entrusted along with other heirless items to the Jewish Cultural Reconstruction to place in a Jewish institution. The Hebrew Union College Collection received the cup at that time.

141. Rogers Family Silver Anniversary Cup (Fig. 9)
Germany, dated 1871
Silver, cast and engraved
6¾ x 3¾ in. diameter (17.1 x 9.5 cm)
Gift of Ilse M. Rogers
HUCSM 9.82

The silver cup was presented as a tribute to a member of the Rogers family in honor of their twenty-fifth anniversary in 1871. During World War II, the cup was kept by non-Jewish friends of the family who buried it. In 1950 these friends sent the cup to George and Ilse Rogers on the occasion of their marriage.

142. Kester Family Prayer Book
Germany, 1867
Velvet-covered book with faux gilt decorations
7⅛ x 4¼ in. (20 x 11.4 cm)
Gift of Susanne and Paul Kester
HUCSM 9.75

143. Fiftieth Wedding Anniversary Invitation for Susanne and Paul Kester (Fig. 136)
Los Angeles, 1999
Printed paper
On loan from Susanne and Paul Kester

Susanne Luft and Paul Kester met in 1939 in southern Sweden at a Jewish boarding school for refugee children. Paul had come

1949 - 1999

*Our looks have changed,
our spirit has not*

**Cat. no 143
Susanne and Paul Kester**

under the auspices of the Kindertransport
program from his native Wiesbaden;
Susanne had come earlier from Berlin. Paul's
bar mitzvah was celebrated at the school
three months later than scheduled because
the synagogue at Wiesbaden had been
destroyed on *Kristallnacht* ("night of the
broken glass"), November 9–10, 1938. One
of the gifts he received for his bar mitzvah
was an embroidered yarmulke that Susanne
made for him, which he has treasured ever
since. After the war, Paul was given a prayer
book by an uncle that had belonged to his
relatives, the Kleinstrass family.

The couple, who felt very fortunate to
spend the war years in neutral Sweden,
were married in January 1949 by Rabbi
Samuel Kath in his study. The photograph
they used on their fiftieth-anniversary
invitation was taken in Sweden shortly
before they emigrated to the United States
and Los Angeles. Their son Daniel and
daughter-in-law Gunilla live in Buffalo, New
York, with their two daughters, Anya and
Shiri, who lent flower girl dresses to the
exhibition. The Kesters celebrated their
fiftieth wedding anniversary in 1999 at the
Skirball Cultural Center.

**144. *Shalah Manot* and *Matan Beseter*
Tzedakah Plate (Fig. 12)**
Maker: Moshe Zabari
Jerusalem, 1989
Silver
3½ x 11 in. diameter (8.9 x 28 cm)
Presented to the Hebrew Union College
 Skirball Museum in honor of the Fortieth
 Wedding Anniversary of Peachy and Mark
 Levy by their children and grandchildren.
HUCSM 23.18

Moshe Zabari's career has been devoted to
the creation of Jewish ritual objects and in
recent years to sculpture inspired by themes
of social justice from the Bible. Israeli born
and trained, Zabari lived in the United States
from 1961 to 1988, when he returned to
Israel. He worked at The Jewish Museum in
New York in the Tobe Pascher Workshop,
which was founded in 1955 by Ludwig
Wolpert, pioneer in applying the principles
of contemporary design to Judaica.

The *Tzedakah* plate Zabari created in
honor of the Levys combines two acts
required to observe the Purim holiday, to
give gifts to friends and charity to the poor.
The Hebrew letters of the quote from the
scroll of Esther (9:22) form the design motif
of the plate.

**145. Peachy and Mark Levy Fiftieth
Wedding Invitation**
Los Angeles, 1999
Printed paper
5½ x 8½ in. (14.0 x 21.6 cm)
On loan from Peachy and Mark Levy

**146. Sabbath Candleholder and
Candle Box**
Maker: Harley Swedler
New York, 1999
Olive wood and silver
On loan from Peachy and Mark Levy

This special box made of imported
olive wood was commissioned from
Harley Swedler, an architect known
for his cutting-edge designs of
contemporary Judaica by the children
and grandchildren of Peachy and
Mark Levy in honor of their fiftieth
wedding anniversary. As turn-of-
the-twentieth-century objects of olive
wood from the Holyland are a
featured part of the Levy collection,
it was a logical choice of material for the

artist. The box is made of fifty layers of
olive wood and stores fifty candles. Inside
the lid is an engraved quotation from the
late Abraham Joshua Heschel, a theologian
whose teachings are especially meaningful
to the Levys: "The Sabbath is a bride and
its celebration is like a wedding." The top
of the box has space for two Sabbath
candles to be lit and includes the words
Sabbath, bride, celebration, and wedding.

147. DeWitt Wedding Invitation
New York, 1948
Printed paper
On loan from Marian and Don DeWitt

**148. Fiftieth Wedding Anniversary
Invitation for Marian and Don DeWitt
(Fig. 135)**
California, 1998
Printed paper
5¾ x 8⅝ in. (14.6 x 21.9 cm)
Gift of Nancy Berman and Alan Bloch
HUCSM 9.84a-f

Marian Bloomgarden and Don DeWitt met
on June 7, 1942 when they were fourteen-
year-old students at Great Neck High
School on New York's Long Island. One
night both attended a show at school and
afterwards went to a local ice cream parlor.
Don borrowed a nickel from a friend to buy
Marian a Coke. Then he gave her a ride
home on the handlebars of his bike. After
graduation Don went to MIT and Marian,
a year later, to NYU. They became engaged
the night of Don's senior prom.

Rabbi Rudin of Temple Beth El in Great
Neck officiated at their wedding on March 7,

Because you have touched our lives in a special way . . .

Cat. no. 148 Marian and Don DeWitt

129

Cat. no. 149
Regina and Morris Tarica

1948 at the Waldorf Astoria Hotel in New York. Don had just turned twenty and because he was underage needed permission from his parents to get the marriage license.

In June 1954 they moved to Los Angeles. Don opened a metal cutting machine tool business and Marian began actively working as a volunteer in the community. They have four children and six grandchildren.

149. Tarica Family Sixtieth Wedding Anniversary Album (Fig. 137)
Los Angeles, 2000
On loan from Dr. Morris and Regina Tarica

Regina Amado was born in Brooklyn, the daughter of Raphael and Esther Amado, who had immigrated from Izmir, Turkey. Morris Tarica was born in Los Angeles, the son of Rachel and Marco Tarica from Rhodes. Regina's family moved to Los Angeles in 1925. She attended Los Angeles High School and then UCLA where she graduated with a major in history. Morris went to Manual Arts High School, LA Community College, the University of Southern California, and USC Dental School, where he graduated in 1937. The couple met through family members active in the Sephardic community; Regina's older sister had married Morris's cousin. Morris proposed at a USC-UCLA football game. They were married in 1940 in the fruit orchard of the Amado family home in Encino, which at the time was a rural stretch of the San Fernando Valley.

The couple lived in Los Angeles for three years, until Morris was drafted into the Army Air Force. For four years, Regina traveled with him throughout the United States from base to base. After his discharge, they returned to Los Angeles and Morris established his dental practice. Over the years, Regina has been known for her service as treasurer for numerous volunteer organizations including the PTA, Wilshire Boulevard Temple, and the two Sephardic temples. The Tarica's two sons, Samuel and Mark, both became dentists like their father. The Taricas have three grandchildren.

In honor of the Tarica's sixtieth wedding anniversary, family and friends created this "Memory Book" with tributes and photographs.

150. Novorr Family Anniversary Cards
Los Angeles, California
On loan from Pearl and Jerry Novorr

Pearl Test and Jerry Novorr met at a Confirmation dance in Kansas City, Missouri, in 1934. Jerry attended the Kansas City Art Institute and Pearl the University of Kansas. They were married in 1938 and moved to Los Angeles in 1945. Jerry worked as a graphic designer with his own advertising agency. He has created a greeting card for Pearl for every birthday, Valentines Day, and wedding anniversary for the past sixty-three years. They have two children, five grandchildren and a great-granddaughter.

Fine Arts

151. *Portrait of a Man from Breslau* (Fig. 54)
Henschel Brothers
Breslau, Germany, ca. 1829
Pastel
18 x 14½ in. (45.7 x 36.8 cm)
Kirschstein Collection
HUCSM 41.6

152. *Portrait of a Woman from Breslau* (Fig. 55)
Henschel Brothers
Breslau, Germany, ca. 1829
Pastel
17¾ x 14½ in. (45.1 x 36.8 cm)
Kirschstein Collection
HUCSM 41.7

153. *Portrait of Rabbi Aaron Chorin* (Fig. 56)
Early 19th century
Oil on canvas
18 x 60 in. (46 x 152 cm)
Kirschstein Collection
HUCSM 41.46

154. *Portrait of Mrs. Aaron Chorin* (Fig. 57)
Early 19th century
Oil on canvas
24¼ x 19½ in. (61.6 x 49.5 cm)
Kirschstein Collection
HUCSM 41.47

155. *Portrait of Katherine Schiff Illowy* (Fig. 58)
Henry Mosler (1841–1920)
Cincinnati, Ohio, 1869
Oil on canvas
35 x 28¼ in. (88.9 x 71.8 cm)
Gift of the Skirball Foundation
HUCSM 41.216

156. *Portrait of Rabbi Bernard Illowy* (Fig. 59)
Henry Mosler (1841–1920)
Cincinnati, Ohio, 1869
Oil on canvas
36 x 29 in. (91.4 x 73.7 cm)
Gift of the Skirball Foundation
HUCSM 41.255

157. *Man by a Window* (Fig. 60)
Josef Israels (1824–1911)
Holland, late 19th century
Oil on canvas
16¼ x 13¼ in. (41.3 x 33.7 cm)
Gift of Mr. and Mrs. Sidney Eisenshtat
HUCSM 41.327

158. *Woman Seated at Table by a Window* (Fig. 61)
Josef Israels (1824–1911)

Holland, late 19th century
Oil on canvas
15½ x 12¾ in. (39.4 x 32.4 cm)
Gift of Mr. and Mrs. Sidney Eisenshtat
HUCSM 41.326

159. *Portrait of Moses Rothschild* (**Fig. 62**)
Louis Kronberg
Baltimore, Maryland, 1935
Oil on canvas
48 x 36 in. (121.9 x 91.4 cm)
Anonymous gift
HUCSM 41.339

160. *Portrait of Miriam Moses Rothschild*
(**Fig. 63**)
Louis Kronberg
Baltimore, Maryland, 1936
Oil on canvas
48 x 36 in. (121.9 x 91.4 cm)
Anonymous gift
HUCSM 41.340

161. *Portrait of Harry and Esther*
Grossfield (**Fig. 64**)
Poland, late 1890s
Tinted photograph
19⅞ x 13 ⅞ in. (50.5 x 35.2 cm)
Gift of Vera S. Hoffman Grossfield
HUCSM 68.266

162. *The Wandering of Adam and Eve*
(**Fig. 3**)
Abel Pann
Jerusalem, circa 1924–1926
Lithograph
10⅞ x 8 in. (27.6 x 20.8 cm)
HUCSM 66543 0

Contemporary Weddings

163. A Wedding at the Skirball
(Fig. 138)
Photographer: Bill Aron
Photographs courtesy of Ruth Ellenson and
Robert Guffey Ellenson

Ruth Andrew Ellenson and Robert Aaron
Guffey were married on Sunday August 8,
1999 at the Skirball Cultural Center in Los
Angeles. Ruth, who was born in Jerusalem
and raised in New York and Los Angeles,
graduated cum laude in religion from the
University of Southern California. Robert
Guffey, who grew up in Huntington Beach,
California, graduated summa cum laude from
USC, where he majored in history and
English.

The couple attended graduate school in
New York City, where Ruth received her
M.F.A. from Columbia University and
Robert is a Ph.D. candidate at New York
University. Currently, the couple resides in

Cat. no. 163
Ruth Ellenson and Robert Guffey

Los Angeles. Robert is the Director of
Interfaith and International Relations at the
American Jewish Committee, and Ruth is a
web producer and writer.

Bill Aron was the photographer at the
Ellenson-Guffey wedding. Bill Aron, who
holds a Ph.D. in sociology, is best known for
his photographic work chronicling the Jewish
communities of the Soviet Union, Cuba,
Jerusalem, New York, and Los Angeles. A
volume of his work, entitled *From the Corners
of the Earth*, was published by The Jewish
Publication Society. Since 1989 Aron has
been collaborating with the Museum of the
Southern Jewish Experience, in Mississippi,
on a project depicting Jewish life in the
"Deep South"; this work is expected to be
published in 2002.

Aron's photographs have been exhibited
in major museums and galleries throughout
the United States, Europe, and Israel. His
work has also appeared in a wide variety of
publications and is found in numerous
public and private collections. Bill Aron lives
in Los Angeles.

164. *Ḥuppah* (**Fig. 18**)
Maker: Corinne Soikin Strauss
Croton-on-Hudson, New York, 1995
Hand-painted silk, silk brocade
6 x 6 ft. (182.9 x 182.9 cm)
Museum Commission with funds provided by
the Estate of Tutty Lowens
HUCSM 9.81

The imagery on the ḥuppah symbolizes the
couple's entrance into the holy covenant of
marriage. The golden gateway of "seven" which
leads to the heavens, full of stars, is a symbol of
limitlessness. The surrounding four seasons
refer to the cycle a marriage goes through. The
rainbow connotes a biblical theme: "Ezekiel
likened God unto a rainbow."

165. Double Wedding Cup
Maker: Moshe Zabari
New York, 1970
Silver, engraved
On loan from Felice and Ronald Andiman

The double wedding cup was a gift from the
artist to Felice Rappaport and Ronald Andiman
on the occasion of their marriage on March 15,
1970. The cup is inscribed from the Song of
Songs 6:3, "I am my beloved's and my beloved
is mine." When open, the cups can also be used
as candlesticks.

166. *Sheva Berakhot* **Cup (Fig. 65)**
Maker: Rafi Landau
Jerusalem, 1998
Silver, parcel gilt
9 in.; 7¼ in. diameter (22.8 cm; 18.4 cm
 diameter)
Museum purchase with funds provided by the
 Family and Friends of Larry and Carol Mann in
 honor of their Fiftieth Wedding Anniversary
HUCSM 9.88a-c

167. Ketubbah
Artist and Calligrapher: Peretz Wolf-Prusan
San Francisco, California, 1980
Ink and silkscreen print on paper
21½ x 29⅝ in. (54.6 x 75.2 cm)
Museum purchase
HUCSM 34.219

This document is an artist's proof of the
ketubbah for Paul Weiss and Allison Kent
whose wedding was held on Sunday, the
second day of Rosh Hodesh Tammuz 5740
(June 15, 1980). The personalized, egalitar-
ian text was written in Hebrew and English.
The *ketubbah* is comprised of seven
decorative panels of handmade paper, each
corresponding to a day in the story of
creation.

168. Yarmulke
New Jersey, 1993
Crocheted synthetic and metal thread
Gift of Andrew and Dina Elkins
HUCSM 9.95

This yarmulke (skullcap) was crocheted by
Hannah Silverstein for the wedding of her
grandson Andrew Elkins to Dina Karmazin
on October 31, 1993 in Alpine, New
Jersey. Hannah Silverstein continued her
tradition of crocheting all of the yarmulkes
for every family bar mitzvah and wedding.

169. Kiddush Cup
Maker: Kerry Feldman
Breckenridge, Colorado, 1995
Glass
Height: 11½ in. (29.2 cm)
Museum purchase with funds provided by
 the Carylon Foundation
HUCSM 18.69

170. Blessing Bowl
Maker: Susan Felix
San Francisco, 1995
Pit and smoke fired ceramic
4 x 14½ x 14½ in. (9.5 x 34.5 x 34.5 cm)
Museum Purchase with Project Americana
 Acquisition Funds
HUCSM 6.7

The bowl was originally made for a
wedding. The guests at the wedding
wrote blessings for the bride and groom
and put them in the bowl, thus the bowl
became a part of the ceremony. The artist
inscribed the bowl in Hebrew with the
verse "May God's countenance shine
upon you," from the priestly blessing
(Numbers 6:26). She chose this blessing
because it is used both for men and
women.

171. Mezuzah
Artist: Luigi Del Monte
Italy, 1999
Anodized aluminum, hand finished
3½ x 1⅛ x ⁷⁄₁₆ in. (8.9 x 2.9 x 1.0 cm)
Gift of the artist in honor of Grace Cohen
 Grossman
HUCSM 37.54

This *mezuzah,* a symbol of welcome to a
Jewish home that hangs by the front door,
created by Luigi Del Monte, is both
traditional and modern. The uncluttered
shape with incised linear designs
maintains the symbolism and characteris-
tics of the traditional object, which
reflects continuity of the tradition from
ancient to contemporary life.

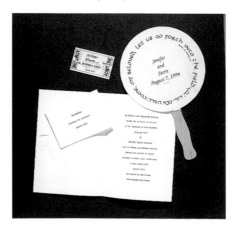

Cat. nos. 173–175

172. Mazal Tov Bag
Maker: Barbara Gordon
Los Angeles, 1992
Cotton and polyester
10⅛ x 8½ in. (25.7 x 21.6 cm)
Museum purchase with funds provided by the
 Audrey and Arthur N. Greenberg Fund
HUCSM 9.69

**173. Robins–Hunegs Wedding Invitation
(Fig. 139)**
Minneapolis, 1994
Printed paper
5½ x 8½ in. (14 x 21.6 cm)
Gift of Ruby and Gerald Bubis
HUCSM 13.116

174. Fan
Minneapolis, 1994
Printed cardboard, wood
Gift of Ruby and Gerald Bubis
HUCSM 9.80a

175. Magnet
Minneapolis, 1994
2 x 3½ in. (5 x 8.9 cm)
Gift of Ruby and Gerald Bubis
HUCSM 9.80b

Jenifer Beth Robins, daughter of Jo Ellen
and Stanford Robins, was married to Steven
Mark Hunegs, son of Dobra and Richard
Hunegs, on August 7, 1994 at Siebert Field
at the University of Minnesota.

176. Sommerfeld Wedding Program
Los Angeles, 1996
Printed paper and ribbon
8⅝ x 5⅝ in. (21.9 x 14.3 cm)
Gift of Irma and Benny Sommerfeld
HUCSM 9.87

Irma Essick and Benny Sommerfeld met at a
Friday evening dinner at Temple Beth Am in
1993. On July 7, 1996 they were married at
the Skirball Cultural Center. Benny, who sings
with the Valley Beth Shalom Synagogue Choir,
had the entire choir sing at the wedding. Irma
and Benny now have two daughters.

A Celebration of Love and Fantasy

The Skirball invited artist Ed Massey to create a site-specific installation based on his engagement to Dawn Harris and their June 20, 1998 wedding. The idea emerged in discussions with the artist after we learned about the incredible wedding gown that Ed had fashioned for Dawn: a nearly two hundred-pound mobile sculpture made of a cloth bodice and steel-frame skirt decked with 1,060 roses handcrafted from cloth and modeling paste. The five-foot train features a pale blue pond with fourteen ducks, to symbolize fertility and the couple's future family. The installation is in two parts: the make-believe birthday party and Ed's proposal; and the garden ceremony with the bride and groom standing beneath a *tallit ḥuppah.*

The artist described his plan for the engagement:

> The proposal had to be so special, so fun, and so very extraordinary...like Dawn. It would have to be surprising, yet not cliché; over the top, but not ridiculous—no bunji jumping, no skydiving, ok, nothing too dangerous! Selecting the right ring was scary enough; both our feet would have to be planted on the ground, after all my head would be in the clouds. No this *yiddishe boychik* would have to dream up the perfect fantasy proposal for my fairytale bride.

Indeed, he did, with the help of his assistant Genero, who organized a pretend one-year-old birthday party for his niece (then nine months old) at a

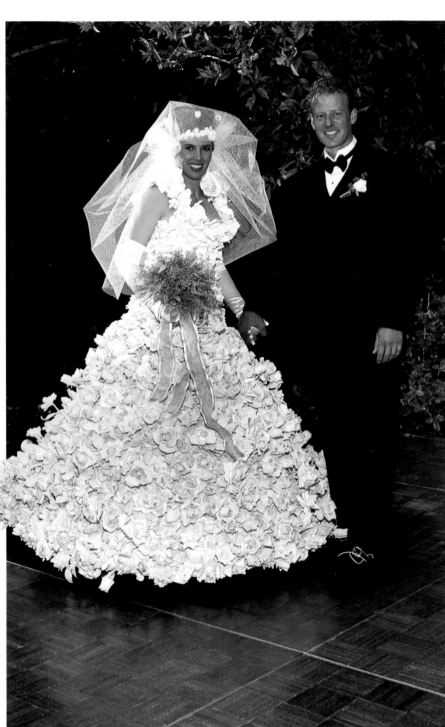

Fig. 140 Ed Massey and Dawn Harris Wedding Portrait, 1998

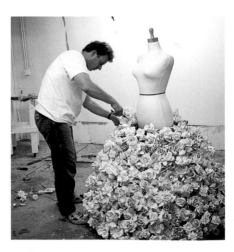

Fig. 141 Ed Massey making Dawn's wedding dress, 1998

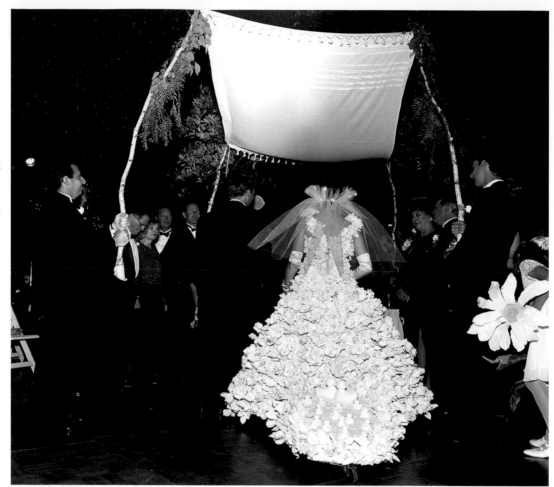

Fig. 142 Wedding ceremony of Ed Massey and Dawn Harris, 1998

Fig. 143 Boy hitting a piñata, 1998

beach in Santa Monica. Six adults and twelve children from his family went along with the ruse. The engagement ring was hidden among wrapped boxes of toys in a piñata. One of the older girls brought the box with the ring wrapped in a felt strawberry to Dawn, who at first thought it was plastic, like the ones given to the children. Finally, Ed proposed; Dawn gave him a kiss and the fantasy engagement became a reality.

Then, came the wedding plans. Ed wrote about the decision to create a gown for Dawn as his wedding gift to her.

> I remember thinking out loud about what Dawn might look like on our wedding day; surely extraordinary — as she is. Her dress would be different from any other.
>
> I could make it.
>
> Dawn listened with amusement. She smiled and said, 'Do it Eddie. I'd wear it.' So my research began—turn of the century, Victorian, contemporary, bodices, hoopskirts, textiles, silks, lace. But after all that, my passion for sculpture dictated my desire for

creating a sculptural gown; our mutual love of roses decided the gown's motif. The dress would be elegant, albeit, with a dose of whimsy. With a gown in full bloom encompassing her, Dawn would be a bride like no other.

The music that accompanies the installation was composed by Dawn Harris, who is a songwriter, as her gift to Ed.

Ed Massey has a B.A. from UCLA and an M.F.A. from Columbia University. His body of work is aimed at the public arena. He focuses on such critical social issues as urban violence, poverty, the homeless, ethnic intolerance, and child abuse in order to rivet attention on those subjects. He is the author of *Milton,* a storybook for children and adults about imagination and the creative process. Massey conceptualized and designed the recently dedicated 165 foot–high *Tower of Hope* in Beverly Hills. The tower, painted by thousands of California children, is a project of Portraits of Hope, a creative therapy program for hospitalized children and their families anywhere in the world. Massey's design for the tower came from his work with the children.

A Guide to Wedding Rituals

Tal Gozani

Both law and custom structure the Jewish wedding ceremony. This guide explains the origins of some of the rituals and describes what to expect at Jewish wedding ceremonies in America today. Many of the customs reflect Ashkenazi and European traditions, but some contemporary wedding rituals that derive from Sephardi traditions and Middle Eastern Jewish communities are also described. This guide takes you through the ritual order of the wedding.

Aufruf

On the Sabbath prior to the wedding, the groom celebrates a synagogue ceremony called the *aufruf*, from the Yiddish "to call up," or *Shabbat ḥatan*, in Hebrew. He is honored by being called up to read from the Torah. After his public reading, the groom is showered with fertility symbols of rice, nuts, and candy.

Mikveh

Prior to the wedding, in observance of Jewish family purity laws, the bride visits the *mikveh* (ritual bath), where she immerses herself in an act of spiritual purification. Traditionally, the Ashkenazi bride's visit to the *mikveh* was conducted discreetly. In some Sephardi and Middle Eastern communities the bride is escorted in a grand procession to and from the ritual bath, making the prenuptial immersion an occasion of great festivity.

Henna

It was customary in a number of North African and Middle Eastern communities including Morocco, Tunisia, and Yemen to paint the bride's hands with red henna, a symbol of her virginity and protection against the evil eye. The timing of the henna ceremony varied in different places, but this tradition was always celebrated with members of both families. The henna ceremony is enjoying a renaissance today as some couples use it to connect to an ancestral tradition.

Kabbalat panim

Kabbalat panim, a festive ceremony welcoming the wedding guests, takes place just prior to the wedding, with the bride and groom greeting their guests in separate rooms. On this day, the bride and groom are considered royalty, and it is customary for the bride to be seated on a throne, surrounded by family and friends. The groom's reception is known by the German term *Tisch*, which refers to the table at which the marriage documents are signed. At the *Tisch*, two documents are signed before witnesses—the *tena'im* between the parents of the bride and groom and the *ketubbah*, the marriage contract.

Tena'im

Originally, in talmudic times, the *tena'im* (literally the "conditions" of marriage) accompanied the formal betrothal. Outlining the specific obligations agreed to by both parties, the *tena'im* constitute a notarized legal contract that specifies not only the date and place of the proposed marriage but the financial arrangement reached by the two families. The *tena'im* detail the nature of the bridal dowry, the level and duration of future financial support for the young couple, and the penalty for breaching the wedding contract. Traditionally, some Sephardi communities in Italy, Holland, Greece, Bulgaria, and Yugoslavia included the *tena'im* text side by side with the *ketubbah* text.

The *tena'im* reflect the Yiddish maxim "*Besser di ershteh lugzeh vi di letzteh,*" "better to argue at the beginning than to fight at the end." As family-arranged weddings have gradually become a thing of the past and *tena'im* are not required by Jewish law, some Jews have creatively reconceptualized the *tena'im* as a type of prenuptial agreement. Couples have used this tradition to formalize decisions about their married life, specifying responsibility for money management, the raising of children, and choices about work and where to live. While this may seem quite contemporary, *tena'im* conform to a precise historical use: to formally announce and protect the couple's respective personal interests.

After the *tena'im* are signed, notarized, and read aloud by the rabbi or another honored guest, a ceramic plate is broken by the future mothers in-law in a symbolic gesture commemorating the destruction of the Temple in Jerusalem. Anticipating the shattered glass that ends the wedding ceremony, the broken plate serves as a physical reminder and admonition that a broken engagement can never be mended. Today, shards of the plate are often preserved in different forms: in their broken state, restored to their original configuration, or crafted into various ornamental objects such as jewelry and amulets.

Ketubbah

The *ketubbah* is a Jewish legal contract that details the groom's obligations to the bride, the bride's rights, and all marital duties. Two witnesses, and in some modern communities the bride and groom, sign the *ketubbah*, which is read aloud during the wedding ceremony. Following its reading, the *ketubbah* is presented to the bride for her to keep. In the eighteenth and nineteenth centuries, and especially among Sephardi women, brides often kept their *ketubbot* folded in an envelope under their pillows.

Bedeken

After signing the *ketubbah*, the groom is escorted to the waiting bride, whose face he veils personally to avoid the famous mistake recounted in the Hebrew Bible of Jacob marrying Leah instead of his beloved Rachel. This predominantly Ashkenazi ceremony is known in Yiddish as *bedeken di-kaleh*, veiling the bride. The rabbi then proclaims blessings of fertility. In some communities the bride's father, or the parents of both bride and groom, will also place his or their hands above the bridal couple's heads and recite a blessing. If the bride is going to sign the *ketubbah*, as in many modern ceremonies, she generally does so at the end of the *bedeken* ritual.

Procession

First the groom and then the bride are escorted to the *huppah* for the commencement of the wedding ceremony. This evokes the bringing of Eve to Adam as recounted in Genesis and echoes the ancient practice of treating the bride and groom like royalty. Even the roles of best man and maid

matron of honor have ancient precedents: Gabriel and Michael, the two angels who, according to the Midrash, witnessed the wedding of Adam and Eve, are the prototypes for the attendants of the bride and groom. Today these biblical motifs have been combined with various American influences to create many different processional customs.

Circling

After the bride arrives at the *ḥuppah*, she will in traditional ceremonies circle the groom seven times. There are numerous interpretations of this custom. One holds that it is an allusion to the seven days of creation, a reminder that marriage is also a process of creation.

Giving of the ring

Erusin begins with a rabbinical blessing and is followed by the bride and groom sipping from the same goblet of wine. The first half of the wedding ceremony is completed with the declaration of the marriage formula under the *ḥuppah*. It is customary for the officiating rabbi to pronounce in Hebrew the biblical formula—"Behold, you are consecrated unto me with this ring according to the law of Moses and Israel"— with the groom repeating it word by word after him. According to Jewish law, a verbal declaration of marriage is not valid unless it is accompanied by a *kinyan*, a legally binding physical transaction. Since the seventh century, a gold or silver ring has been the traditional and preferred *kinyan* offering. Its round shape and never-ending contour symbolize the hope for an eternal marriage. Another precept of Jewish law holds that the ring must be unpierced and free of precious stones to avoid any possible misrepresentation that its value could be construed as the actual basis of the marriage.

It has become common in the United States, especially in Reform and Conservative congregations, to have a "double ring" ceremony in which the bride also gives a ring to the groom and recites either

marriage vows or a biblical verse, often "I am my beloved's and my beloved is mine," from the Song of Songs 6:3.

Sheva berakhot

The Seven Benedictions initiating *nissu'in*, the second portion of the wedding, are read either by the rabbi or by special guests whom the bride and groom wish to honor. The liturgy of six of the blessings, recalling the presence and acts of God, originated in the Talmud. In the sixth century, the seventh blessing, the sanctification of God's name over wine, was added. These same blessings are read again at the conclusion of the festive meal and after meals throughout the ensuing week of wedding celebrations.

Breaking the glass

After reciting the *sheva berakhot* and drinking the wine, the groom breaks a glass under his right foot, which is sometimes followed by the rabbi's invocation of the traditional priestly blessing. While the breaking of the glass may be the most recognizable and memorable element of the Jewish wedding, it is merely a custom with limited religious significance. In medieval Germany, the groom would throw the glass against a designated stone, called the *Traustein*, built into the wall of the synagogue yard. In Libya, the groom broke a glass full of wine as a sign of plenty.

Several interpretations of the meaning of this custom exist. The talmudic explanation suggests that it serves to temper excessive and indecent rejoicing. Amid the troubles of the fourteenth century, a second interpretation surfaced, relating the breaking of the glass to the destruction of the Temple in Jerusalem and thereby reminding Jews that, even at the height of joy, moments of sadness should be recalled. After the Holocaust, the custom has also come to signify a more general reminder for historical Jewish suffering and loss. Another suggestion is that the breaking of the glass was originally intended to ward off evil spirits. All interpretations do agree on one

point, namely that following the moment of reflection, the time has come to rejoice!

Yiḥud

Immediately following the ceremony under the *ḥuppah* and as the wedding guests assemble for the wedding festivities, the bride and groom retire to a secluded spot for a few moments of privacy. This recalls a traditional ceremony called *yiḥud*, in which the bride was carried to the groom's home where their marriage was consummated in private. It is customary for bride and groom to fast on the day of their wedding, and the couple break their fast during *yiḥud*.

Seudat mitzvah

One of the best-known Jewish wedding-dance customs is lifting the bride and groom in chairs on the shoulders of their guests. Sometimes the couple will be whirled around each other, holding the ends of a handkerchief; sometimes they are paraded around the room in a processional. The origin of this custom most likely celebrates the privileges of bride and groom as equivalent to those of king and queen, who were often carried in chairs through crowds and in parades. Another theory for the origin of this custom is that during the days when bride and groom were separated by a *meḥitzah*, a physical barrier that isolated men from women, the added height let them catch a glimpse of each other.

Mizinke

The *mizinke* is one of the last dances of the wedding reception. Traditionally, this dance paid tribute to a mother who has brought her last daughter to the *ḥuppah*. Today, the custom is commonly extended to include both father and mother in recognizing the marriage of their last child. Seated on chairs in the center of the dance floor, the parents are presented with bouquets and circled by the company in a dance that celebrates the completion of their parental responsibility.

Conservation of Wedding Costumes in the Exhibition

Sharon K. Shore

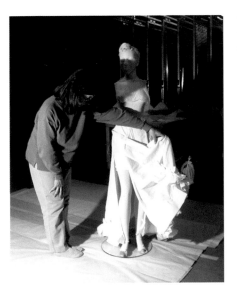

Fig.143 Sharon K. Shore working on Annie Oshinsky's gown for the exhibition.

The costumes seen in this exhibition were probably worn for less than a day during one of our most important cultural events, the wedding ceremony. During this momentous occasion, the nervous bride-groom perspires, droplets of celebratory champagne fall onto the bride's dress, last-minute pats on bridal makeup leave red and pink traces on gloves, and tiny bits of wedding cake stick to lace bodices, trousers, and veils.

After the ceremony, the wedding clothing is stored with loving care and seldom seen. Perhaps the bridal dress is worn again by daughters at their weddings or much later, altered to become a Purim costume. Forever a symbol of cherished memories, it is again folded, draped, or boxed for storage. Over time wrinkles and creases can be seen, fabric fibers age, and storage paper slowly becomes more acidic. The conservator, as a trained professional who provides care and preservation for art and artifacts, assumes the task of addressing this accumulated history. Guided by principles of protection and respect for the integrity of the costume artifact as part of our cultural heritage, the conservator develops and carries out appropriate treatment to make it structurally stable and aesthetically acceptable for exhibition.

In order to determine treatment of costumes for an exhibition, the conservator carries out a systematic procedure of description and condition assessment. He or she examines each costume closely and compiles a detailed description of weave, fiber, construction, and embellishment, as well as manufacturer and designer labels. Multiple measurements are taken and recorded for use later during customization of exhibition mannequins. Occasionally, the conservator discovers intimate and personal details of the costume. For instance, small "something blue" posy of velvet flowers tied with silk ribbon, found sewn to the inside of a satin train, was a complete surprise to the bride, Peachy Levy, who had worn the wedding gown. Analysis of puzzling features of construction revealed alterations made for second- or even third-generation wearers.

Next, the conservator makes a thorough and careful assessment of the condition of the costume, which will become part of the permanent conservation record. Every aspect of the costume's condition is noted, from weak, deteriorated areas of aged fiber, losses, and tears to missing beads and sequins. Some older bridal veils, made of silk or nylon, have deteriorated to a crumbling state. The conservator tests the solubility of discolorations, stains, and soils in neutral cleaning solutions, and a photographic record is made to show overall views and document salient details of condition and construction before treatment. Finally, a treatment plan is outlined, after consideration of all of the above information.

Out of respect for the integrity of the costume artifact, only that treatment necessary to help ensure the stability of the costume and provide an acceptable visual appearance for exhibition is undertaken. Because the costumes will never be worn again, they are not subjected to rigorous refurbishing. The first treatment step is superficial cleaning by controlled vacuuming, using handheld attachments. If present, soil spots and stains are cleaned locally to flush out harmful substances or to minimize discoloration. Although makeup stains are a vivid reminder of the wedding day, they contain oily substances that can cause deterioration to silk and wool fibers over time. Embellishments, such as detached silk flowers or loose beads and sequins, are sewn back on by hand. Open seams are secured and tears in fabrics supported benignly from the back. Alterations and prior repairs, when stable and not likely to cause further damage to original materials, are often left intact as a record of personal use.

Throughout the entire process, selection of treatment materials is crucial. Not only must they be technically and aesthetically appropriate, but also nonreactive chemically. The support fabric used behind a tear in sheer ecru lace must nearly disappear so as not to interfere with the original appearance of the costume, and it must be chemically neutral so that further damage to fragile aged fibers does not result from use. When treatment is complete, a final report is prepared and the costume carefully packed in archival tissue paper with interleaving and padding to support delicate details and dimensional construction. Custom-made boxes, fabricated by museum staff, are used

to store costumes having voluminous fabrics and fragile parts during the interim periods between conservation treatment and catalog photography.

Special mannequins designed for exhibition of museum costumes are used in exhibits. Unlike fashion mannequins with idealized body forms, the exhibition mannequins are made of many discrete parts that, when assembled, can be adjusted to suggest a variety of body types. The waist telescopes up and down, and arms, hands, head, and upper torso tilt and turn. The upper legs are made of adjustable metal stems instead of solid thigh shapes to allow for lengthening. Using these features, the mannequin is customized to fit specific costume measurements and style. Next an elaborate process of alternately adjusting, measuring, and remeasuring costume and padding out the mannequin with soft materials continues until the illusion of an appropriate human form emerges. The costume is then carefully lowered over the mannequin for a trial fit, with two to three people gingerly supporting train, shoulders, hem, and so forth. Proper undergarments are needed for the costumes to fit well a fact that some museum visitors find surprising. Depending on design and historical period, long and short slips, crinolines, hoop skirts, and "longline" strapless bras are assembled to help suggest prevailing standards of beauty and style. For this exhibition some ready-made undergarments were purchased or loaned to the museum and others are components of the original costumes, saved since the wedding day. Patterns for several silk underslips and faux undershirts were drafted and the garments fabricated by a volunteer with dressmaking skills. Various types of stockings and hose, purchased at local department stores, are used to give the impression of proper wedding attire and to help smooth out padding.

After carefully arranging the costume components of tunic, robe, skirt, and blouse, dress, pants, or jacket on the mannequin, accessories are added to complete each costume ensemble. Shoes, gloves, and jewelry are chosen to suggest historical period and style as interpreted by the exhibit curator. Finally, where appropriate, paper hair wigs, fabricated separately by museum staff on removable mannequin heads, add a subtle reminder of the era.

When available, photographs of actual brides wearing the exhibition costumes were used throughout the process of dressing mannequins. These images provided an important guide to costume fit, accessories, hairstyles, and other details to personalize the wedding ensembles. The entire process of preparation and dressing of mannequins is carried out on-site in the museum collection storage area where conservators are handily, and with unending good humor, assisted by museum staff.

Recommendations to a Modern Bride

Cara Varnell

Two of the most frequently asked questions of textile conservators are from newlywed brides or brides-to-be.

These questions are, "I just got married, how do I preserve my wedding gown so my daughter can wear it?" and "I'm planning my wedding, and I want to wear my mother's (grandmother's) wedding gown. What should I do?"

The following recommendations are designed for quick and easy reference. If additional information is needed, conservators in museum textile-conservation labs around the country are available for further consultation.

Caring for Your Wedding Gown

The gown should be stored clean. Take it to a reputable dry cleaner and point out any spots or stains. It is especially important to note clear liquid spills, such as champagne. For if all residual sugars are not cleaned, these areas will eventually turn into permanent brown stains. The gown should be inspected after cleaning and before it is boxed.

Many dry cleaners will pack and box a wedding gown for long-term storage. Beware of expensive services such as "heirlooming" that includes sealed boxes or "vacuum packing." The advantage of these services is questionable and sometimes they may eventually prove harmful. Choose only a dry cleaner that guarantees that they use only archival-quality storage boxes and tissue paper. (Archival refers to paper products made from 100 percent acid-free papers that will not cause discoloration and so are appropriate for long-term storage. Archival box board comes in several colors; acid-free tissue is only white.) Beware of boxes designed specifically for wedding gowns that are only lined with white acid-free paper, while the rest of the box is common cardboard.

After the dress is cleaned, an alternative to using the dry cleaner's storage service is to do the job at home. Archival packing materials are available through specialty archival suppliers, some of whom sell a kit

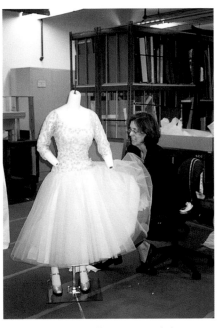

Fig.144 Cara Varnell prepares Judith Moss's bridal gown for the exhibition.

complete with box and tissue paper just for wedding gowns.

To pack a wedding gown at home you need an archival box appropriate for the size of the dress, another box for any accessories, and at least twenty-five large sheets of acid-free paper. First, line the box with a few sheets of tissue paper. Then, starting with the skirt, front facing down, position the dress carefully in the box using as few folds as possible. To prevent hard crease lines from forming, pad each fold with long crumpled sheets of tissue. Cover the skirt with tissue paper. Then place several long tissue pads at the waist and fold the bodice back over the skirt. With crumpled balls of tissue, pad the bodice and the sleeves into their natural shape. Finally, cover the folded dress with another layer of tissue paper.

Open the box and look at the dress every few years. If properly packaged, the dress will long retain its beauty. Periodic inspections can help mitigate or completely avoid developing problems during the years of storage. Store the dress in a cool, dry place. Avoid uninsulated damp basements and hot attics. These extreme conditions can be the catalyst for a variety of problems from mold to dry, cracking fibers.

Wearing a Vintage Wedding Dress

Sometimes nothing can match the charm of a vintage wedding gown, especially a family heirloom. Before deciding to wear a vintage gown consider the following:

To determine if the gown can withstand the stress of being worn, start with a "tug test." Take a very small section of fabric, hold it between the first finger and thumb of each hand, and then gently tug. Does the fabric tear or are there sounds of tiny fibers ripping? Test several areas; focus on the stress points around the arms and shoulders or across the back. Do a similar test with the dress seams, tugging slightly to verify that the thread is still strong. Check the threads securing the decorative details. Weakened sewing threads are easier to reinforce than splitting fabric. If the fabric survives the test but the threads break easily, consider the dress wearable. If fibers give at all or the fabric splits when tugged, it is smarter to choose another dress and perhaps incorporate an element of the old dress, such as the lace, into a new dress.

A dress's size is not the only proportion that matters. Also, in order to conform to the original look of the dress, choose undergarments that are consistent with the original line or silhouette of the gown. Even if a vintage dress seems to fit well, the bride must be able to move comfortably without stressing the sleeves, shoulders, and bodice back; minor alterations may be necessary. If possible, consult with a textile conservator, for restoring or revamping an heirloom wedding gown is work that requires an aesthetic sensitivity, knowledge of old and new fabrics, as well as an understanding of a variety of clothing-construction techniques.

Contributors

The list of contributors follows the order of the catalogue.

Uri D. Herscher, President, Skirball Cultural Center

Grace Cohen Grossman, Senior Curator for Judaica and Americana, SCC

Tal Gozani, Assistant Curator, SCC, Ph.D candidate, Department of History, UCLA

Didier Y. Reiss, Ph.D candidate, Department of History, UCLA

Shalom Sabar, Chairman of the Folklore Department, Hebrew University, Jerusalem and Director of Misgav Institute of Hebrew University for Sephardi and Islamic Communities

Esther Juhasz, Department for Jewish and Comparative Folklore Studies, Hebrew University, Jerusalem

No'am Bar'am Ben Yossef, Curator, Judaica and Ethnography, The Israel Museum, Jerusalem

Jenna Weissman Joselit, Visiting Professor of American and Jewish Studies, Princeton University

Barbara C. Gilbert, Senior Curator for Fine Arts, SCC

Keren T. Friedman, Folklorist, Field Research in Djerba 1980-86, Literacy Coordinator, Visalia Adult School Literary Program

Sharon Shore, Textile Conservator

Cara Varnell, Textile Conservator

POSTCARD TRANSLATIONS:
Rabbi Jerry Schwarzbard and Rena Berkowicz Borow, Jewish Theological Seminary, New York
Didier Y. Reiss

VIDEO:
Paul Heller Productions

EXHIBITION DESIGN:
Darcie Fohrman Associates

BOOK DESIGN AND PRODUCTION:
Dana Levy,
Perpetua Press

INDEX:
Kathy Talley-Jones

PHOTOGRAPHY CREDITS:
Carmela Abdar, Fig. 43
Bill Aron, Fig. 138
The Babylonian Jewry Museum, Fig. 37
Benazraf Family, Paris, and The Israel Museum, Jerusalem, Jewish Ethography Archive, Fig. 35
Willyne Bower and Saretta Berkson Cohen, Fig. 44
Julie Breitstein, Fig. 86
Michelle Cait, Fig. 108
Thérèse Chriqui, Fig. 107
Naomi G. Cohen, Fig. 49, 134
Family of Judy M. Cowen, Fig. 100
Congregation Emanu El, New York and photographer Malcolm Varom, Fig. 28
Marian and Don DeWitt, Fig. 135
Susan Einstein, Figs. 1, 2, 4, 6–9, 11, 12, 15, 18–20, 23-25, 27, 29–32, 45, 48, 51, 54–64, 67, 70, 71, 73–82, 85, 87, 88, 91, 94, 99, 101, 104, 105, 117–133, 139
Ruth Felmus, Fig. 52
Delia Fleishhaker Ehrlich, and Mortimer and David Fleishhaker, Fig. 90
John Reed Forsman, Figs. 3, 10, 47
Keren Tzionah Friedman, Figs. 114, 116
Shirley Garfinkle, Figs. 41, 42
Germanisches Nationalmuseum, Nuremberg, Fig. 22
Madeline Rosenthal Goodwin, Fig. 89
Mary and Sidney Green, Figs. 83, 84
Sarah Guerrero, Fig. 106
Marilyn Hasson, Fig. 92
Hebrew Union College, Frances-Henry Library, Los Angeles, Figs. 14, 33
Hebrew Union College, Klau Library, Cincinnati, Fig. 26
Robert and Joseph Hirsch Families, Fig. 93
Israel Museum, Jerusalem, Jewish Ethnography Archive; Nahum Slapak, photographer, Fig. 39
Sally Joseph, Seemah Menashy, and Diana Saul, Fig. 112
Ronald M. Kabrins, Fig. 46
Shirley Kalish, Fig. 50
Susanne and Paul Kester, Fig. 136
Leah Levavi, Ramat Gan, and The Israel Museum, Jerusalem, Jewish Ethnography Archive, Fig. 40
Peachy and Mark Levy, Figs. 95-98
Ed Massey, Fig. 141
Grant Mudford, Fig.115
Tom Neerskin, Figs.140, 141, 143
Ruth Rosen Orbuch, Fig. 103
Marvin Rand, Figs. 5, 13, 16, 17, 53, 66, 68, 69, 72, 109

Baruch Rimon, Fig. 65
Homa Sarshar, Fig. 111
Sassoon Family, Jerusalem, and The Israel Museum, Jerusalem, Jewish Ethnography Archive, Fig. 38
Schocken Library, Jerusalem, Fig. 21
Anita Segalman, Fig. 102
Siman-Tov Family, Jerusalem, and The Israel Museum, Jerusalem, Jewish Ethnography Archive, Figs. 34, 36
Dr. Morris and Regina Tarica, Fig. 137

A video highlighting the various aspects of Jewish wedding ceremonies was made possible by the following people who shared their wedding memorabilia:

Dr. David and Miriam Ackerman
Nadene and Barry Alexander
Dee and Alvin Becker
Ilene and Don Berkus
Rabbi Karen Binder and Rachel Bernstein
Teddy Brown
Adele Lander Burke
Michelle Cait
Mildred Cohen
Joyce W. Cowan
Laura and Randy Dudley
Rabbi Lisa Edwards and Tracy Moore
Gloria Frankel
Sidi Klausner Freedman
Zita and Jack Gluskin
William and Maria Herskovic
Steven Hochstadt and Stephen Sass
Sharon Jacobson
Ruth and Ed Krischer
Debbi Laskey and Allan Pratt
Bea and King Levin
Rita Lipshutz
Alicia and Itzhak Magal
Ruth Orbuch
Drs. Gary and Leslie Plotnick
Marcia Kahan Rosenthal and Family
Jo Schatz and Family
Joan and Joel Schrier
Andrea and Sheldon Shapiro
Clara Nudelman de Silberstein
Renée and Edward Sokolski
Ellie Somerfield
Ann Spicer
Sharon Tash and Family
Suzanne and Jerome Urfrig
Lesley Vandernoot and Keith Jones
David Welsh
Barbara and Jerry Werlin
Jody Garfinkle Zaviv
Majdoline Zelkha

Index

FRONT COVER
Left to right, top to bottom:

Wedding Portrait of Jeanette Bergman and Max Friedman, 1926

Ruth Ellenson and Robert Guffey Wedding, 1999
Photographer: Bill Aron
Photograph courtesy of Ruth Ellenson and Robert Guffey Ellenson

Jewish bride of Tunisia, 1983
Photogapher: Keren Tzionah Friedman

At the Betrothal from J. Ch. G. Bodenschatz,
Kirchliche Verfasung der heutigen Juden, 1748.
Courtesy of Hebrew Union College, Frances-Henry Library, Los Angeles

Romantic New Year's Greetings: A Happy Couple, 1915

Wedding Portrait of Annie Oshinsky, 1897

BACK COVER
Left to right, top to bottom:

Anita and Mischa Cohen, 1927
Gift of Anita Segalman

Couple, New York, 1977
Photographer: Bill Aron

Venice *Ketubbah*, 1649
Kirschstein Collection

Wimpel, 1830
Kirschstein Collection

"Song of Love" Sheet Music, 1912
Museum Purchase with funds provided by the Lee Kalsman Project
Americana Acquisition Fund

Wedding Dress of Marion Rheinstrom, 1920

ROMANCE & RITUAL
Celebrating the Jewish Wedding

was produced for

The Skirball Cultural Center

by Perpetua Press, Los Angeles

Editor: Letitia Burns O'Connor

Designer: Dana Levy

Printed in Hong Kong

through Asia Pacific Offset